S E A M S

A R T A S A

PHILOSOPHICAL CONTEXT

CRITICAL VOICES IN ART, THEORY AND CULTURE

A series edited by **Saul Ostrow**

Seams: Art as a Philosophical Context

Essays by Stephen Melville
Edited and Introduced by Jeremy Gilbert-Rolfe

Capacity: History, the World, and the Self in Contemporary Art and Criticism

Essays by Thomas McEvilley
Commentary by G. Roger Denson

Forthcoming Titles

Hot Potatoes: From Formalism to Feminism. Essays by Lucy Lippard. Commentary by Laura Cottingham

Media Research: Technology, Art, Communication. Essays by Marshall McLuhan. Commentary by Michel A. Moos

Literature, Media, Information Systems. Essays by Friedrich A. Kittler. Edited and with a Commentary by John Johnston

This book is part of a series. The publisher will accept continuation orders which may be cancelled at any time and which provide for automatic billing and shipping of each title in the series upon publication. Please write for details.

GILBERT-ROLFE

JEREMY

STEPHEN

MELVILLE

SEAMS

ART AS A

PHILOSOPHICAL CONTEXT

Essays by
Stephen Melville

Edited and
Introduced by
Jeremy Gilbert-Rolfe

G+B
ARTS

Australia Canada China France Germany India Japan
Luxembourg Malaysia The Netherlands Russia Singapore
Switzerland Thailand United Kingdom

Amsteldijk 166
1st Floor
1079 LH Amsterdam
The Netherlands

Chapters one and three appeared in *Arts Magazine* (1982) and *MLN* (1987), respectively. Chapter five was published originally in *Critical Inquiry* (1986); chapter six in *Vision in Context: Historical and Contemporary Perspectives on Sight*, eds. T. Brennan and M. Jay, Routledge (1996); and chapter seven in *Deconstruction and the Visual Arts: Art, Media, Architecture*, eds. P. Brunette and D. Wills, Cambridge University Press (1993). Chapters eight, nine, and ten were printed initially in *October* (1982), *Art History* (1991), and *Art and Design* (1992), respectively.

British Library Cataloguing in Publication Data

Melville, Stephen W.
 Seams : art as a philosophical context : essays. -
 (Critical voices in art, theory and culture)
 1. Art - Philosophy
 I. Title II. Gilbert-Rolfe, Jeremy
 700.1

 ISBN 90-5701-031-3 (hardcover)
 90-5701-021-6 (softcover)

CONTENTS

ritical Voices in Art, Theory and Culture is a response to the changing perspectives that have resulted from the continuing application of structural and poststructural methodologies and interpretations to the cultural sphere. From the ongoing processes of deconstruction and reorganization of the traditional canon, new forms of speculative, intellectual inquiry and academic practices have emerged which are premised on the realization that insights into differing aspects of the disciplines that make up this realm are best provided by an interdisciplinary approach that follows a discursive rather than a dialectic model.

In recognition of these changes, and of the view that the histories and practices that form our present circumstances are in turn transformed by the social, economic, and political requirements of our lives, this series will publish not only those authors who already are prominent in their field, or those who are now emerging—but also those writers who had previously been acknowledged, then passed over, only now to become relevant once more. This multigenerational approach will give many writers an opportunity to analyze and reevaluate the position of those thinkers who have influenced their own practices, or to present responses to the themes and writings that are significant to their own research.

In emphasizing dialogue, self-reflective critiques, and exegesis, the *Critical Voices* series not only acknowledges the deterritorialized nature of our present intellectual environment, but also extends the challenge to the traditional supremacy of the authorial voice by literally relocating it within a discursive network. This approach to texts breaks with the current practice of speaking of multiplicity, while

continuing to construct a singularly linear vision of discourse that retains the characteristics of dialectics. In an age when subjects are conceived of as acting upon one another, each within the context of its own history and without contradiction, the ideal of a totalizing system does not seem to suffice. I have come to realize that the near collapse of the endeavor to produce homogeneous terms, practices, and histories—once thought to be an essential aspect of defining the practices of art, theory, and culture—reopened each of these subjects to new interpretations and methods.

My intent as editor of *Critical Voices in Art, Theory and Culture* is to make available to our readers heterogeneous texts that provide a view that looks ahead to new and differing approaches, and back toward those views that make the dialogues and debates developing within the areas of cultural studies, art history, and critical theory possible and necessary. In this manner we hope to contribute to the expanding map not only of the borderlands of modernism, but also of those newly opened territories now identified with postmodernism.

Saul Ostrow

PREFACE

Stephen Melville and **Jeremy Gilbert-Rolfe**: "Self-Determining Systems"

*T*he texts by Stephen Melville and Jeremy Gilbert-Rolfe in this volume represent not only the complexity of their individual projects, methodologies, and practices, but also what each believes is intellectually and culturally at stake. Given their projects and approaches, Melville and Gilbert-Rolfe guide us through the diversity of contemporary thought and philosophy, unravelling the Gordian knot that circumscribes their subject: art and the practice of the art historian. Gilbert-Rolfe brings to the task of critically reviewing Melville's writings not only his own knowledge and analytic ability, but also an astute self-interest. The consequence of this is a text that articulates the subtle shading of Melville's arguments, as well as his own, within a broader philosophic discourse. Neither Melville, a literary theorist turned critic and art historian, nor Gilbert-Rolfe, an artist, critic, and theorist, are detached academics. Therefore their writings reflect not only a real concern for what art and culture may represent, or how one might interpret these, but also the more practical question of how these issues will affect their practices.

Gilbert-Rolfe identifies Melville's subject as being the intricate interface between the art object, its history, philosophical interpretation, and the practice of the art historian. Using Melville's texts and drawing on both the writings of Heidegger and such contemporary thinkers as Derrida and Lacan, Gilbert-Rolfe demonstrates the function of each of their texts and their relationships to one another. His writings, like those of Melville, are not merely detached views, but the product of a proposed model of criticism, art history, and philosophy. This model is itself premised on a self-reflexive discussion of

what can be attributed to a given object, while taking into account that the history of an object's interpretation is distinct and different from the history of that object itself. In other words, the authors argue that such histories reside within the context of one another. From this vantage point, the writings of Melville and Gilbert-Rolfe are not only a product of the function of such multiple frames of reference, but are also part of an ongoing disquisition that attempts to bring sense to what we might make of such things as art, history, and philosophy within the discursive framework of postmodernism.

To begin with, Gilbert-Rolfe makes a case for the view that art history's problem at the end of the twentieth century is the crisis of modernism's historical project itself. Beyond this standard argument lies another far more sophisticated one. This is premised on Melville's proposition that art history's tripartite subject—art, art history, and the art historian—is to be found situated, albeit uncomfortably, between the question of the art object and that of the object of art. Obviously the passage between the question of what art is and what it says is not necessarily clear. To complicate things further, Melville represents the relationship between the discourses of art history, philosophy, and the art object as being somewhat dysfunctional, because art resists being circumscribed by either its history or by philosophy. The resulting dance of approach and avoidance functions in such a manner that the various discourses at work are not complementary, but instead are the means by which the limitations of each become antibodies, preserving the health of their respective subjects. The implication is that the modernist goal of stasis or balance is not art's enterprise. Instead, what Melville and Gilbert-Rolfe propose is that its goal should be the self-preservation and maintenance of each discourse's identity in relation to others. In this construct each element becomes the subject of its own self-critical discourse, rather than becoming enfolded one into the other or reduced to common ground.

In this, each practice is the product of a deconstruction of its own metaphysics. This results in "it" coming to exist within its own "self-determining" system, while remaining true to its material identity and practices, as well as its necessarily existing as such within a heterogeneous rather than homogeneous environment. The consequence of this proposition is that the need to develop a totalizing or

unifying concept that would dialectically resolve all differences is discarded in favor of something like a field of deferral, parallelism, and intersection. Gilbert-Rolfe shows that Melville's thinking is premised on the existence of a Kantian art object, a Hegelian model of history, and a Heideggerian practice of philosophy. The identity of each of these, Gilbert-Rolfe argues, arises from the discourse produced or induced by each system existing within and by its own criteria. Despite this diversity of criteria, the postmodern world herein described is not one in which "anything goes," for the ensuing heterogeneity guarantees the terms and identity of each thing within an environment of noncontradictory differences. In this manner, both the subjectivism and arbitrariness that are implicit in other models of postmodernism, as well as the universalism of modernism, are not only set aside but rejected.

Saul Ostrow

INTRODUCTION BY JEREMY GILBERT-ROLFE

Stephen Melville and Art's
Philosophical Attitude Toward
History

STEPHEN MELVILLE AND ART'S PHILOSOPHICAL ATTITUDE TOWARD HISTORY

It is of the essence here that this posing of criticism as a problem is not tantamount to transforming criticism (and art history) into art—that is simply to refuse the newly posed question and to reaffirm the impossibility of contamination . . .[1]

*T*he subject of art history may be found situated, not necessarily comfortably, between the question of the art object and that of the object of art. One is a question of what it is and the other of what it says, and the passage between the two is not necessarily clear. The two are, however, linked in one obvious sense: *what it can* say is to some extent *conditioned* by *what it is*. This leads directly, by implication rather than through explication, to the question of whence might emanate any "saying" that the work may do. Stephen Melville has examined the tripartite identity of art history's subject—art, art history, and the art historian—largely with this last question in mind.

It is clearly the case that art history's problem, at the end of the twentieth century, has to do with a crisis associated with the historical project itself. While most art historians seem quite content to let their discipline be a history of the decisions of art dealers, so that art history is a subject formulated by Ph.Ds in response to the behavior of people with undergraduate degrees, it is nonetheless unclear that a theory of progress or regression—i.e., of historical development—can provide an adequate motive for what seems to be better described as an economy of recirculation and reconvention. Deprived of a historical trajectory many historians of art, like economic and cultural historians, seem to have settled for theories of irreversibility as substitutes for the theories of development which once allowed them to perform that confusion of methodology with

actuality of which the discipline was accused by Nietzsche but which nonetheless permitted it to indulge in the fantasy that meaning is a result of acts converging with historical interpretation, of objects entering historical space.

Melville offers an alternative. Where some would have meaning follow from an encounter with history—where interpretation allows the work to become historical and in that able to realize, as it were retrospectively, the historicalness of its becoming—Melville sees meaning as both a component of the art object as phenomenon and simultaneously undermined by it. Melville's is an art object which can't be contained by the historical because it is what produces history, an art history which is at once historicist but which relies on contextualizing historicism within a field of theoretical reference which gives point to historical method rather than deriving its own meaning from it. Where the discipline has sought, over the past fifteen years or so, to find a historicism shorn of the claims of the past but still firmly in control of its object(s)—so that one historian would now have us believe that painting is an essentially eschatological activity, obsessed with its historical end because it knows itself to have a history, and another that the surrealist revision of the object gave rise to an historicism of the unconscious, in which art after art becomes no more than a mimesis (confused with reification) of a structural model committed to referring through rejection to the one which it replaces—Melville has tended to look not to the problems of the discipline but, more generally, to the problem of description which precedes them. This is the problem of what is being described, and with what, and therefore *for* what. This leads away from history toward the philosophical. Where elsewhere one finds the question of what to do with the art object as an historical object once history has died, in Melville one finds the question of what to do with art as a philosophical subject after deconstruction and the alleged departure of the metaphysical. Where, therefore, the art object after art becomes, enchantingly, no more than a little counter in a miniseries about the end of a form (conceived from the beginning as a process concerned with its own end), or a screen on which to project fairy tales (or other mythological allegories) about the shape of consciousness—a model of advanced consciousness which, like its predecessors, turns out to have a remarkable, but surely coincidental,

resemblance to the neurotic formations characteristic of its author—
in Melville's writing it offers complexity rather than awaiting it. Prior
to the object, in Melville, is the question of permitting it to be.
Unlike too many of his colleagues, he is prepared to raise the ques-
tion of what it does, rather than assume that all the interesting
answers are to be found in the corollary one of what can be done to
it. I shall say that Melville's thinking suggests not so much an anxiety
as a lively interest in regard to the irreducibly phenomenological sta-
tus of art objects in a period when the discipline in which he works
seems indifferent to that irreducibility. In Melville, the work of art
(the non-production of that which comes after art, is now if it is at all)
leads from Derrida (*et les autres*) to structuralism and thence to all
that both sought to replace or whose dilemma both sought to resolve,
reconsidering but not necessarily resolving the dilemma. As such, art
can become something which is, something which exists as other
than a function in or product of a discourse. As such, it can have an
attitude toward the history which it's said to make by those who actu-
ally insist that it's made by history. This is a philosophical attitude,
but not in that one of resignation or tolerance, that allows Melville to
be involved with objects which are not necessarily continuous with
their history. Which is to say, to be sensitive to art as producer rather
than product, and then as a producer not reducible to (an interpreta-
tion of) what is produced.

Melville interests me primarily because he is a thinker who is prepared
to begin with the visuality of the visual arts. More than most contem-
porary writers, he is concerned with the role of phenomena as much as
appearance, to cite Heidegger's distinction between that which does
not know concealment (and is therefore present in itself) and that
which *does* (and therefore is not present, or not entirely). I suspect that
it is Melville's background in literature which facilitates this willing-
ness to accept that to see is not necessarily to find lack in all things,
because literature itself has largely managed to evade or ignore the
government by historical categories and goals which have character-
ized the visual arts since before the modern period. To be
Heideggerian again, I suspect it may be from literature that Melville
derived the possibility that to say is not necessarily only to reenact a
series of historico-ideological (which would include the psychological)

chains of signification. It's not so much that Melville replaces a theory of art history in which art goes somewhere with one in which it's going nowhere, it's that he makes the *question* of where it's going into an element of what it is, and necessarily one which always has the same relationship to that. Melville has described the situation as follows:

> [I]t can be tempting to imagine that "poststructuralism" can be defined in whole or in part by a certain return of or to phenomenology. There is, I think, something to this: but it also mistakes both the extent to which questions of perception and interpretation have been radically recast by the appeal to Saussure's model of language and the extent to which the interests underlying that appeal, outside of its most purely scientistic forms, are shaped precisely by a history of engagement with phenomenology and its hermeneutical offspring. This, I would argue, is visible even in the work of Lévi-Strauss—an aspect of his work that is lucidly registered by Ricouer in his remark that what Lévi-Strauss argues is a Kantism without the transcendental ego, a description that opens an easy passage between that work and Heidegger's. This of course would be to suggest that the difference between structuralism and poststructuralism is less usefully thought of as a difference about phenomenology than as the unfolding or repetition of a difference properly within it, marking limits at once internal and external to it. That is, structuralism and poststructuralism alike can be said to belong, in part at least, to phenomenology just insofar as it is not a settled body of practices or propositions but something more like a style or movement—and is a movement just because it is bound to the unfolding ambiguities of its claim to grasp things as they are— ambiguities that importantly pass between "description" and "interpretation". If the emergence of theory marks a crisis for phenomenology, bringing out its internal impasses and demanding its continuation in a radically transformed register (one in which it can no longer or only with great difficulty recognize itself), this is perhaps because the newer work forces the recognition that what presents itself as perceptual cannot be registered except under some condition of legibility—which is to say that the ambiguities within the claim to "grasp things as they are" are not simply infelicitous features of a language we are obliged to use but are a part of the structure of that grasp.[2]

The question of legibility is, as I've observed elsewhere, one which links Derrida to the phenomenological method of which he has been such a profound critic—a profundity produced, incidentally, by being playful rather than severe.[3] Where Barthes' structuralism can imagine a division between "readerly" and "writerly" works, the latter have no place in deconstruction or phenomenology because it can

only be to the extent that they are legible that they can be said to be, or to be about not-being. That which takes writing to a certain limit without regard for the reader can only, in these terms, provide reading with a certain challenge. And in meeting that challenge, reading finds something out about itself, namely that there's yet another form that it can take. There is of course no reason to suppose that a reader could not be swept up in reading, lost in it, left behind only to reappear at the end transformed. But that is only to say that reading is something in which individuals take part rather than something they control. The idea that there could be works which, in their complexity or reduction, become illegible is in this sense founded in a confusion of language with semiotics, legibility with interpretation. What could be more lucid and transparent than the intentionally illegible? The problem, if any, would not be unreadability but too clear a read, since one would see only negation and therefore an untransformed trace of the negated. That, by definition, would be nothing that one hadn't seen before.

If legibility is presumptive in both philosophy founded in perception and in philosophical critique of the very idea of perception and all that it implies, then it is also the case that "the extent to which questions of perception and interpretation have been radically recast by the appeal to Saussure's model of language" is the extent to which that appeal reflects and exacerbates a bifurcation of legibility within the art object. References to Ricouer aside, what Melville's writing helps to clarify is the need for a method which will account for the work as both a signifying thing and a cluster of signs. Philosophy has never been very good at distinguishing things from concepts—things coming to life only as concepts and concepts living only in things—but in an important sense that is what interpretation is ultimately bound to interpret. If perception responds to phenomena, interpretation seeks to make sense of an incompatibility, on which the legibility of the work is founded, between the mark and meaning, what it is or seems to be and what it says or seems to say. What does not lead back to the object must lead somewhere else, to structure and comparativism and in that to dematerialization, signification as the final resting place of the signified. What does lead back to it must first pass through all that which makes its legibility interpretable as a series of signifieds—the discourses of the historical, psychological, first and

last the ontological—and thus clarify what it does by way of exceeding its appearance as signification, which is to say, what it is as art. Melville's work resonates with the realization that that which "grasps things as they are" does so, currently, in the knowledge that in art any one thing is two things: the one that turns into a text and plays with legibility by leading it into the world (without an earth) of the sign, and the other that signifies by being irreducible to signification while constantly presenting itself as that on which signification and the legibility it promises depend.

To say that the appeal of methods and approaches ultimately indebted to Saussure (or, more likely, to Saussurianism leavened by Peirce and Barthes) reflects interests "shaped precisely by a history of engagement with phenomenology and its hermeneutical offspring" might, in this sense, seem like a bit of an understatement. One geneology for the postphenomenological hermeneutic is, for example, Merleau-Ponty's. Despairing of ever finding an adequate account of the Chiasmos—of the mutuality of perception and cognition in response to an intended object—Merleau-Ponty finally threw up his hands and went in for structuralism instead. Which is to say that at least some of phenomenology's hermeneutical offspring first sprang off out of exasperation with, as much as any desire to elaborate or shore up, the perceiving subject.

The hermeneutical subject which that elaboration produced decodes rather than perceives, while being itself an encoding—of "the structure of its grasp." It sees not objects, but legible messages. It's an historical subject to the extent that it is concerned with the message as a product. Knowing language as a code, it recognizes the role of historical change in the code's formation. Ricouer, intent on finding a theoretical explanation for the connection between the layers of literary texts, ended up stranded in psychologism because the alternative would have been a return to the aesthetic. The search for the hermeneutical subject has, over the past twenty years, similarly led many others to Lacan. Where the phenomenological object *is*, the hermeneutical text *refers*. This capacity permits it to be engaged in all that the object as phenomenon is not. At the same time, in answering the questions left dangling by theories of perception, it finds itself detached from things by its function as a sign. To be present as a sign is to be not present as phenomena; the sign occludes the

object in the act of providing it with an hermeneutic volition. Phenomena give way to appearance, to a world of the hidden or partially revealed, in a word to textuality. Thus it is that one talks about the text as a deorigination; hermeneutic legibility connects the work to discourse, but in so doing loses sight of its origin in and as phenomena—to the extent that it might be as well to think of *re*origination as the actual task of the hermeneutic (the message came from Zeus, but you're going to get it as one of Hermes' little notes).

For Melville, as for Michael Fried—and for Merleau-Ponty as far as that goes—the hermeneutic becomes the epistemological and also the place of the episteme. Because for Melville and Fried at least it is there that the struggle becomes something other than a question about art. Certainly this returns both of them to the phenomenological hermeneutics of being and essence—structurally speaking, presentness signifying its own presence—but it does so by way of an argument about the place of art in discourse. From the art object to the object of art as an object *for* art (for example, a historical goal or a job as a bulletin board for contemporary theories of consciousness) and back again with a view to seeing what happens to art's objects when they're brought back into some confrontation with the object itself. Melville's treatment of Fried's notion of absorption goes straight to the point. The question is twofold: What does it take to absorb those who are already involved with legibility? In the first place, an image of absorption itself. What is such an image an image of? The perceiving subject perceiving or in some suspended state of not-perceiving (sleep, reverie, reading), i.e., the question of what has taken perception's place expressed in terms which are themselves a question about perception.

An important aspect of this absorption is that it is not based in any sense of the physical. In a sense Fried's notion of absorption threatens to be a kind of professor's dream, the senses engaged but beyond the body as well as discourse: relief from the latter without the threat of the physical. And all in the language that professors understand better than any other, the language of concentration. And Fried is right (I'd say "obviously right" had he himself not once told me that the thing he found least convincing about English writing was its tendency to use the word "obviously"). Clearly the only work that could absorb those engaged in legibility as a virtue—which

would be not only professors, but anyone interested in art and its problematics—would be that which could employ the hermeneutic—the world of decoding—to reach beyond it towards an encounter with the conditions which permit the decoding to occur, the question of engagement or absorption. Melville understands this aspect of Fried's writing very well, and has used it to develop an approach to the methods provided by "phenomenology's hermeneutical offspring" which follows Fried's in certain respects but which also finds within it a number of possibilities for the work of art, and with that for art history, which lead elsewhere.

These begin to emerge in the essay reprinted here as chapter 8, which deals with Fried's methodology at length. "Notes on the Reemergence of Allegory, the Forgetting of Modernism, the Necessity of Rhetoric, and the Conditions of Publicity in Art and Criticism" announces itself as a "scattered collection of notes" but is in fact a thorough discussion of art criticism's perennially central theme, which is: What are the works that one may take seriously, once one has accepted that the viewer proposed by the work of art is by definition one who is hermeneutically preoccupied (as, to underscore the contemporary's continuity with the Enlightenment, was Diderot)?

That's not what the essay purports to be about, since it is written in the context of a discussion about art history where no one is ever allowed to raise questions of preference as such because that might reveal too much about the institutional profile of the art historian. To say that one prefers something is, at least to some, bound to reveal something about the one doing the preferring. But that is in large part what the essay is about, and specifically it is about the viewer that would be adequate (i.e., the art historical approach that would be adequate) to an ambitious work. I put it as a circularity because it may be bluntly expressed as such: what does a work have to be to be taken seriously by a sophisticated viewer is a crude restatement of the idea that the work proposes a sophisticated viewer for itself. The sophistication is hermeneutical, the viewer is aware of the work as a sign which seeks to get beyond its signifying function.

Melville understands Fried's contribution as few others seem to do. While there may be a number of reasons why this should be so, the one I prefer is that Melville has no particular loyalties with regard

to this or that sort of art. In any case he sees the general significance of Fried for art history in general, and sees it as being grounded in his rejection of an art which employs a rhetoric of withholding. This rejection of the work of art as the deployment of a kind of coyness is for Fried tied to a necessary preoccupation with renewal on the part of the work of art of its hermeneutic identity.

In my opinion the key to Melville's use of Fried is to be found in the contrast he observes between Fried and Greenberg on the matter of painting's essential (if it is) flatness. It is a contrast contained in two quotes. First, Greenberg:

> The task of self-criticism became to eliminate from the effects of each art any and every effect that might conceivably be borrowed from or by the medium of any other art. Thereby each art would be rendered "pure," and in its "purity" find the guarantee of its standards of quality as well as of its independence.[4]

Elimination of the extraneous returns one then to the surface as a condition of identity which is also a guarantee. Not so for Fried:

> ... flatness and the delimitation of flatness ought not to be thought of as the "irreducible essence of pictorial art" but rather as something like *the minimal conditions for something's being seen as a painting*; the ... crucial question is not what these minimal and ... timeless conditions are, but rather what, at a given moment, is capable of compelling conviction ... This is not to say that painting *has no* essence; it *is* to claim that that essence—i.e. that which compels conviction—is largely determined by, and therefore changes continually in response to, the vital work of the recent past. The essence of painting is not something irreducible. Rather, the task of the modernist painter is to discover those conventions that, at a given moment, *alone* are capable of establishing his work's identity as painting.[5]

While it is not clear to me how the essence of anything could be non-irreducible and still be essential, particularly not if that which is non-irreducible can still be associated with the adjective "alone," I understand that Melville establishes that the difference between Greenberg and Fried is one which gives a more active role to the play of the historical as rhetoric—the deployment of conventions for effect and as effect—in the latter's theorizing than in the former. Greenberg proposes, in terms which are not irreconcilable with Heidegger's

notion that the world the work makes should lead back to and be in tension with the earth on which it stands, nor with Nietzsche's notion of advance as return, purity as a goal and as a guarantee. Fried substitutes the word "essence" where Greenberg uses "purity," and finds the essential as a problematic at the hermeneutic level of the work. Greenberg's (possibly rather innocent in this regard) perceiving subject becomes in Fried a subject which is obliged to do quite a lot of decoding on the way to perceiving. Fried's is a phenomenological subject encumbered, or liberated, by hermeneutics. Encumbered in as much as the work, in order to be at all, must first negotiate a series of demands derived from, or manifested as, questions of historical appropriateness and acknowledgement. The hermeneutical dimension turns out to be the place where the work announces and articulates itself as a response to—and participant in—a discourse. It is liberated for the same reason, insofar as this acknowledgement of the work as a participant in an argument frees it from a concern for the purity of its means because their historicizing—a convergence with a historical argument that converts the search for purity into a rhetorical position—suspends, or if one prefers, *precludes* that concern in its substitution of a historical materialism for what is either an idealism or a version of Heidegger's earth/world tension which similarly rejects the immediately historical as an authentic component of the work's reconsideration of history as such. As Melville puts it, Greenberg's is a position which wants to argue that "the crucial thing about a work . . . is simply that it is and not that it means," while Fried, though closely associated with and implicitly drawn to it, nonetheless "appears to see in contemporary theory a way neither to recover meaning nor to produce new meanings but a way to grasp objects insofar as they are capable of exerting effects, art historical effects above all."[6]

Anecdotally speaking, it's worth remembering that the opposition to Greenberg was the result of his insistence that the eschewal of meaning in favor of being was the only art historical effect worth achieving. That said, one may then say that Melville sees that Fried has found a way out of Greenberg's preoccupation with a possibly false ontological reduction by diverting attention to the discursive function of what may no longer be seen as a reduction. Fried figures prominently in Melville's writing. In the last few pages I've moved

from one essay to another in the quotes I've used to illustrate the points I've sought to make. Melville sees Fried as the contemporary thinker who has sought a hermeneutic elaboration of the phenomenological object and the perceiving subject it proposes which would not lose sight of the existential actuality of the art work as a thing which is never a thing.

He is of course aware of the evolution of Fried's thought, and makes considerable play with the implications of that development, as the reader of this volume will see. Fried is, however, an ancillary to a larger project, as is Greenberg, in that the figure who recurs most— and most tellingly—in these essays is Heidegger himself, and the reason is that, for Melville, the challenge that the work of art offers art history is to be found in the fact that art objects are indeed objects. For Melville, art history's difficulty is that its objects are not in themselves historical objects. This seems to be what theory, as something which can be opposed to art history as a practice, means for Melville. Phenomenology frustrates historicism even while its own insolubility causes a hermeneutic flowering which threatens to overgrow and obscure the ground on which it grew.

The effect of Derrida's engagement with Heidegger is, in Melville (in his reading of Fried and also elsewhere) to reoriginate through deorigination. Deconstruction restores the Heideggerian work of art while making its relationship to the contemporary more explicit (more legible) and thus complicating and indeed deferring its possible realization of the ground out of which it putatively sprang. It is in this sense that Melville places Heidegger at, as it were, the origin of the tripartite enquiry with which I've identified him here: the artwork plays a game with its own origin; art history is the history of works which have a conscious and therefore not continuous relationship to the historical; the art historian is the historian of, and as the perceiving subject, reconsidered *by* the hermeneutics of—which is to say, generated by—the artwork's own identity. If the difference between Greenberg and Fried is, for Melville, the difference between purity and mutability, his version of Fried takes the latter's thinking, perhaps, toward a more elaborate version of what is present to what. For Melville, the phenomenological object described by Fried, complicated by the (inauthentic because it is not eschatological) historical space it both enters and transforms, is the postmodern object, present as the evasion

of an idea of presence which depends on purity (authenticity), deoriginated and thus reoriginated in its polyvocality, but entirely dependent on what it seeks to evade because it continues to be dependent on the lived body whose embodiment its own invokes. How Melville makes it become this is to be found in the following sentence: "If postmodernism names modernism insofar as it is inevitably its own allegory, deconstruction names self-criticism insofar as it cannot exempt itself from itself."[7] Whatever modernism was, it is now only what it can be while being past, deoriginated by and reoriginated within what succeeds it—or, to gesture toward the gloomier side of both Fried and Heidegger, what fails to follow its characteristic failure. Whatever deconstruction deconstructs survives it by being that upon which it depends. Melville—Fried also, but less insistently—returns one as reader (ideal or just real) to the implication that legibility bears: writing writes the reader, signing signs, while art history is the history of readers (hypocritical or not, but hypercritical of necessity) proposed by the objects whose objects, as proposals, they are.

* * * * *

Phenomenological theories of human embodiment have also been concerned to distinguish between the various physiological and biological causalities that structure human experience and the *meanings* that embodied existence assumes in the context of lived experience. In Merleau-Ponty's reflections in *The Phenomenology of Perception* on "the body in its sexual being" he takes issue with such accounts of bodily experience and claims that the body is "an historical idea" rather than "a natural species."[8]

Thus Judith Butler, while the following is from Melville:

At the level of what one might imagine as a shared intuition into the rhetoricity of vision—what I have been describing as its division from itself, the insistence of a certain heterogeneity at the heart of its transparency—I would point to Lacan and Goethe's insistence that the field of vision is above all a play of light and opacity arising from bodies and images in displacement.[9]

If the field of vision is made out of light and opacity then it comes to us as color, and one thing we know about color is that it doesn't work the way Goethe wanted it to, which was quite similar to the way in which philosophers had always wanted it to work, and

in which they continue to want it to work—and I'd differ with Melville as to whether "Goethe offers a better guide to how material color behaves than Newton."[10] John Gage, who recently published the book of books on the subject, demonstrates quite conclusively that Kant and Hegel clung to Goethe in flagrant disregard for the fact that he was demonstrably wrong.[11] Philosophy wants vision to be made out of recognition rather than phenomena, as, of course, must psychologism of any sort, especially one whose model is semiotic. This is the problem around which Melville makes the work of art be a reconsideration of the idea of historical formation in both its connotations: the work and its perceiving subject formed by history; history remade in its making.

In "Color Has Not Yet Been Named: Objectivity in Deconstruction," chapter 7 in this book, Melville establishes the limits of the "hermeneutic radicalization" which begins with Heidegger, and they turn out to be Heideggerian limits, the limits that phenomena place on language only capable of dealing with appearance:

> We know how to describe color in strictly physical terms. We know also something about how to analyze it semiotically, and indeed color can easily appear a prime candidate for semiological investiture, displaying the full force of "cultural construction." The physical phenomenon in its relation to our nomination of it seems to map directly onto Saussure's diagrammatic representation of the double continua of world and sound into which language cuts. . . . But color can also seem bottomlessly resistant to nomination, attaching itself absolutely to its specificity and the surfaces on which it has or finds its visibility. . . . The movement of color in painting is a movement in or of deconstruction. And if deconstruction can in some sense feel at home in reading the texts of color as they pass through the Renaissance through de Piles and Goethe and Chevreul, it is in a much harder place when it comes to actually speaking the work and play of color—not because that work and play are ineffable but because its "speaking" just is the work of art and its history.[12]

Heidegger says little about color, which in fact means that he avoids it as phenomena in favor of appearance and the concealment that comes with it. Color is both entirely present and complete, in Heidegger's terms. It is exactly not what Plato and Goethe wanted it to be, an accidental consequence of a peculiar relationship to an intended object. But there's nothing for it to do hermeneutically. It refuses the hermeneutic, which surrounds it and replaces it but can-

not find itself within it. Melville correctly observes that art history contains both the view that color is ornamental and therefore expendable–the position of Leonardo, the French Academy, and American minimalism, with its absurd social realist decadence in the work of Haacke and Holzer—and that it is where the truth of painting (i.e., of visibility) is to be found. Both positions encourage its infinite deferral and its subordination to a more immediately recognizable semiotic regime, that of drawing, which is to say of discourse—the code, the idea, the ideology—which is to say, *pace* Melville on Panofsky (and passim), of a discourse of power and power relationships, and hence the transformation of the work of art into a historical product rather than producer.

Like Greenberg and Fried, Melville is fond of saying that art works *are*. It is this which most obviously links all three with Heidegger, and Melville is not alone in linking this beingness with the adjective "just", when it's clearly nothing of the sort. Whether we get back to it if we succeed (Greenberg), find it in the contingences of what it supports, i.e., in realizing the historical potential of the conventions as they currently are (Fried), or see it in what the hermeneutic defers (Melville and also Derrida), it only "just is" by default, in the sense that it can't be described as a complexity or imagined as synthetic or otherwise combinatorial. If "color['s] . . . speaking just is the work of art and its history"—suggesting that the voice shapes rhetoric as much as rhetoric determines the voice, or moreso, and therefore that the body is not a semiosis but what lies beneath one—then what it speaks is silence. It is there that it can make silence concrete without deferring it into a sign. Or, actually, it can't, because it cannot *not* be hermeneutically active, it hasn't been named but it also can't say its own name. Heidegger says little about color—certainly doesn't seem to realize that that Greek temple would probably been painted in some bright hue of which he would doubtless have disapproved—but we recall what he had to say about silence:

> I: Who could simply be silent of silence?
> J: That would be authentic saying . . .
> I: . . . and would remain the constant prologue to the authentic dialogue *of* language.
> J: Are we not attempting the impossible?[13]

Speaking as speaking of—drawing a picture, telling a story, describing and thus interpreting, and therefore *vice versa*—is always what follows a silence which gives rise to it, what gives form to a silence but rises out of it, perhaps, may originate in it although that's by no means clear, fills it certainly but can't express or be it, and obviously needs it. Heidegger's essay "A Dialogue on Language," from which the above is drawn, and which takes the implausible form of a chat between Martin himself and an old friend from Japan (two old Axis buddies deliquescing on both the ultimate irrelevance, and the immediately deplorable condition, of the historical), contains another passage which is relevant here, and which deals with Kant and the question of appearance:

> J: In appearance as Kant thinks of it, our experience must already include the object as something in opposition to us.
> I: That is necessary not only in order to understand Kant properly, but also and above all else so that we may experience the appearing of the appearance, if I may put it that way, originarily.
> J: How does this happen?
> I: The Greeks were the first to think of *phainomena* as phenomena. But in that experience it is thoroughly alien to the Greeks to press present beings into an opposing objectness . . . Thus appearance is still the basic trait of the presence of all present beings, as they rise into unconcealment.
> J: Accordingly, in your title "Expression and Appearance" you use the second noun in the Greek sense.
> I: Yes and no. Yes, in that for me the name "appearance" does not name objects as objects, and least of all as objects of consciousness—consciousness always meaning self-consciousness.
> J: In short: appearance *not* in the Kantian sense.
> I: Merely to contrast it with Kant is not enough, For even where the term "object" is used for present beings as subsisting within themselves, and Kant's interpretation of objectness is rejected, we are still far from thinking in the Greek sense—but fundamentally though rather in a very hidden sense, in the manner of Descartes: in terms of the "I" as the subject.
> J: Yet your "no" suggests that you, too, do not think of appearance in the Greek sense.
> I: You are right. What is decisive here is difficult to render visible, because it calls for simple and free vision.[14]

"Just is" calls, as it were, for "simple and free" vision. Heidegger's invocation of Descartes confirms Butler's accusation of the separation

of the phenomenological subject from the sciences of the body, and this is a separation which lies at the heart of Melville's notion of legibility. Legibility, for Melville, requires more than a semiotic, and the reason why this should be so returns one to the problem of phenomenology's object and its relationship to art, art history, and the art historian. Regarding the sciences of the body as a semiotic, Melville has made extensive use of Lacan, where what presents itself to vision remains outside or beyond its own present: "[F]rom the moment the real gives itself as remarkable—becomes, then, the Real—we have access to it only through the play of Imaginary and Symbolic it sets in motion."[15]

In Melville's reading, Lacanian *jouissance*—and orgasm is presumably the body as experience in both the English and French senses of the word (as both intransitive and transitive, involuntarily open and engaged in an experiment)—produces a model of logic without truth, logic which doesn't defer to truth—color which doesn't color a thing but is wholly color, is color rather than a coloring: "We thus enter a universe in which logic does not act as a guarantee of truth; instead truth acts to guarantee the comprehensibility of logic (a Heideggerian kind of universe, then), harnessing the letter into a dialectic whose very openness is its best guarantee of closure. "*La lettre, ca se lit*," Lacan writes—but this writing is already read, needs no reading from us, and is enclosed in pure self-affection".[16]

But such a reading is in no sense simple and free, but rather what Melville calls an act of appropriation.[17] Any application of a semiotic requires prior naming, a reversal of "the priority of hermeneutic activity over and against our theoretical reconstructions of it."[18] In this respect, among others, phenomenology's rejection of physiological and biological causation is directly comparable to its indifference to art history. Melville sees that for phenomenology the problem with science, whether that of the lab or Panofsky's, seems to be that it cannot help but be prior to its object. The problem becomes that with which color confronts philosophy: it lies outside and before its explanation, which in fact is one that philosophy can't provide. Color is not a function of ratio, it's not an accidental effect caused by squinting or exhaustion or the peripheral, as Plato and Goethe convinced themselves it was, nor in any other way a product of what philosophy can in fact manage, which is the passage from black to white. What cuts phenomenology off from the body is not its indifference

to science, then, quite the contrary, since the latter is similarly divorced. It's phenomenology's recognition of the prior status of saying as a ground for legibility, where it is understood that legibility implies a transformation, by the reading, of what is read, where the attribution of legibility can only remember the ground which it covers with the imaginary and symbolic.

Melville, seeing phenomenology as the heart of that "theory" which stands in some relationship of opposition or supplementarity to the discipline of art history, finds something like an answer to the difficulty with which art presents history in the work of Gadamer, whom he contrasts with Panofsky in the following terms: "For Panofsky, the work of art belongs to the history of human meaning; for Gadamer it does not: if anything, the history of human meaning belongs to it."[19] His description of Gadamer is, in fact, suspiciously similar to what he sees in Fried: "Gadamer's work can be taken as an argument against any claim to objective knowledge, but it is more accurately taken as arguing a radically different model of objectivity—that is, of how objects are in history and in interpretation."[20] Elsewhere he talks about "a sustained investigation of the stability of the visual as such and not simply of its presumed discursive construction" as a goal for the discipline of art history, and here I'd draw attention to the word "sustained."[21]

In this one sees what it is that Melville is doing to the art object, art history, and the art historian. In Gadamer's thinking, says Melville,

> hermeneutics offers to defeat our methodological self-understanding as exterior to the "tradition" we presume to form our object, and so to return us to an essentially Aristotelian position. . . . The explicit opposition here is to a modern self-understanding Gadamer explicitly attributes to Kant that separates theoretical and objective, or subsumptive, judgment from subjective and aesthetic, or reflective, judgment. It is perhaps implicit in (Melville's) argument . . . that Gadamer misses how far the Heideggerian formulations he is systematizing and extending . . . depend upon a radicalization of the kind of judgment Kant called reflective.[22]

His engagement with Heidegger, then, involves a modification of the idea of recognition. So too, perhaps, for Melville, but with the difference being that he speaks from a position where legibility is a

process wherein both Heidegger and Kant have been rewritten by Derrida, the one in conjunction with the other.

As his use of Lacan suggests, Melville understands that he lives at a time when "the orientation to psychology and sociology that is prepared by the turn away from Heidegger"[23] can, at least where the former is concerned, be shown to have led back to him. Likewise he knows that the sociological is frozen, known only by its formulae: "the male gaze is that through which the feminine is made object and stripped of its freedom"; "my submission is secured through the imposition of visibility on me"; until "my naming calls me into visibility and so, in (Althusser's) double sense, subjects me, rendering me a subject"—a perceiving subject knowing itself as such only to the extent that it knows itself to be oppressed by (its own) visibility.[24]

Melville is aware, that is to say, that the same hermeneutic elaboration that threatened to sweep away the phenomenological practice it in effect restored did indeed wholly undermine the certainties of science. His preference for Goethe over Newton is not, as it turns out, a preference for a bad color theory over one that works, but for a space that is made out of color rather than filled with and traversed by lines. Panofskian art history, Melville seems to imply, threatens to turn the saying of the art object into reported speech instead of entering into a dialogue with it which wouldn't require pretending that it had ceased to speak. These are the terms in which Melville argues for an art object which continues to be a saying, to be in its saying, after it has entered history and thus demonstrated that history is present in it as well as to it. A work of art is a speech act which never becomes wholly a text but which was entirely written from the start. One could say that for Melville the meaning of art objects lies in their deferral of the naming of their saying. First (he might say "simply" or "just") comes the deferring of the name, and it is this which in its turn leads one back to the deferring which is the work in a manner that characterizes it as a phenomenologically hermeneutic event. This is what he's derived from Fried's revision of Greenberg and Gadamer's of Heidegger, and from Derrida. In Melville's account Fried's location of meaning in the deployment of convention as a double-sided historical signification—something very like action masquerading as reaction—seems quite consistent with Gadamer's idea that "the work actively prolongs itself through interpretation,

through its engagements of us" or its alternative expression that "'meaning' is not at the origin of this activity but is its constant and constantly altering effect."[25] To this view of the art work and how to think about it he brings Derrida, and the Heidegerrian rereading of Kant which offers the frame as the only avenue through which to approach the unframedness it claims to name. It is time to talk about Melville and Smithson, and also Melville and Turner.

* * * * *

> There can be no doubt, however, that the real consequence of the
> enlightenment is . . . the subjection of all authority to reason. Accordingly,
> prejudice from overhastiness is to be understood as Descartes
> understood it, i.e., as the source of all error in the use of reason.[26]

Melville is not Bartleby, it's not that he would prefer not to name color or anything else. He is—as it were *simply*—not prepared to name the unnameable one more time, and is in any case more interested in what happens in the name's being deferred—the name itself being a deferral in the first place.

As I've suggested, Melville does not see the theoretical problem that art offers art history as a Kantian one but rather as one which is the result of the latter's turning away from, or having great difficulty in turning toward, Heidegger. Melville seems to see the work of art itself, though, in largely Kantian terms, and as in that implicitly—one could say, conventionally—suspended in Hegelian explanation of the historical implications of those terms. This is, in more than one sense, the puzzle that art presents (not only for Melville). It remains Kantian long after philosophy has ceased to be Kantian, or history Hegelian. And so, conceivably, does the perceiving subject it requires and thus perhaps invents or reinvents. In practice, Kant is the art object's defense against Hegel: its capacity to transform the world into another, intrinsically logical, version of itself is what allows it to be more than a function of the process advertised by art historians and sold by art dealers. Melville's topic, when he talks about works, as opposed to the theories they upset and redraw, is the Kantian object in a post-Kantian world which, through art, finds itself drawn back to Kant.

The Kant that one gets from Melville is Derrida's Kant, as I've already said, it is the Kant where beauty is framed by the sublime but also, as it turns out, *vice versa*. This is Heidegger's Kant too, where the

mark as a depth suspended in a depth is the fundamental counter of that framing of framing, and where one is led towards what that framing frames in a way that determines that the leading will be the arriving. A work in which there is no final resting place because (*pace* Fried) it is its resistance to resting which is its meaning. Lyotard, a writer who crops up in Melville from time to time, talks in his essay on Barnett Newman of the painting as an enigma of "*is it happening?*," a question which asks whether the painting is finding a way to expand the instantaneous into a movement, to intervene in and reverse technology's exclusion of the experience of time.[27] Melville's Kantian art work is also reminiscent of Deleuze's event, irreducible to its cause or its effects—i.e., any effects it might have as, itself, a meeting of effects—and made up of converging lines of flight, *a*discursive accidents of discourse. As I've remarked elsewhere, Deleuze has Kant identify the beautiful with fluidity—"(the oldest state of matter), one part of which separates or evaporates while the rest rapidly solidifies"[28]—and this, which reads like a description of paint drying, is as good a place from which to approach Melville's idea of the work of art, the Kantian geneology of which seems to me to be demonstrated not least by the primacy it gives to painting as a model for all the visual arts.

This volume begins with an essay that Melville wrote about Smithson in the early eighties, and concludes with one written ten years later in which he talks about, among others, Cindy Sherman. Neither of these names, I'd venture to suggest, is likely to cause your run-of-the-mill art critic (or run-by-the-mill art historian) to think about painting. They are, almost certainly, likely to induce talk about the death of painting instead. Such talk is the basis of both artists' careers. Melville seems quite indifferent to such invocations of mortality excepting in the sense that, in his view—which is also mine—painting has always tried to get outside of itself, and that it should live on in objects and practices which seek to deny it confirms its vitality rather than the opposite.

Smithson was the artist of framing and of the landscape, and this is the sense in which it was possible, in 1982, for Melville to see him as a painter: "Smithson worked the boundary between art and criticism as he worked the boundaries between the arts. If I insist on writing here of Smithson's work as painting, I do so in order to reopen these various negotiations, because it is, still, in these negotiations that his achievement is to be seen."[29]

For these negotiations between the arts to take place, they require the language of painting. It is painting which provides a model, and the model is not one of historicist eschatology but the reverse, one concerned with the eschatological in terms which subsume the historical. Reasonably enough, Melville links Smithson to Romanticism, and with that to an American tradition on the one hand and to a general principle of allegory on the other. Romanticism was, perhaps, an art of displacement in that it was so preoccupied with translation. Melville describes Mallarmé as "a late and peculiarly complex Romantic, a materialist of the word whose very rigor opens him everywhere to idealist simplification and reversal" and this, he says, "is, I think, how we must see Smithson as well."[30] What is at issue in Melville's description of Smithson is, along with a couple of other questions, the capacity of the latter's own tendency to be seduced by idealist simplification into producing in practice a complex materialism.

Smithson's tendency toward a lamentable reductiveness occurs, as Melville makes clear, in his thinking about (against) painting as that had been argued for by Greenberg and Fried. Melville shows Smithson railing against Fried while working in a manner entirely consistent with Fried's account of the work's engagement with (its own) (art) history. The model is derived from painting, and in that from Kant. Where Greenberg and—with all the emendations and adjustments already noted here—Fried formulate a theory of the surface (leading some of us to see there another place where a Deleuzian reading of painting might be fruitful) their antagonists develop one of depth: "Where Louis and Noland saw in Pollock's 'allover' a discovery of the canvas and its radical flatness, Rauschenberg and Smithson discover for us depth, time, and displacement."[31] Negation, in other words, produces inversion. What happens in Smithson is, however, not reducible to that inversion, but is, rather, the complex product of its terms. In Melville's account—and on this score too I entirely agree—Smithson becomes a *montagiste* of depths, where montage is not quite the right term. Montage implies things stuck together, possibly on a surface which they obscure, and, insofar as the term is cinematic, sequentially, in an inexorable sort of way. In Smithson these depths interpenetrate each other as they might in painting, bound together by a continuous surface that would run through them once

they were painted and no longer applied, and in that be in them, and insofar as these depths would be suspended in a simultaneity, they would be in an order which as such employed the temporal but deferred the inexorable to the question of whence its constituents had come—of what lay *behind* or *beneath* them, i.e., to that which they, as signs with a geneology, traces which in their presence announce the disconnectedness between what is and that which they remember but to which, as memories, they perhaps cannot return. The trace announces the irreversibility on which reversibility depends, which lies underneath or behind it, since reversibility would mean "it has happened already," and here, I think, may be where one finds Greenberg meeting Derrida in Melville as also in Fried: "For writing, obliteration of the proper classed in the play of difference, is the orig-inary violence itself: pure impossibility of the 'vocative mark', impos-sible purity of the mark of vocation."[32] Isn't flatness, which was always already there, a vocative mark of a comparable impossibility? Doesn't Greenberg's notion of purity become one of reorigination in these terms, an idea of originality as a convergence between the act of paint-ing and its ground which acknowledges its function and identity as an intervention rather than a production? Derrida's sentence comes from his (in)famous attack on Levi-Strauss, where he argues that writ-ing was always there before the white imperialists came along with their (rewriting) writing. Greenberg's purity leads to Smithson's fan-tasy of the world as painting unframed, sublime instrumentality, not rebuilding and refiguring its earth into some temple or other, but dis-interring its layered contents in order to retrace the trace and, in so doing, reorder the priorities on which it seemed to depend. The reader will recall what Derrida has Heidegger's reading of van Gogh's shoelaces do—he has them lead to the back of the canvas. Flatness returns one to the canvas as neither back nor front but pure surface. Smithson, in the *Spiral Jetty* especially, treats the earth not as grounds for temporality but *as* a temporality. Melville is absolutely right: from pure surface as pure simultaneity to pure depth as pure temporality. And the logical corollary is this: Greenberg rejected monochrome painting absolutely and out of hand, acknowledging therefore the role of the temporal as intervention and source of order—or as the neces-sary intervention of another order, the temple as the revelation of what it's not but at the same time is. Smithson is absolutely dependent

on the simultaneity of the work as an intervention and representation of a temporality—two sides, as it were, of the same rift.

There are two Kantian sides too: flatness framed by (another, historically specific) surface; depth framed by (another, historically specific) temporality. Nor should one forget Smithson's playfulness, he did after all write an essay on laughter. Elsewhere in this volume Melville makes the elegant point that the Apollonian/Dionysian opposition returns because it is fundamentally all we have, but in this context it is perhaps worth recalling that according to Nietzsche it is Kant who sets it in motion as more than a one-sided triumph of authority: "Let us now recall how . . . Kant and Schopenhauer succeeded in destroying the complacent acquiescence of intellectual Socratism, how by their labours an infinitely more profound and serious discussion of questions of ethics and art was made possible— a conceptualized form, in fact, of Dionysiac wisdom."[33]

Artists play. What they do for a living other people look at in their spare time (as play). They play, thoughtfully but also unknowingly—irresponsibility is a fundamental component of play—with the play of signification. Or think they do and are thought of so doing, actually, it plays with them. Regarding the idea mentioned earlier of the historical belonging to the artwork rather than the work to history, artists are in this sense possessed except that it's not even clear—such is the regime of the irresponsible—that they belong to what possesses them. The artist constantly brings into play more than she bargained for, an unpredictable surplus. Melville rather politely observes that Smithson has a somewhat loose theory of the dialectic, in which the terms combine but decline synthesis. It's the *site/nonsite*'s simultaneity, its refusal—in this reminiscent of Lacan's letter—to come to closure, which opens Smithson up to a play of difference that sets us "on our way to understanding something of the affinity of Smithson's work for much recent French philosophy— philosophy that begins explicitly from a recognition of the difficult failure of Hegelian dialectic (difficult because it is a failure that arises precisely from its success)."[34]

We know that the French philosophy of which Melville has made such good use in the essays presented here is itself a consequence, a *response-to* which is a *thinking-through*, of the origins of both Hegel (art history) and Heidegger (phenomenological hermeneutics) in

Kant: "Indeed, Hegel's first philosophical publications—the writings whereby he entered the philosophical scene—were focused in a special way on Kant. On the other hand, we also know that Martin Heidegger, by taking up the question of the meaning of Being as the proper task of thought and by linking this question to the deconstruction of metaphysics, was led, from the period of his first writings, into a confrontation with Kant."[35] In seeing how irreducibly Kantian art is, Melville sees the work of art as the origin of the irreconcilable interests which are art criticism.

I have myself written about Smithson, and like Melville would describe my own writing as being indebted to Fried's version of the work's activation of and activity within the historical. I am therefore alert to the possibility that I might confuse my own interpretation with his. But that said I think I see in Melville's essay on Smithson a felt need (which is to say, a logical obligation) to get outside of the antinomies which characterized the thinking of both Smithson and the Fried of "Art and Objecthood." The problem with "Art and Objecthood" is that it seems to fail to account for the role of physicality. The result is an essay which clearly states the big question of the time but, in doing so, leaves the reader with the impression that the author has somehow come down too firmly on one side of the argument. After all, at the time you would have had to be ideologically driven to say the least—subject to all that obscured perception— not to see that a lot of the Greenberger painting that was around was lousy, while minimalist sculpture really got your attention, albeit that, as Fried makes clear, what absorbed one was its indifference to absorption, its function as a negativity. Jacques Taminiaux, the author of the above quote about Hegel and Heidegger's common origins, also points out that it is to Hegel that Heidegger turns in the formulation of an idea of Being (a theme also present in Melville's treatment of Lacan), and does so because, following Hegel, he will find Being in the negative. "In Hegel's terms . . . Being is 'the labor of the negative' ", and I think Melville, like myself, wants to see the negative at work at the production of its own negation on both sides of Fried's opposition, while he himself (impressively, still) can't.[36]

Smithson's Romanticism, and therefore his Kantianism, is most emphatically expressed in his attitude toward landscape, the unframeable framed and not in the interests of a stabilizing signification: "He

is . . . an agent of displacements . . . related to the world through discontinuity rather than imitation and filiation, and is more nearly an allegorist than a discoverer or forger of symbols. . . ."[37] That is also where Melville finds his Americanism, which he will and will not allow to be Puritan: yes, if it's that Puritan tradition from which William Blake may be seen to have descended (England's pleasant land being in ancient times by implication not a Papist shithole dripping with social inequity and superstition); no, if it's that " 'Puritan' impulse in art history which produced (Smithson's) most savage polemic effusions".[38] Smithson himself, as we keep being told, was a Catholic, and I wonder where that relates to his attitude to the landscape. I recall that English artists tended (and still tend) to have a great deal of difficulty with Smithson's attitude toward intervention and rearrangement. Hamish Fulton, for instance, once expressed (to me, in conversation) profound misgivings about going around scattering bits of broken glass over a bit of ancient land. I make this point here because I want to say, in closing, a few words about Melville and transgression. Melville, to adapt the sentence from his essay on Smithson with which this essay began, is concerned not "to refuse the newly posed question" and to affirm the possibility of contamination. One could say that he is concerned with developing a hermeneutics of contamination by means of which art history can be drawn into the playfulness of the—hypothetically, *its*—object. The reasoning behind this concern may be seen most clearly in chapters 2 and 4 of this volume, but it is seen in action in chapter 10, in which Melville gives us Turner as a painter who, rather than positing a historicist ambition for the end of painting—historicist in that it would make that end be visible and as that a visible end—presents a world in which eschatological closure would of necessity be invisible: "A peculiarly lucid end, one might say; a death invisible even in broad daylight, perhaps especially in that light".[39]

The verb "to live" speaks in the largest, uttermost, and inmost significance, which Nietzsche too in his note from 1885/86 was thinking when he said " 'Being'—we have no concepion of it other than as 'life'. How can something dead 'be'?[40]

Smithson did not conceive of content being lost in context because the former framed the latter, and his desire that decomposition (rust) be grounds for the composition (the patina as the surface) meant that the work would always be a temporality tracing a temporality, there too uncomfortable with the pace of art history perhaps, and certainly intent on getting outside it by trying to become its outside.

Turner, says Melville, "makes pictures of the sublime. . . . In this beautiful sublimity nature coincides with itself, and with art too. . . . Nothing is lost and nothing bequeathed—in the absence of mourning, what is continued is only the actuality of painting . . . Turner's painting cannot but succeed—nothing has become impossible."[41]

For Melville, the absence of mourning means that Turner's painting has missed an encounter with philosophy, where "the event will always be the same: something—painting—has become impossible."[42] But what does he mean by "philosophy?" He means, I think, philosophy after Kant, because it's with Hegel that impossibility begins and with Heidegger that it's reinvented. Nothing is impossible in Kant in the same way that nothing's impossible in Turner's painting. The progression could be expressed as: Kant/Turner/nature and conscious choice; Hegel/history and consciousness of—and as—determination; Heidegger/hermeneutics and consciousness as consciousness of the inevitable indeterminacy of consciousness.

Melville operates in a discipline largely defined by eschatology as triumphalist morbidity, largely expressed as demystification. He has far more patience than I with the Duchampian crowing about the death of painting which lies behind the public presentation of Cindy Sherman's face, or the talk of endgames and reification of those (at least in their preferences) *eminences encore plus gris*, but his thinking about the vitality of the art object is no less strong a counterargument against theirs. It is, in its insistence on the vitality of the art object, an argument for a beginning in, and as, contamination of that which ends up in, and as, light—the inevitably pure. It is in this a theory of Dionysiac wisdom, and in Melville light comes up in Turner as in Lacan: it's the place of *jouissance* rather than the death drive.

There is much more to say but I'll end my introduction here. I have talked about Melville's relationship to three ideas: art history, the art historian, and the art object. I'll suggest that in Melville these take the following forms:

• Art history is irreducibly Hegelian and therefore the mirror image of the art object, in the sense that it's constantly being supplemented and undermined by phenomenological hermeneutics, its faith in authoritative negation constantly undermined by that which guarantees the art object an originary role—albeit one reoriginated in the terms of its legibility (what could also be, perhaps, called its encounter with the perceiving subject).

• The art historian is thus suspended (or otherwise engaged) between art history as teleology and the art object as counter-teleology subsuming everywhere but also turning back, turning around, turning against the former, and in doing so making the former itself become visible in its engagement with (the inevitable deferral *of*) its return to the latter. In Melville the historical can only be known through the counter-historical; it is the agent of demystification which constantly needs demystifying. Not only as a matter of *quo custodies custodiet*, which is certainly a constant question in a world where the guards appoint themselves, but because the task of history is its own demystification before it's anything else.

• The art object is irreducibly Kantian, and all that follows from that is all that we have. The irreducibility of the art object as far as philosophy after Kant is concerned would follow from its not being able to be without being seen to be—legible as—a kind of intending which is intention made present. Being is saying, not what has been said. The dead have no intentions, they had them. What is dead is not happening. Art is.

Melville finds Kant's sublime—as do I, once again—in Heidegger's gigantic. I see Melville's sublime beauty in a Kantian art object which clarifies the sea of contamination on which the object was designed to float, and which is its fluid ground.

ESSAYS BY STEPHEN MELVILLE

CHAPTER ONE
ROBERT
SMITHSON:
"A LITERALIST
OF THE
IMAGINATION"

*N*ot quite ten years after his death, Robert Smithson's achievement would appear undeniable. But this is not to say that it is therefore no longer difficult, no longer in need of critical understanding. Robert Hobbs, in the retrospective he has organized and which has now passed through New York after a year and a half of displacements from Ithaca to California and back again, and in its companion book, has offered such an understanding—an understanding neatly summarized in the title book and show share: *Robert Smithson: Sculpture*.[1] The natural question then is whether, or how far, this will do.

It is Hobbs' contention that "before 1963 Smithson regarded himself as a painter" and that by 1964—allowing for a certain amount of transitional work—Smithson had become a sculptor. And surely this is right—the objects are there in the show to be seen: they are such proof as we have for such theses. Rosalind Krauss, among others, has written convincingly of Smithson as he figures in the history of sculpture. Others—Lucy Lippard perhaps most notably—have written of Smithson as he figures in the half-lost histories of the garden, the park, and the landscape; and there has been a goodly spate of writings on Smithson and architecture. But all of this only goes to show what, and where, the difficulty (still) is. What, we might ask, is the grammar that is peculiarly Smithson's and through which these various histories and critical possibilities are geared into one another and into the body of his work? How are these views at once tempting and powerful, and finally inadequate and even betraying?

It is at this point that we may want to try out the notion that Smithson is properly described as a "conceptual artist"; our point of

appeal will most likely be *Incidents of Mirror-Travel in the Yucatan*, a documentary essay published in *Artforum* in 1969. Hobbs writes of it:

> . . . *Incidents of Mirror-Travel* appears to give a detailed account of no longer extant works of art, but it quickly leaves the mundane realm and enters a mythical realm; criticism and art history have become art. The mirror-displacements, the supposed art works, disappear and their documentation, in its heightened form, becomes the work of art (p. 152).

But this subsumption of Smithson's writing wholly into the arena of art should not leave us any happier than the opposed—and equally tempting—move of taking his writings to be the clear and adequate explanation of his works, obliging the act of criticism to mere repetition.

Smithson worked the boundary between art and criticism as he worked the boundaries between the arts. If I insist on writing here of Smithson's work as painting, I do so in order to reopen these various negotiations, because it is, still, in these negotiations that his achievement is to be seen. I do not pretend these things ever hung on someone's wall.

There are nonetheless senses in which we may be tempted to say exactly this. It is Hobbs who picks out the clear relations between Piranesi's "Carceri" etchings and Smithson's *Entropic Landscape* and *Spiral Hill* (pp. 45, 210–212), between the pours and flows of 1969 and the drips and flows of New York painting (between *Asphalt Rundown* and Pollock especially) (pp. 174–176, 182–183), between Smithson's *Hypothetical Continent in Stone: Cathaysia* and "the shifting, fractured planes of a de Kooning" (p. 142). Again and again, the analogies and precursors Hobbs finds for the work he wants to call sculpture are from painting. When one adds to this the interesting fact that a number of Smithson's "sculptural" works—another version of Cathaysia called *Map of Quicksand and Stones with Two Snakes* and *Spiral Jetty* are both instanced by Hobbs—are explicitly prefigured in early ("presculptural") Smithson paintings, it becomes tempting indeed to say that one of the important features of Smithson's work is precisely that it did once hang on some wall—and is in this sense (the sense, that is, of having been) painting. It is in this perspective that one might most usefully contrast Smithson's insistence on limitation with Tony Smith's famous nightride on the turnpike:

> I don't think you can escape the primacy of the rectangle. I always see
> myself thrown back to the rectangle. That's where my things don't offer
> any kind of freedom in terms of endless vistas or infinite possibilities.
> (*Writings*, p. 170; cited by Hobbs, p. 136)[2]

Hobbs sees Smithson's first major sculptural work coming out of a
"quasi-minimalist phase" during which he made "'crystalline' fabri-
cations in which traditional artistic values are subverted and negated"
(p. 11). This category includes the various works constructed of mir-
rors and mirrorized plastic (*Vortex*, *Enantiomorphic Chambers*, and the
like) as well as the metal, and frequently serial, pieces like *Alogon*,
Pointless Vanishing Point, *Terminal*, and *Shift*, and, finally, the assorted
glass and mirror *Strata*. That the interest of these works is not,
finally, minimalist is, I think, clear by now: the forms themselves are
not minimal, their seriality (where there is seriality) is not simple rep-
etition, and—this is the deep and binding point—they do not relate
to painting in the same way. The work we still call minimalist under-
stood itself as the logical conclusion of a development internal to
painting which led, in the end, outside of it (and so was subversive of
it) into the simplicity of the "specific object." The minimalist object
implicitly claimed to supplant and do away with painting. Smithson's
objects are increasingly complex realizations of the painted—
attempts to realize in the world the conventions through which
painting would otherwise represent that world.

Foremost among these conventions is, of course, perspective,
and most of the pieces from this "quasi-minimalist phase" play upon
the paradoxes inherent in the realization—"literalization" Hobbs
writes (p. 87)—of perspective as itself an object in the world it is
intended only to enable the representation of. The drawings from
this period—I think particularly of a sketch for *Leaning Strata*—are
striking in their visual ambiguity, balancing between being views of a
three-dimensional object to be constructed and being the two-
dimensional matrix for the flat representation of such an object. The
1972 sketch for *Ring of Sulphur and Asphalt* is similarly ambiguous—
either a Noland cartoon or a view of something more complex.[3]

Smithson's seriality takes its form and sense from this interest
rather than from any direct interest in repetition as such. The various
Alogons multiply for us as in a mirror, receding stepwise in diminish-
ing perspective. These works, like the *Enantiomorphic Chambers* and

their companions, point to the potential for Smithson's work of mirrors and glass. The same impulse that brought him to objectify perspective pushed him to work with the literal forms of the major Western tropes of representation, the mirror and the window. The mirror is particularly important here since it links the problem of perspective directly to the larger problem of representation; its logic underlies the play of eye and horizon that is at the heart of perspective representation. (And if the mirror became a privileged material for Smithson, the camera, for similar reasons, became his sketch pad; mirrors and photographs both offered themselves as materials for the *Cayuga Salt Mine Project*.)

We have the habit—or the tradition—of calling what we see in a mirror a reflection or representation of something else. Smithson would force upon us the knowledge that if we see it in a mirror, then that is where we see it: what we see has been displaced. An artist is thus not a maker of representations but an agent of displacements—an artificer and not a copyist. He is related to the world through discontinuity rather than imitation and filiation, and is more nearly an allegorist than a discoverer or forger of symbols—so that if we want to call Smithson Romantic (and there are good reasons to do so), then we will want also to speak of Romanticism as that deep renewal of allegory that Northrop Frye first reopened in his work on Blake.[4]

Smithson's major work of displacement is, of course, the *Incidents of Mirror-Travel in the Yucatan*, and we should now be able to recognize in it one of a series of representations of representation that dot the history of Western art. Two other such representations—Velázquez's *Las Meninas* and Courbet's *Studio*—have recently commanded considerable attention; it may be that these are the standards against which Smithson's work must in the long run be measured. I am not prepared to say how things would stand in such a comparison, but I would be playing Smithson false if I did not acknowledge that just such measuring is precisely what his work would most deeply contest. To press such a comparison would be to subsume the work under a "Puritan" impulse in art history that provoked his own most savage polemic effusions. Smithson aimed always at impurity—at contaminating sculpture with the terms and problems of painting (which is why we must be uneasy calling his work too simply sculpture and pretending that "in 1963" painting ceased

to be a central reference and moment of self-understanding).[5] Smithson's painting, coming to understand itself as displacement, came to be displaced into three-dimensional objects—and this displacement never stopped happening, never let itself fall into its own tradition, its own genealogical order: the step from an early Abstract Expressionism to "quasi-minimalism" is not, in principle, different from the step from that "quasi-minimalism" to Hobbs' ensuing "cartographic phase" (mapping merely renaming and displacing displacement) or from there to the "dialectical phase" and so on. At each step we are called upon to imagine a displacement of an activity—to make our appeal to the imagery and logic of mirrors and crystals, rather than to the all-too-familiar tropes of the organic and developmental.

The issue here is double, and it marks Smithson's difference both from his minimalist contemporaries and from such anti-minimalist critics as Michael Fried (and it is important to note that Fried and Greenberg are insistent presences throughout Smithson's writings; anthropologists have long known that we make war against and marry into the same tribes . . .). On the one hand, there is the matter of the critic's assumed exteriority to and insulation from the art he discusses. The ambivalence of our language served Smithson well, and to a view of criticism as representation here he could implicitly oppose his literalism of displacement—my (or his) writing on his work is itself an act, a further displacement of it. This is one of the stakes behind *Incidents of Mirror-Travel* . . . (and, in fact, the status of criticism is at issue in any representation of representation; this no doubt has something to do with the interest both the Velázquez and the Courbet have for us now). It is of the essence here that this posing of criticism as a problem is not tantamount to transforming criticism (and art history) into art—*that* is simply to refuse the newly posed question and to reaffirm the impossibility of contamination (and so is of a piece with the wish to have Smithson pass wholly from painting and into sculpture). What Smithson's essay calls for is a new recognition of the ways in which criticism is tangled up in its objects.[6]

The other side of the issue of displacement opens into our understanding of "art history." Smithson, we might say, does not want to belong to "art history." He does not want to make the kind of object that can be consumed without remainder by that sense-

making machinery, by the art history of the modernist sensibility above all. But this, put thus baldly, makes little or no sense—what could it mean to say of an artist that he does not want to belong to the history of art? That he wants his work to be without connection to what we value as art? This is not only senseless; it is emotionally incoherent and unimaginable—how, after all, does one come to call one's self an artist except through an experience of what, however unhappily, one calls art? Smithson was, willingly, an artist, and he found in art history—in a way of imagining how art is in time—a block to that will. Hobbs writes that "in Smithson's art, aesthetic apprehension takes precedence over mere looking at an object; it becomes a dialectical experience that takes into consideration thinking as well as looking, and context as well as the isolated object" (p. 108). All this is true enough, but just because it is true enough it also ought not strike us as terribly new; sight and vision have long been at war, and we do well to see Smithson here as a late rewriter of Blake.

It is out of this quandary that Smithson began to elaborate his contrast between "two types of time—organic (Modernist) and crystalline (Ultraist)" (*Writings*, p. 49).[7] His sense for "crystalline" time seems to have found its first explicitness in his thinking about the construction of art works for the Dallas-Fort Worth airport; the view from above of something the apparent flatness of which is in fact a record of sedimentation and layering in depth fed directly into the entire network of his concerns, offering a new means to the realization of the conventions of painting (offering, that is, an interpretation of "flatness," a passage—as in *Ring of Sulphur and Asphalt*—from Noland to landscape), and offering as well a new model for the way in which structures and events are one another's occasion in time—a logic of discontinuity and heterogeneity to oppose to the continuous unfolding of the organic out of itself or the emergence of new art out of its own history and internal constraints and imperatives. Real time, ultraist time, geologic time, is a matter of strata and as such rejoins the problematic of glass and mirrors—and the various works called *Glass* or *Mirror Stratum* are, in their difficult play of transparency and opacity, in some measure models for the art history in which Smithson would locate his activity—as also, newly marked by their belatedness, their desperation, and their freedom, are the smashed glass heaps of *The Map of Glass* (Atlantis) and the proposed piece for Vancouver Island.[8]

This discovery of the sedimented and cataclysmic depth of flatness is of a piece with Rauschenberg's discovery of the "flatbed" painting. The same intuition works both and the same master stands behind them as well: where Louis and Noland saw in Pollock's "allover" a discovery of the canvas and its radical flatness, Rauschenberg and Smithson discover for us depth, time, and displacement. And where Louis and Noland can appear to have exhausted the resources of one vision of time, Rauschenberg and Smithson would offer new ways to come to grips with the history to which they (would not) belong—through the incorporation of representation in the one case and through a thoroughgoing insistence on the structure of displacement in the other (an insistence that links Smithson's work more closely than Rauschenberg's to the "formalist" line of development).

Hobbs' extended remarks on *Six Stops on a Section* point once more to the continuing dependence of Smithson's "sculpture" on "painting" by noting that the bins of the Non-sites "become analogous to the framing edges of Abstract Expressionist paintings, and the rocks contained within are similar to the 'overall' compositions of artists such as Jackson Pollock" (p. 119). But the insistence on analogy and similitude cushions the insight and may prevent us from seeing that if one version of history sees Pollock's canvases unfolding more deeply into themselves in the work of Louis and Noland and Olitski (or, on a different account, into Rauschenberg's flatbed layerings), another version would displace those canvases into the slatwork bins of the Non-sites—displacements that explicitly name and display themselves as such.

Smithson called the play of Site and Non-site a dialectic, but it is a dialectic, as both Alloway and Hobbs insist, that is without resolution. What "dialectic" seems to mean then, what it wants to name, is the mutual adhesion of site and non-site, the refusal of the work to let itself be sundered into any duality like that of representing and represented, work and world. This mutual adhesion marks the fact of displacement. If we go on to suggest that site and non-site are thus bound to one another as each other's trace, we are on our way to understanding something of the affinity of Smithson's work for much recent French philosophy—philosophy that begins explicitly from a recognition of the difficult failure of Hegelian dialectic (diffi-

cult because it is a failure that arises precisely from its success).[9] This philosophic situation is significantly similar to Smithson's painterly and critical situation in relation to Greenberg, Fried, the painters for whom they argued, and the arguments they used. It is then perhaps interesting to remark that Smithson's response to the achievement of painting in his time is close to Marx's early response to Hegel's achievement—the common impulse is that of the last of the *Theses on Feuerbach*, an impulse to realization:

> The philosophers have only *interpreted* the world, in various ways; the point, however, is to *change* it.

This brings us around to politics, and the Site/Non-site works remain his most political. Their interest here bears upon the way in which the structure of the gallery world tends to suppress the boundary between art and non-art, accepting too easily what lies within its reach and refusing with equal ease, as Lippard points out in her essay, what lies beyond. Smithson's interest lay always in interfaces, in the crossing of boundaries, in opening up the relations between walled-off positions (and in entropy), and so also his interest lay, like Duchamp's, in making the transactions between art and non-art fundamental, in placing that exchange or displacement in the foreground. (In this respect the *Cayuga Salt Mine Project*, dividing as it does the gallery against itself and stretching its mirror trail from the gallery of the museum to the galleries of the mine, is perhaps his finest gesture.) If there is to be a larger politics to Smithson's work, it would seem to have at its center a critique of any all-consuming sense-making apparatus that either envelops its margins or rejects them utterly, owning to no relationship with them. Smithson would inflict upon any such system, economic or art-historical, a recognition of and responsibility for its enmarginment, the complexity of its limits. Anything else is idealism.

With this we reach and touch upon the outer limits of the Site/Non-site work and do well to move back closer to the objects presented: trapezoidal bins miming perspective recession, flatbed containers layering their contents in depth, frames offering up their overall jumble of geologic time. The complexity of the puns on sight embedded within these works is deeply resistant to unpacking. We

are, for example, given to see a non-site, and we are given to see it, more often than not, within a material literalization of the terms of our traditional landscape vision—we are given, that is, something that is above all a sight, a view, a moment of the picturesque—but we are given it as somehow undone, outside of or away from itself. And what this nonsight teaches us to recognize as its site, real as it may be, contains nothing for our eyes—and the Nothing it does contain for us is the trace marked out by the nonsite: vision and position entwine as in a mirror set in snow. Such difficulty—and such images—are nearly Mallarméan.

Mallarmé is read now as a late and peculiarly complex Romantic, a materialist of the word whose very rigor opens him everywhere to idealist simplification and reversal, and this is, I think, how we must come to see Smithson as well—the last thing he would be is a conceptual artist and yet somehow that is, at times, what he most nearly is. If we see him in this light we can get certain fundamental things about him right: his profoundly American, and thus Romantic, intrigue with landscapes and the facts of vision; his fascination with the monumental and with its ruins; his need to rethink and rework the terms by which his art takes its place in time, in history. We can begin also to pick out and make sense of one crucial set of precursors: Piranesi, whose prison etchings did not simply prefigure certain of Smithson's sketches but also anticipate in their thematic and formal logic of containment and transgression the central issues of Smithson's later work (the salt/mirror pieces at Cornell, the overarching theme of the spiral); Blake, the great and explicit Romantic materialist of the word and Smithson's forerunner in the suturing of language and vision; and the Poe of *The Narrative of Arthur Gordon Pym*, running his own late Romanticism up against the prospect of radical allegoresis and the priority of sign over sense—a priority Smithson came increasingly to equate with the fact of prehistory, the necessity of belatedness and artifice.

Within this last we may glimpse the sense behind another bundle of precursors—the Mannerist painters that figure with increasing prominence in his late writings, painters (as he would have them) of pictures rather than paintings (precursors, then, to Longo and Sherman and Anderson—or versions of them in any case). One paints, whether Rembrandt or Pollock, in Smithson's view, within a

history of organic growth and expression; one pictures within a geo-
logic time of layered representations supervening on and subsiding
beneath one another, "a network of tiny surfaces, that reflect nothing
but ungraspable meaning" (*Writings*, p. 214)—and this is the deep
project of any allegory: not the simple recognition of the cut-and-
dried, the already-known, but the discovery of signification, the
drawing attention to the fact that, and ways in which, the world is
marked in advance and however ineffably with sense, with mystery
and intimacy, with the uncanny. Allegory insists upon a slippage of
sense that is internal to it, disruptive of it, and nonetheless its final
guarantee: it is what we see and read—grasp and fail to grasp—as we
gaze upon the flat earth from our plane.

There is a last figure to be set into this art historical enfiguration
of Smithson, and it is Marcel Duchamp. Not—not primarily—the
Duchamp of the Readymades, but the Duchamp of *The Large Glass*
(another Mallarméan materialist) and the Duchamp to whose *Three
Standard Stops* Smithson's *Six Stops on a Section* would appear to be a
tribute. This Duchamp, like Smithson, is still very much a stranger to
us, a figure whose words and works remain profoundly difficult, and
so one we are still powerfully inclined to approach through repetition
and quotation rather than criticism. I too will slip the challenge and
settle for citation. The passage is taken from Smithson's unpublished
1967 essay "From Ivan the Terrible to Roger Corman, or Paradoxes
of Conduct in Mannerism as Reflected in the Cinema." It passes
from Parmagianino's Mannerism to Duchamp's literalism with
implicit mediations through Piranesi and Caspar Friedrich (not to
mention Poe and Mallarmé):

> Parmagianino transforms a humourous illusion into a solid fact, while
> Rembrandt turns a solid fact (himself) into a humourous sensation.
> Parmagianino's "idea alchemy" is similar to Duchamp's in so far as
> Duchamp takes every opportunity to transform ideas into facts. Both
> artists seem to deal with the concept of a *prison*. Says Duchamp,
> "Establish a society in which the individual has to pay for the air he
> breathes (air meters; imprisonment and rarefied air) in case of non-
> payment simple asphyxiation, if necessary (cut off the air)." The world of
> Parmagianino appears to verge on asphyxiation, the air in his pictures
> seems about to be turned off, his figures seem on the brink of being
> frozen. The terrible prison-like world Duchamp proposes is related to
> Mannerist esthetics and conduct. (*Writings*, p. 215)

This is not only a world in which it matters to break out; it is a world in which it matters most of all that the prison not be denied. It is just this denial one risks in thinking that painting is something Smithson could somehow stop in 1963—and this risk covers itself over in the suggestion that in Smithson criticism and art history become subsumed under art itself.

It may appear that in recalling the fact of imprisonment, redescribing Smithson in the face of and on the occasion of this first retrospect on his career, I am returning him to the prison he worked so hard not only to expose but to destroy. My claim, of course, is that one cannot come to grips with his work without opening one's self— and his—to that risk and charge: they are, as it were, its medium. If Robert Smithson was able to create newly and as if outside of art history, its categories and routines of cooptation, it is because he was able so deeply to displace it—and because, in the end, all he could do was displace it, he cannot but belong to it. One may be tempted then to see him caught finally in his own mirrors, but this would be to ignore the way in which art history now belongs to him (what we call his achievement). Smithson's mirrors are occasions of discovery and displacement, not reflection and entrapment.

1982

CHAPTER TWO
DESCRIPTION

*T*t is evidently widely felt in contemporary theory—to the point that it may seem an entry condition for it— that the news, to be received in various ways and from various more or less convergent places, is that "it's interpretation all the way down." That this news is, as it were, first reported to the humanities by literary scholars is perhaps important; at least it may be important that art history, taking up this news, does so in a field that has, in a way literary discussion does not, "description" as an explicit topic. What I want in these pages is to turn this matter of description and interpretation over by exploring how it may figure within one important modern intellectual tradition—phenomenology—both in its general history and at one important moment within it. The closing sections of the essay will then attempt to draw some morals with respect both to the conceptual foundations of art history and, more fleetingly, the particular purchase of these issues on the situation of contemporary art and criticism.

1. Phenomenogical Movements
Maurice Merleau-Ponty's major early work, *The Phenomenology of Perception*, opens by laying out an understanding of the general enterprise to which the book's title subscribes him:

> What is phenomenology? It may seem strange that this question has still be asked half a century after the first works of Husserl. The fact remains that it has by no means been answered. Phenomenology is the study of essences; and according to it, all problems amount to finding definitions of essences: the essence of perception, or the essence of consciousness, for example. But phenomenology is also a philosophy which puts essences back into existence, and does not expect to arrive

at an understanding of man and world from any starting point other than
that of their "facticity." It is a transcendental philosophy which places in
abeyance the assertions arising out of the natural attitude, the better to
understand them; but it is also a philosophy for which the world is
always "already there" before reflection begins as an inalienable
presence; and all its efforts are concentrated upon re-achieving a direct
and primitive contact with the world, and endowing that contact with
philosophical status. It is the search for a philosophy which shall be a
"rigorous science," but it also offers an account of space, time, and the
world as we "live" them. It tries to give a direct description of our
experience as it is, without taking account of its psychological origin and
the causal explanations which the scientist, the historian, or the
sociologist may be able to provide. Yet Husserl in his last works
mentions a "genetic phenomenology," and even a "constructive
phenomenology."[1]

As the gloss on the opening question makes clear, Merleau-
Ponty's description reflects a certain history of the phenomenolog-
ical enterprise. It is in this respect very different from any number
of parallel statements one might draw from the writings of Edmund
Husserl, statements that would not foreground the back-and-forth
movement of possible paradoxes or contradictions that organizes
Merleau-Ponty's account, and that would work actively to resolve
or suppress such motion in favor of clear and rigorous statements of
method or procedure. Indeed, the bulk of Husserl's writing consists
in just such efforts at clarification and resolution (rather than in the
actual production of the analyses those procedures aim to make
possible).

Each of Merleau-Ponty's contrasts—with the exception of the
last one—is not to be found directly in Husserl but lies rather
between Husserl and Martin Heidegger (to whom the quoted
phrases "facticity," "already there," and "lived" are to be attributed),
so that Merleau-Ponty is actually giving an account of phenomenol-
ogy both as a proposal and as the reception of that proposal—an
account of phenomenology as a movement rather than a fixed body
of procedures or propositions either arising from or subtending
those procedures. As he puts it a page later: "phenomenology can be
practised and identified as a manner or style of thinking [which]
existed as a movement before arriving at a complete awareness of
itself as a philosophy." The particular strength of such an approach is
precisely that it allows—and all but demands—that one begin by try-

ing to understand the peculiar historical fruitfulness of a body of work that seems in many ways distinctly unpromising.

Husserl's general project, like Gottlieb Frege's, was to find a nonpsychological ground for philosophy. He imagined that such a ground could be found in the close description and analysis neither of objects in their independence nor of subjects in theirs but of objects as they appear in the only place they do in fact appear—in consciousness. To this end, Husserl took over from his teacher Karl Brentano a central insistence on the intentional structure of consciousness. "Intentionality" here is meant to register that there is no consciousness that is not consciousness of . . . something, and that this "of something" is integral to its being consciousness at all. By the same token, there are no objects except insofar as they are objects of consciousness, and so the particular, essentially encyclopedic, project of phenomenological philosophy must be to describe the particular nexuses that constitute the things of the world before we abstract these nexuses into the encounter of some imagined preexisting consciousness with an equally imaginary, pre-existent and independent thing—to understand then what it is to grasp a cube as a cube rather than to be waylaid into wondering, for example, whether or how we can know that there are beyond these aspects that currently face us other aspects that do not. The latter question is one that arises only after the fact of our actual apprehension of it and render that apprehension mysterious and opaque. Husserl imagined—and his methodological reflections aimed to guarantee the terms of this imagination—that the way to such rigorous description of things (like cubes, but also like perception or the consciousness of time) lay through a series of suspensions (epochés, reductions, or bracketings in Husserl's vocabulary) of our imposed attitudes toward and interests in things in favor of their simple appearance. Thus the celebrated phenomenological slogan "To the things themselves!"

If Husserl, for most of his career (the crucial later formulations mentioned by Merleau-Ponty arise partly in response to Heidegger), emphasized the dimensions of this thought that implied a cataloguing of forms of objectivity understood to be transcendental with respect to our apparently more natural dealings with things, it was left to his distinctly wayward student Heidegger to refuse this essentially idealist project in favor of an insistence on the ways in which

no consciousness can be abstracted from its embeddedness in a particular world and tradition (and, Merleau-Ponty will add, body). On this account, Husserl's dream of a rigorous descriptive science of essences is empty; what remains of it is a work not of description but of interpretation, and "interpretation" here refers to the appearing or showing of things as the things they are. Thus for Heidegger, phenomenological method opens immediately into ontology (the explication of the way things [more or less actively] are) and hermeneutics:

> Thus "phenomenology" means [. . .] to let that which shows itself be seen from itself in the very way in which it shows itself from itself. . . . Phenomenology is our way of access to what is to be the theme of ontology, and it is our way of giving it demonstrative precision. *Only as phenomenology, is ontology possible.* . . . Philosophy is universal phenomenological ontology, and takes its departure from the hermeneutic of Dasein, which, as an analytic of existence, has made fast the guiding-line for all philosophical inquiry at the point where it *arises* and to which it *returns.*[2]

"*Dasein*" is Heidegger's term for the kind of beings we humans are—beings that have (or, as Heidegger will argue, essentially are) a question about Being as the very form of their inhabitation of the world. *Dasein*, sometimes rendered into English as "there-being," names human being both as a relation to what Heidegger calls Being (the central object of his philosophic work) and as beings who are by being extended into the world and its things, ex-sisting (another Heideggereanism) beyond themselves in the objects and concerns that are the shape of their consciousness. *Dasein* is thus a Heideggerean revision, radicalization, or interpretation of Husserlian "intentionality."

Merleau-Ponty's way of summarizing this drift within the context of his particular interest is as follows:

> Perception is not a science of the world, it is not even an act, a deliberate taking up of a position; it is the background from which all acts stand out, and is presupposed by them. The world is not an object such that I have in my possession the law of its making; it is the natural setting of, and field for, all my thoughts and all my explicit perceptions. Truth does not "inhabit" only "the inner man," or more accurately, there is no inner man, man is in the world, and only in the world does he know himself.[3]

The 1960s saw the emergence within literary studies of a strong phe-nomenological school of literary criticism centered in Geneva. Such critics as Georges Poulet, Jean Starobinski, and Jean-Pierre Richard saw their task as one of making out the internal dynamics and lived logic of a writer's "imaginary universe" (Richard) or "self-conscious-ness" (Poulet). The work of this school not only offered a variety of models for understanding the relevance of phenomenology to liter-ary study but also exerted an important influence on the subsequent development of literary study in both France and the United States.

There is no parallel development within the practice of art his-tory, as indeed there is nothing to point to (outside of one specific historical moment to which I will return) that would count as a direct influence of phenomenology on (or appropriation of phe-nomenology by) the history of art. This is of course not to say that there ought not be such an influence, as it is also not to preclude a considerable indirect influence that may stand in need of more explicit recognition.

The absence of any direct relation between phenomenology and art history can, I think, be laid above all to the work of Erwin Panofsky—work which lays down an understanding of the relations between description, interpretation, and intention that functions as a powerful defense against phenomenological styles of thought.[4] That it is, in fact, intended as just such a barrier may be suggested by the clearly visible shift in Panofsky's position between roughly 1930 and 1940: the early "Zum Problem der Beschreibung und Inhaltsdeutung von Werken der bildenden Kunst"[5] expresses a clearly sympathetic interest in Heidegger's views on interpretation with their explicit argument for the violence of the move by which one passes from what is explicitly said to an "unsaid" it both conceals and depends upon (or from what Merleau-Ponty picks out as "all acts which stand out" to that "background" which is the condition for their standing out), while the English reworking of it as "Iconography and Iconology" drops all mention of Heidegger in favor of a view of interpretation roughly equivalent to that of E. D. Hirsch in literary study—that is, a view in which interpretation is more or less solidly grounded in an act of description that stands free of and prior to it and in which interpretation follows as the essentially nonviolent unfolding of that description in terms of larger unities of meaning.

This shift may well reflect something of the force of Panofsky's move from Germany to the very different intellectual climate of the United States as well as political antipathy toward Heidegger's continuing involvement with National Socialism; intellectually it amounts to a consolidation of Panofsky's longstanding neo-Kantian allegiances and his intellectual closeness to its leading figure, Ernst Cassirer.

The single work whose reception Panofsky can be said to have most effectively blocked is, I would argue, Hans-Georg Gadamer's magisterial systematization of Heidegger's remarks on and practice of interpretation, *Truth and Method*.[6] A work more often cited than read, even within literary study, *Truth and Method* resists easy summary, in part because, in keeping with its commitment to the bottomlessness of interpretation, its methodological argument is embedded in an interpretation of the shifting shape of humanistic knowledge in the modern period.[7] At its core are three key propositions Gadamer takes to follow from Heidegger's formulation of hermeneutic phenomenology: [1] that interpretation as a primoridal structure of the appearing of things is bottomless; [2] that it therefore happens always within the horizon of tradition and accordingly has the prejudice of tradition as its enabling condition; and [3] that interpretive understanding so conceived is always a historically effected and historically effective event. This is, in effect, to embrace the full force of the circularity "Iconography and Iconology" attempts to hold at bay. As a challenge to the normal practice of art history, Gadamer's work can be taken as an argument against any claim to objective knowledge, but it is more accurately taken as arguing a radically different model of objectivity—that is, of how objects are in history and in interpretation.

If the direct influence of phenonomenology on art history remains in important respects hostage to Panofsky (and, beyond him, Gombrich, who can be said to seal art history within the orientation to psychology and sociology that is prepared by the turn away from Heidegger), it is nonetheless the case that phenomenology and phenomenological hermeneutics have played a considerable role in preparing the ground for many of the tendencies that are frequently loosely assimilated under the rubric of "new art history."

What we now know as "theory" is a notably complex and far from monolithic formation that has been repeatedly modified and

transformed as it has passed from what one might imagine as its origins in France to Great Britain and the United States and as it has found itself placed in new relation to such initially independent lines of development as the work of the Frankfurt School in Germany, pragmatism and neopragmatism in the United States, and the emergent movement toward cultural studies in the United Kingdom.

It is of at least historical importance that the various French developments are strongly conditioned by an ongoing engagement with phenomenology. Merleau-Ponty's engagement with the Husserlian legacy is far from an isolated instance. His major early partner in exploring the implications of phenomenology was Jean-Paul Sartre, whose *The Transcendence of the Ego* and *Phenomenology of the Imagination* remain important parts of the phenomenological literature. Among later writers whose work takes off more or less directly from Merleau-Ponty, one might include both the philosopher Jean-François Lyotard and the art historian Hubert Damisch.

Looking more broadly at the careers of some of those most closely associated with the rise of structuralist or poststructuralist theory, one might note Michel Foucault's early interest in the existential psychoanalysis pioneered by Ludwig Binswanger, Jacques Derrida's early engagement with Husserl's *Origins of Geometry*, Jacques Lacan's translation of Heidegger's "Logos," and his appraisal of Merleau-Ponty in *Les temps modernes*, and Maurice Blanchot's strong appropriation of Heidegger to literary criticism. This reflects a much broader fact of French postwar intellectual culture (at least in the humanities—one notes the absence of the names of Claude Lévi-Strauss and Louis Althusser from this list) which is that some such engagement with phenomenology or phenomenological ontology had become something of a rite of entry into that culture. In effect (and with the notable exception of Gadamer's work), the European fortunes of phenomenology are, from about 1930, worked out in France rather than Germany—a clear consequence both of political developments in Germany and of pressures internal to French intellectual life.

The relationship between the various structuralisms that emerge during the 1950s and 1960s and phenomenology is, at first blush, strongly oppositional—pitting language against perception, mediation against the presumed immediacy of lived experience, abstract

structure against the primacy of the body, and an image of the signifying surface against that of a presumed depth of meaning. Nothing, perhaps, seems more alien to the structuralist impulse than the imagination of the deep, meaningful copresence of self and world forged in, to take a central example, Merleau-Ponty's elaboration of phenomenology in close proximity to both Gestalt psychology and the organismic biopsychology of Kurt Goldstein[8] (an elaboration whose aesthetic bearing is clearly indicated in Merleau-Ponty's influential late writings on art and, notably, Cézanne). Jacques Derrida's 1966 remark, closing the discussion of his paper "Structure, Sign, and Play in the Discourse of the Human Sciences," that "I don't believe there is any perception" would in this context seem to be the last word in such resistance to phenomenology.[9]

And yet it is also Derrida who appeals to the strongly phenomenological psychoanalytic work of Nicolas Abraham and Maria Torok in his polemic engagement with what he takes to be Lacan's anti-Heideggerean hyperstructuralism, as it is also Derrida who repeatedly asserts the irreversibility and necessity of the path opened by Heidegger. In something of the same fashion, Jean-François Lyotard makes his first major appearance as a poststructuralist theorist precisely as a champion of something like phenomenological depth—something in any case importantly derived from Merleau-Ponty—over and against the structuralist reduction of signification to relations imagined as if unfolded on a pure, depthless surface.[10]

In this light, it can be tempting to imagine that poststructuralism can be defined in whole or in part by a certain return of or to phenomenology. There is, I think, something to this: but it also mistakes both the extent to which questions of perception and interpretation have been radically recast by the appeal to Saussure's model of language and the extent to which the interests underlying that appeal, outside of its most purely scientistic forms, are shaped precisely by a history of engagement with phenomenology and its hermeneutical offspring. This, I would argue, is visible even in the work of Lévi-Strauss—an aspect of his work that is lucidly registered by Ricouer in his remark that what Lévi-Strauss urges is a Kantism without a transcendental ego, a description that opens an easy passage between that work and Heidegger's.[11] This of course would be to suggest that the

difference between structuralism and poststructuralism is less use-
fully thought of as a difference about phenomenology than as the
unfolding or repetition of a difference properly within it, marking
limits at once internal and external to it. That is, structuralism and
poststructuralism alike can be said to belong, in part at least, to phe-
nomenology just insofar as it is not a settled body of practices or
propositions but something more like a style or a movement—and is
a movement just because it is bound to the unfolding ambiguities of
its claim to grasp things as they are—ambiguities that importantly
pass between "description" and "interpretation." If the emergence of
theory marks a crisis for phenomenology, bringing out its internal
impasses and demanding its continuation in a radically transformed
register (one in which it can no longer or only with great difficulty
recognize itself), this is perhaps because the newer work forces the
recognition that what presents itself as perceptual cannot be regis-
tered except under some condition of legibility—which is to say that
the ambiguities within the claim to "grasp things as they are" are not
simply infelicitous features of a language we are obliged to use but
are a part of the structure of that grasp.

In this light, it will be important to say that Gadamer's reflec-
tions on interpretation mark a certain limit to phenomenology's
movement—as if, for all the direct interest we may well have in open-
ing our models of interpretation in Gadamerian direction, his work
nonetheless will finally mark a vanishing moment between making
out what or how things are and making out a meaning held to under-
lie their being and to which they are ultimately to be held in some
sense accountable. This is, I take it, not a way of vitiating the art his-
torical interest of Gadamer, but simply a way of specifying it—what
Gadamer finally offers is not a theory of interpretation one might (or
might not) prefer to Panofsky's but a way of working through the
question of interpretation to a position from which interpretation
can be seen not to be self-supporting but to depend on something
like the terms of our attachment to particular works. At this level, the
challenge phenomenology offers the current practice of art history,
both old and new, is to be located in its suggestions that no theoreti-
cal ajudication between the relative weights or roles of description
and interpretation is possible, even as neither of these terms is simply
disposable.

2. Framing and Folding

The issue here is put clearly in a familiar enough passage from *Being and Time*. Heidegger writes in §32:

> "The fact that when we look at something, the explicitness of assertion can be absent, does not justify our denying that there is any Articulative interpretation in such mere seeing, and hence that there is any structure as-in it. When we have to do with anything, the mere seeing of Things which are closest to us bears in itself the structure of interpretation, and in so primordial a manner that just to grasp something *free*, as it were, *of the "as,"* requires a certain readjustment. When we merely stare at something, our just-having-it-before-us lies before us *as a failure to understand it any more."*

While the consequence normally taken is that there is no such thing as description because it is, instead, interpretation all the way down, we should now be prepared to see that it follows equally well from Heidegger's statement that there is no such thing as interpretation and that the elaborations we undertake in its name finally answer only to the needs of description. That is, to belabor the obvious, the real burden of the passage is not to replace "description" with "interpretation" but to undo the imagination in which description is understood to be prior to, and so capable of anchoring, a separate activity called "interpretation." Failing to take this in will stick one with a notion of interpretation that is essentially silly—and there is abundant evidence that a good bit of work taken to be theoretically sophisticated is silly in just this way. In particular, one is going to be in the position of believing that interpretation is without criteria, whereas what one ought to believe is that the criteria for interpretation cannot be disentangled from that other set of criteria one might like to assign separately to description. Getting this right means, at least for art history, that the end of any interpretive exercise must always be a question on the order of "Can you see it this way?" And sometimes it will be important to answer that question by saying "No"—that is, by asserting that the interpretation proposed fails to register as a description regardless of any other strength or interest it may have. This is presumably what is happening when art historians say, as it seems to me they often do, that a given interpretation doesn't "stick to the painting." What I am trying to do here is gain a certain amount of explicitness about the full complexity of such remarks.

It is in this general context that I want to look once more at the much written over exchange between Heidegger and Meyer Schapiro. In terms of the immediate issues of that debate, much of what I will say will come down to the claim that Schapiro does not appear to know that the object he is engaging is a painting, whereas this may well be the only thing Heidegger knows about it.

Given the range of things that have already been said, it seems useful to begin by being as explicit as possible about how I understand Heidegger's essay "The Origin of the Work of Art."[12] Two general remarks may be useful here: The first is that, in general and despite its presentation as belonging to a sustained examination of Hegel's *Aesthetics*, I tend to take it to be, particularly in the parts I will be discussing, as fundamentally engaged with Kant. This is partly pure prejudice but one in which I feel confirmed to the extent that Heidegger's various dealings with Hegel seems always to slide back toward Kant, who I take to be, at least among modern philosophers, the vampire that made him (just as I tend to take Derrida and others of his approximate generation to have been for the most part made by Hegel). The second is that I understand much of the essay's work, at least up through the van Gogh example, to be well described as rhetorical, by which I suppose I mean that the main burden of the argument is to bring its reader into an appropriate disposition rather than come to any strongly reasoned conclusion. The maneuvers here do seem to me roughly Hegelian, and the analogy I would offer is to the *Phenomenology's* "Introduction."

The essay's opening strategy, as I understand it, is to set up something that looks like a certain kind of argument—basically a working one's way from the apparently most general and foundational considerations pertinent to an artwork (that it is a thing, that it is an artifact) to its founded specificity as a particular type of artifactual thing—and then to display the breakdown of that order of argument in two related ways: on the one hand, by observing its particular failures and by doing so in a way that can later be seen to have been implicitly diagnostic, and, on the other hand, by inserting into the midst of the voice that explores that argument momentary surges of at least one other voice.

The repeated and explicit failure of the approaches to "the thing" is that we keep finding ourselves wanting to define it through

terms that, because they derive from the notions of artifact or work, are not yet available to us; the implicit diagnosis is that we've got the order of these things wrong, and it is the reversal this implies that the van Gogh is meant to enact. The work of the surges of what I will treat, perhaps somewhat summarily, as a single, palpably lyrical or poetizing voice I take to be a sort of sowing of this possibility in the midst of the feigned argument. One such passage that is important to me occurs on pages 20 and 21 of the English translation as a sort of "ode to the thing."[13] It may be in some contexts that one would want more distinctions than I'm going to operate with here and so to say that the passage as a whole modulates from the argumentative voice to the poetizing one through the intervention of a distinctively Heideggerean involution that can speak only through a certain kind of repetition—thingliness of the thing in its thing-being, etc.—but however one counts the voices here it seems to me important to tie this general pattern back to Hegel as well (it is a kind of enacted expansion of Hegel's glossing of the speculative proposition as a matter of counterthrust, rhythm, and prosody).

But the "ode" itself is "Kantian" in the sense that its work is to let one hear the familiar phrase "thing-in-itself" as remarking a certain self-containment we may not ordinarily hear in it, and to hear that as a particular modification of the general way in which we (ordinarily, i.e. poetically) find things always and only "in" (which the ode expands through a range of related prepositions and imaginations). The effect of this bit of rhyming is to prepare one to let the "thing-in-itself" as one normally hears it approach the self-framing self-showing of the Kantian beautiful, which is, of course, a version of the reversal Heidegger wants and which is most simply put as the reversing of the genitive in the essay's title.

If I stress this particular passage, it is because I think it helps make clear a crucial dimension of the reversal as it is enacted through the introduction of the Van Gogh: because Heidegger is interested in the ways in which a work of art is self-showing and self-framing (participates in what Derrida will call "the *sans* of the pure cut"[14]) it is important to him that the work not appear in the first instance as bound up in an external frame across which we would then have to negotiate our access to it, so he smuggles it in under the guise of equipment or artifact, the region to which the argumentative voice

has turned in the wake of the failed engagement with the question of the thing.

And yet it is the frame, passed over in a first moment and displaced in the second, marked by Heidegger's "And yet—"and the emergence of his fantasy from within the worn opening of the boots, that seems crucial to the transition through which the van Gogh declares itself as other than equipment. Derrida seems to me get all of this right in recounting Heidegger's argument, and his own figure of lacing means to display the insistence of the frame that Heidegger does and does not acknowledge. That acknowledgment, as Derrida seems to understand, is continuous with the acknowledgment of paint, and motif, and woven canvas; it would grasp the painting as pure self-figuration.

What I am interested in here is something fairly simple; whether we take Schapiro to be right or wrong in his well-supported and finally slightly ludicrous sense that van Gogh in 1886 is no longer a country boy but a member of the urban proletariat and regardless of the political and ideological transparency of Heidegger's imagination of van Gogh's Aryan peasant woman, it is absolutely clear that Heidegger—or his text, if you want—knows that the fantasy is just that. That is, it is constructed so as to explicitly contradict a description Heidegger has already given with sufficient accuracy to, among other things, allow Schapiro to pick out which painting is in fact under discussion.

When I teach this text, I often ask students to imagine it—as it pretends to be—as a classroom performance, and ask them how to understand Heidegger's eyes in relation to the words he's speaking and the slide one might imagine projected behind him. There's the quick glance, to confirm that it's there and of shoes (this doesn't seem necessary and there is something to be gained in imagining that Heidegger takes its presence so much for granted he doesn't even pretend to look); there's the longer look that goes with the accurate description and an apparent turning away that is then broken or checked by the "And yet—." And then, in a certain sense, it doesn't seem to matter where his eyes are because the fantasy is in a strong sense a passage of blindness that is ended by the recognition that clearly does bring his eyes back to the painting in recognizing it as such—or, if you think his eyes have never left it or were checked in

leaving it and turned back for the fantasy, then perhaps you will want to say that sight returns to his eyes.

So two things are happening here: we are being persuaded (if we are) into accepting a claim for the priority of the artwork over the things we have been philosophically tempted to take as prior to it, both in the order of thought (thing–artifact–artwork) and in the order of representation (shoe–picture of shoes), and we are being brought to that position through an exercise in which its being an artwork comes only after we have ceased to see it, to be looking at it, and apparently comes only by grace of its misinterpretation. Presumably this is the position Heidegger intends we should find our-selves in, and he does so, in part at least, because this play of priority and belatednes is to be taken as informing the apparent naturalness of the path taken by the (misleading, diagnosable) argumentative voice of the essay.

Now if Heidegger's interpretation fails—as, I would say, it cer-tainly does—it fails because it does not count as a description of the painting. But this will not mean that it fails to be adequate to the ini-tial moment of presumably accurate description—because that moment is itself not a description of a painting but of a piece of equipment that exactly resembles van Gogh's work. Schapiro's inter-pretation fails for exactly the same reason. The difference between them is simply that Heidegger at least knows what it would mean to succeed.[15] There is, on Heidegger's account, no external criterion to which interpretation can appeal; it either is of what, in its light, shows itself to be a work, or it is not.

Jacques Derrida, coming late to the debate, addresses these mat-ters by saying, in part, that Heidegger fails to attach the shoes to the painting, to the canvas, and he ties this failure both to Heidegger's general rhetorical strategy and his underlying drive to radically distin-guish work and artifact, art and technique.[16] Another way to phrase the same point would be to say that Derrida holds it against Heidegger that he is not actually interested in the shoes he takes up either as equipment (say, elements in the technology of walking) or as painting. Derrida's essay "Restitutions"[17] thus tries to unfold across a range of voices the various ways in which the failure to be interested in the shoes is continuous with a failure to be interested in the paint-ing as painting, which failure is continuous in its turn with a failure to

deal adequately with the convertibility of artifact and work that is, nonetheless, the actual heart of what matters about "The Origin of the Work of Art." What I take to bind these things together is an enacted meditation on the relations between description and interpretation. These things can be said to be knotted together around the work's frame in the following way:

1. The condition for what I've been calling the "accurate" description of the contents of the painting is that it be introduced as essentially unframed, a mere representation on a par with, for example, an illustration from a shoe manufacturer's catalogue.
2. The condition for the emergence of Heidegger's interpretive effort is the discovery that the represented shoes can be taken as a frame, but this frame—unlike the one silently dismissed in bringing the painting on stage in the first place—is strictly an opening into the work rather than a real or potential barrier between us and it.
3. The main consequence of the interpretation is the discovery that the thing in question has been, as it were all along, a work, a painting. I take this to be a tacit recognition of the complex work of the frame.

That this last moment is tacit—that all these movements are silent with respect to the frame they stand so variously toward—is crucial, and is why I do not call the final step an "acknowledgment" but only a "recognition" of the frame. The point is that although Heidegger everywhere depends on the fact of the frame, it is itself not something he can explicitly acknowledge. And he cannot do so just because the frame is, with respect to the thing he most centrally wants to distinguish, undecidable: the frame is what makes it possible both that the van Gogh should merely hang on the wall "like a rifle or a hat," and that the van Gogh might in the end be discovered as radically different from a rifle or a hat.

Derrida forces this point through his notion of frame as *parergon*, a notion whose relation to his interest elsewhere in turning our imagination of allegory inside out so that we attend to the shell rather than kernel.[18] In both arenas, Derrida insists on a logic of meaning

(*sens*) that poses it as always "outside" (*sans*), and it is important to run this up fairly directly against Heidegger's orientation to self-containment as the essential shape of meaning and identity (as, for example, in "the ode to the thing").

What Derrida's reading of Heidegger shows is that the way the work shows itself as in itself—as autonomous or self-framing—cannot be expressed without entering a simultaneous appeal to its being beyond itself, "laced" to an otherness that can be neither simply made a feature of its underlying identity nor equally simply relegated to some other thing or circumstance. And this is also to say that it cannot be registered in one beat or moment (something Heidegger's text shows clearly enough) and cannot, once thus registered, be refolded back into any simple originality (something Heidegger's text cannot admit). The originality of the work—its being, as Heidegger would have it, an origin—is inseparable from the structural belatedness of its recognition. This would be why we continue to need separate words for "description" and "interpretation" even as we acknowledge that they ceaselessly fold back into one another and that their criteria cannot be disentangled from one another.

3. Time Frames

If we take from the first part of this essay the thought that description and interpretation are bound to one another by the terms of our attachment to our objects, and from the second part the further thought that their difference turns or is enacted around the work's frame, then we may be prepared to imagine that one way the discipline of art history can happen—can find its foundation—would be through one or another practice of the frame.

Erwin Panofsky's essay on the first page of Giorgio Vasari's "Libro" is one of a number of essays—others would include the essays on perspective as symbolic form and on the history of theory of human proportions—in which historical work on a particular object or practice is at the same time a staging of the distance and relation appropriate to such work in such a way that the Italian Renaissance is repeatedly found to be the place in which art history can know itself and its proper mode of objectivity.[19] In this instance, the object is a drawing of a work by Cimabue around which Vasari has further inscribed a frame. Panofsky's elaborate exploration of the relation

between work and frame culminates in the discovery that their conjunction just here—on this page, at this time and place—marks the permanent and simultaneous emergence of a properly artistic interest and a properly historical grasp of it (a recognition of what art history comes to know as "period style"). This amounts, within the general drift of Panofsky's argument in these essays, to the claim that Vasari's picture shows that he knows himself as subject and the past as object and understands as well the fundamentally modern and rational terms of their intercourse. The frame thus appears as that which both makes the work available to our objective descriptive grasp and marks the distance that calls forth a further act of intepretation grounded on that descriptive availability. It makes possible the transformation Panofsky is never quite able to complete of the hermeneutic circle into a vertically ordered structure founded on descriptive evidence.

By contrast, Heinrich Wölfflin's *Principles of Art History*[20] can be said in this context to decline imagining the integrity of the work by reference to its frame in favor of a practice in which works—necessarily plural—are understood to do something like frame one another and thus deliver their features to visibility.[21] Such a radically comparative method (radically comparative in the sense that comparison is a dimension of the work and not simply something to which the work is submitted) implicitly understands the framedness of a work as an acknowledgment of the necessity that it *be* by being outside itself, related, laced to otherness. It would apppear to be a natural consequence of this position that it will both place a primary emphasis on description (it will be "formalist") and that it will stage this descriptive activity in such a way that one's engagement in it will draw fluidly—as Wölfflin's indeed does—on the further language of interpretation, revision, reading, and the like. This fluidity is clearly continuous with Wölfflin's insistence on grounding the two modes of vision he both entangles and disentangles[22] on a quasi-Kantian contrast between "things as they are" and "things as they appear" that he refuses to heal over. Another consequence would be that the word "later" in the book's subtitle shows itself to be necessary and integral to Wölfflin's grasp of his object: work is only as it is "after," and the art historian cannot deliver him- or herself from oscillatory play set in motion by that assertion (the undecidable and always decided play of classical and baroque, priority and belatedness).

Both Panofsky and Wölfflin are working to inscribe themselves as art historians within the history that will form their object, making out around the frame the shape of their attachment to what shows through it. The difference is that Panofsky does so in such a way that the act of inscription disappears into its result, freeing the art historian into a "natural" objectivity that no longer appears as a structure of attachment, even as the rhythmic structure that made such inscription possible is transformed into the frozen spatial distance between the Renaissance as historical moment and as moment privileged by its ability to stand outside a history it is now free to take as object; whereas Wölfflin leaves himself radically exposed to a rhythm he can only enact without mastering (which is not to say he cannot show or find words for it, but only that such showing and wording will continue to be subject to its conditions). One obvious consequence of these differences is that Panofsky can take his object for granted, while Wölfflin is obliged to "prove" it each time (to show it as such)—to the point that this amounts to a description of his method.[23]

4. The Rhythm of Things

Wölfflin presumably means in the *Principles* that the various distinctions he lays out as subjacent to the overarching distinction of Classical and Baroque should apply uniformly across the arts of painting, sculpture, and architecture. But one of those distinctions— perhaps the most memorable—appears to, if not exactly privilege, then at least draw in a somewhat odd way on one of those arts in particular. This is, of course, the distinction between "linear" and "painterly." This needs remarking on in the present context just because this paper has itself done its own, possibly related, easy trading between questions and assertions about "the work of art" and about "the painting." Such slipperiness may seem risky given the weight I am trying to place on the notion of the frame, especially since there are obviously art works (including many things we would call paintings) that are not, or at least are not clearly, framed.

One might note that Heidegger is clearly much more interested in the kinds of works that are at least not explicitly framed than he is in painting. Poetry is what really matters to him, and when he deals with it he does so for the most part by focusing on individual

words rather than on those dimensions of the poem one might be tempted to assimilate to a painting's frame—as, for example, meter. Given the high value he places on Hölderlin, this is a palpably odd position for him to hold and causes some odd stresses—as for instance in his conducting a lengthy discussion of measure—*spannung*—in full awareness of its relation to meter without finding himself led to discuss meter as a feature either of Hölderlin's writing or of his theoretical reflections on it.[24] "The Origin of the Work of Art" sketches out along its way a pretty clear Heideggerean hierarchy of the arts with poetry at the top, architecture and sculpture closely paired behind it, and painting a poor third or even fourth. Both the hierarchy and the reading practice make sense if we take it, correctly I think, that Heidegger's general preference is for art he can present as framing rather than framed. But of course such work could not have done the rhetorical work van Gogh's painting did for the essay, so in considering all this we are looking at one more place where Heidegger is unable to fully acknowledge what is in fact visible in his essay: it is important that it is a painting to which Heidegger fails to attend and on which the movement of the essay nonetheless depends. Wölfflin's appeal to the painterly works the opposite way: it is of a piece with the temporal complexity integral to his imagination of art and, I would suggest, its particular importance is close to the value Hegel also assigns painting; it is, essentially, belated, and the belatedness is tied to an explicitness about its reserve—about what it necessarily cannot show or be or about its being marked *by* and *as* what it does not contain. To put is as Hegel did, as Wölfflin implicitly does, and as I think Derrida must: painting "just is" *after*, and as such its historical preeminence is an important condition for the emergence of the work of art from out of its invisible originality.

This thought was already implicit in the reading I sketched of Panofsky's dealings with the page from Vasari's "Libro," but bringing it to explicitness here lets us see, I think, two further things:

(1) It is a problem for art history that its disciplinary claims appear to depend on the universalization of a particular historically and culturally emergent category, "art." Current tendencies in the history of art are to take the claim to universality either as natural and direct or else as a matter of arbitrary cultural imposition. Either fram-

ing things as art is a mere remarking of an always available artistic interest or it is a criminal act. One general burden of the present essay must be that neither of these alternatives can be simply embraced or simply defeated: the possibility realized as the work of art is inherent in the rhythm of things and cannot be gone back on or repealed. This is, of course, also a point against Heidegger's nostalgia.

(2) The history of phenomenology explored in the first part of this essay intersects with contemporary art and criticism at a moment that serves as one important opening for the subsequent turn towards theory in art history. This is a matter of the controversies around minimalism that effectively transformed formalist criticism in ways we have yet, I think, to fully work through. Two dimensions of this moment perhaps particularly stand out against the ground I've tried to explore here. The first is simply that, as against the story one might tell about literary study, these controversies prepare a formalist ground for the reception of French theory, a ground that will then continue to have an important stake in maintaining a play between description and interpretation rather than being inclined to take "theory" as announcing a triumph of interpretation over description. The second is that these controversies importantly turn on the status of painting, which is to say that they unfold in a place whose pertinence to more general imaginations of the possible shape of art history is massively overdetermined.

1995

CHAPTER THREE
AESTHETIC DETACHMENT

Review of **Jacques Derrida**, *The Truth in Painting*. Trans. Geoff Bennington and Ian McLeod.
Chicago: The University of Chicago Press, 1987.

*J*acques Derrida's *La vérité en peinture*. appeared in France in 1978; the essays collected in it date back to 1974. I start with these facts because they mark out essential differences between the conditions of reception available to the translation of this work and those available to the bulk of Derrida's writing. One of these differences is rhetorical: if Derrida's "natural" audience in America has been the literary critical community, the audience for this work is more complex, because it claims with a new directness the interests of contemporary art criticism and because it may claim in a way Derrida's earlier work so far has not the interests of the American philosophic community, or at least those parts of it with a continuing interest in aesthetics. Another is historical: since 1978 the question of "postmodernism" has gained an extraordinary salience across a wide range of disciplines, and this salience seems to be in considerable part a product of the ability of the notion of postmodernism to gain real purchase within discussions of visual art. A third difference is geographical or geopolitical: the purchase of postmodernism on visual art is supported by practices emerging in the New York artworld; claims from Germany and Italy have been entered as well, but the continuing absence of French art (as opposed to French theory) is as striking a feature of the postmodern scene as it was of late modernism.[1]

I will not attempt any systematic discussion here of the consequences of this nest of differences. The mere listing of them is perhaps enough to indicate to what extent it is uncertain how these texts address us now. Of the four essays, two—"Parergon" (a reading of elements of the *Critique of Judgment*) and "Restitutions" (a reading of

Heidegger's "The Origin of the Work of Art" and Meyer Schapiro's critique of it)—can and should insert themselves into the discussions of critics and aestheticians, and through that entry may be found to address the issues raised by the current welter of claims for and oppositions to the postmodern. The other two—"Cartouches" (an essay on the art of Gérard Titus-Carmel) and "+ R (Into the Bargain)" (an essay on the paintings of Valerio Adami)—are perhaps less readily available, in large part because the art that supports them is less available to us. This lack of availability can itself support further reflection: one is tempted to argue that this is in fact the lack of access to a past (this would be what it means to recognize New York, by theft or otherwise, as the capitol of the artworld), and to argue further that this lack of access to a past obliges Derrida to a thinness, an absence of historical pressure, that we are not accustomed to in his writing. The result is perhaps most visible as a sliding of what would be a discussion of art toward an appropriation of it as illustration.

Derrida's back-cover blurb to the French edition begins, "Disons que, pour m'en tenir au cadre, à la limite, j'écris ici quatre fois *autour* de la peinture" (Let's say that, to hold myself to the frame, at the limit, I write here four times *around* painting. Or: Let's say, to hold myself to the frame, at the limit, that I write here four times *around* painting). Between the two possible translations, one avowing an intention and the other only setting conditions for it, a complex field is opened. On the philosophic side, we are engaged from the outset in the issues of the later Heidegger—questions of the condition and origins of the work of art, of the thing and its description as the binding together of the fourfold (*Geviert—la plus belle carte postale que Martin nous ait envoyée de Freiburg: La Carte postale*, p. 75), and of technology, its reign as *Gestell*, most frequently rendered "frame," and its link to questions of representation and research (what we might call "theory"). On what we might think of as the writerly side, we are faced with a new (I'm tempted to say "more literal") mode of engagement with the topical and tropical terms that serve as a major resource for deconstructive writing—inside/outside and "frame" above all. The link between these two sides is given in the figure of the abyss—a figure whose philosophic history begins for modernity with Kant on the imagination and comes to Derrida through the powerful Heideggerean revisions of "The Origin of the Work of

Art." To write on the frame (about the frame, around the work, about the work, on the frame) is to write *en abîme* in a way that perhaps makes more difficult our recurrent and problematic tendency to receive the practice of "mise-en-abîme" as essentially reflective, centripetal, and oriented to a certain kind of "depth." Within such writing, the decaying, mutilating reproductions, incised and incisive drawings, Gérard Titus-Carmel renders from his models take on an emblematic power, offering figures for Derrida's mutilation of his text on Kant, the cuts in which are so shaped as to make the text frame to its own absences, enacting within the economy of the book the play between internal absence and external frame that Derrida reads there and reverses in the "polylogue in n + 1—female—voices" of "Restitutions" as it (un)tangles the laces of Van Gogh's shoes into the terms of the argument by which they are now framed for us: pure limit, uncertainly framed or framing. *Ça tire de l'abîme*, and it draws endlessly.

What is one to make of this tangle, this meandering, now thick now thin, line?

In his recently published Norton Lectures (*Working Space*, Cambridge: Harvard UP, 1986) Frank Stella writes that "there is no doubt that Pollock, like Mondrian, enlarged the space available to abstraction by spanning the surface of painting with his enameled tracery. But how is this tracery tied to the edges of its support? Can the paint skeins be self-supporting? . . . The question of where the paint skeins are in relation to the painting's surface is an important one because it seeks to define the working space of abstract painting. The fact that this working space is defined by a contradiction which allows the paint skeins to be in two places at the same time should give us pause" (83–84).

Stella's lectures, like Derrida's essays, hold themselves within the possibility of something that could be called postmodern (but which neither writer names), soliciting some turn or new inflection. For Derrida explicitly and for Stella arguably this possibility is linked to the presence of Heidegger. I would thus stress not "tracery" but "spanning" in the Stella passage, tying it to the *Spannung* of Heidegger's writings on Hölderlin and finding its presence in both texts dictated by a common concern for the complex relations between work and space in the production of art. *Ça tire de l'abîme*: it

draws on, draws from, the abyss. In their different ways both Stella and Derrida are in search of the secret that binds the fact of the frame to the engendering (Derrida, contemplating the two shoes of Van Gogh and the terms of argument deployed around them—"peasant woman," "urban man"—by Heidegger and Schapiro will take this term more seriously than Stella could) of space within it and so creates the space within which art can work. What perhaps separates the two writers is a question about how far the complexity of this space demands a treatment in terms not solely of opticality but also of something like textuality, what Derrida has called "spacing." (Mere "readability" continues to be a term of dismissal for Stella, even as the complexities he picks out in both Caravaggio and Pollock seem to invite glossing in terms of a more sophisticated notion of reading; one might draw Michael Fried's recent *Realism, Writing, Disfiguration: On Thomas Eakins and Stephen Crane* [Chicago: U of Chicago P, 1987] into the discussion here.)

So one way to read *The Truth of Painting* might be to imagine that the frame on which it is written surrounds, say, *Autumn Rhythm*, and then to ask what it means that this is possible (this would be a question not just about Derrida's writing but also about Pollock's painting and the ways in which we might say it does or does not have a frame). In large measure the meditation thus opened will turn on questions of the place of criticism, the attachment and detachment of that place from the space of its object. These are to a high degree the questions Derrida works in his reading of the *Critique of Judgment*; they are also, I think, the questions that nerve the most compelling of recent claims to the postmodern. And they connect with another way of locating the absence these essays surround—by attending to an essay excluded from both French edition and English translation, "Economimesis" (in the collective volume *Mimesis desarticulations*, Paris: Flammarion, 1975). This reading of the Third Critique, a companion piece to "Parergon," turns on what Kant excludes—the obtrusive, the disgusting, that which would appear to permit no detachment—and on what this exclusion still more radically excludes—that which does not appear to permit no detachment but which indeed permits no detachment and so does not appear (odor, the stuff of some of Titus-Carmel's early work, figures here). Framing the Third Critique with Kant's gloss on disgust as "an

impulse to get rid of what we have eaten by the shortest route out of the digestive tract (to vomit)" (Immanuel Kant, *Anthropology from a Pragmatic Point of View*, trans. Mary J. Gregor [The Hague: Martinus Nijhoff, 1974] §21), Derrida's allover text weaves its way toward the glottal stops of *Glas*, the problematics of mourning and incorporation engaged in his psychoanalytically oriented writings, the patterns of stricture and release that work Kant's discussions of the sublime and of humor, and the stricture/structure of painting displayed in the lacing of Van Gogh's shoes, a thing divided and bound, *la chose-même* (the lacing hyphen here opens into the region Derrida marks with +R: trait, translation, *tiroir*...).

The Truth in Painting is, I think, essentially a book on Kant and as such it moves toward opening up a text and a region that remain central to our thought about modernity, whether in philosophy, art, or literature and its criticism. Its immediate context includes Lyotard's writings on the sublime and the various writings of Lacoue-Labarthe and Nancy on Kant, Heidegger, and German Romanticism. This turn back to and working through Kant seems to open new possibilities for French philosophy as it moves beyond the agenda set by the reception of Husserl, Heidegger, and Hegel in the thirties, including the prospect of a new exchange with elements of Anglo-American philosophy. As it moves back toward the substantial terrain of Romanticism, it opens as well the possibility of a new reading of the project of deconstructive criticism as it has emerged in this country (something of this rereading is intermittently visible in Derrida's *Memoires for Paul de Man* [New York: Columbia UP, 1986]).

We have come to think that the era which in so many ways starts with Kant is now coming to an end, and so we find ourselves once again trying to imagine the shape of historical break and rupture. *The Truth in Painting* offers, it seems to me, peculiar and difficult resources for such thought, teasing from Kant and Heidegger a thought of detachment as frame. Metaphors of frame, view, and perspective have a deep hold on our imagination of the world, and it is a hold we know, more and more acutely, betrays the insights it promises (think of our recurrent fascination with and confusions about what "perspectivism" could mean in Nietzsche, or of our fascination with and uncertainty about what we mean by "representation" or a "critique" of it). The most powerful work of *The Truth in*

Painting lies perhaps in the disturbances it can provoke in our handling of these terms. As we begin, for example, to reimagine the Kantian "architectonic" away from a foundational sense and toward a pictorial one, we begin also to be able to think the difference between logical and temporal priority (a task explored and assigned by Heidegger) in ways that permit a recognition of the historicity of Kantian analysis (moving here too into a region first mapped by Heidegger's efforts to work through the imagination of the First Critique). What is peculiarly Derridean in these readings would then be the insistence that these questions are inseparable from the work and place of the writing through which they are framed. What we gain in historicity here we may well lose in historical authority, so that if we are to speak of the postmodern we may well end up arguing, that it appears precisely in or as our inability to claim it.

What would it mean to call these essays a "deconstruction" of aesthetics? Certainly there is woven throughout a strong critique of any radically autonomist formalism, including here and there attempts to recognize the existence of art in a market and so on. But there is no particular effort to make the category of the aesthetic go away or to empty it in the manner of de Man's late essays on and around Kant. Indeed, the general work of the essays seems to be to recognize the depth of our attachment to art (a depth more autonomist notions presumably mean to register but from which they end by removing themselves). Like Heidegger's, Derrida's critique of Kant is a reading of him, a pursuit of the fullest complexities of Kant's terms and text; it moves toward an account of an entanglement of art and life that can find no rest in either their radical separation or their simple identification. In this sense, it attempts to understand art as above all an object of criticism, speech and writing, in the absence of any theoretical grasp of it—and this is, after all, just Kant, beyond Kant: an engagement within the postal system, knowing in advance its inability to erect itself into the simplicity of any break that is not also a hinge.

I have tried to work my way into Derrida's text by opening, perhaps forcing, a distinction between a statement of intention and a statement of its conditions. This is, it seems to me, a space in which Derrida regularly writes. To the extent that Hegel sets the agenda, this space gets articulated as the difference between an intention and

its material or textual fate. As Derrida focuses on Kant, the space takes on a transcendental inflection, measuring the difference between a thing (an artwork, say, or a text) and its conditions of possibility (an intention, a support, a frame). In either case, the work of deconstruction is to at once confound these distinctions (within Kant or Hegel and between them) and to insist upon their continuing pertinence to our life and thought. The world would then need to be thought as its own condition of possibility—without permitting that thought to collapse into mere empiricism, which I take to be both one name for the collapse of world into picture Heidegger so feared and a continuing risk for advanced theory as it engages in what it calls "a critique of representation."

1987

CHAPTER FOUR
POSITIONALITY,
OBJECTIVITY,
JUDGMENT

*T*he questions that set this essay in motion are, so to speak, professional. By this I mean that they are questions posed within highly specific professional contexts—that of the College Art Association and of an International Congress for Art History—to panels whose members could be said to represent a broad range of contemporary theoretical interests within the history of art.[1] Keith Moxey's charge to the first of these read as follows:

> The notion that history is a form of knowledge that has a privileged relation to empirical data, one that is uncompromised by the kind of intellectual speculation we associate with theory, has largely been abandoned. Historiographers and philosophers of history from Hayden White and Dominick La Capra to Michel de Certeau and F. R. Ankersmit have repeatedly emphasized history's debt to theory.
> The recognition of the ways in which the historical horizons of the past can only be made relevant to our own cultures in terms of the values of our own time, has opened up a broad new range of art historical initiatives whose possibilities have only just begun to be be systematically explored. These opportunities, however, prompt us to examine theory's relation to history and history's relation to theory. If theory is what allows us to make sense of the past in terms that are relevant to the present but theory is itself historically determined then what criterion can we apply in deciding which of the plethora of theoretical alternatives currently available to us we will make use of in our own work and is this a decision that can be decided in purely rational terms? The papers in this session will analyze and evaluate the relation between history and various different forms of theoretical interpretation in an attempt either to define or collapse the distinction. It is hoped that a discussion involving members of the audience will help us to clarify some the issues that are at stake in these maneuvers.

The first part of this paper attempts to take seriously both the question and the professional desire to pose it in these terms; it thus attempts both a response and a diagnosis with a view to shifting the ground toward the more positive account offered in the second part, which unfolds in its turn toward the difficulties aired in the closing section.

I lay some stress on these matters of origin and context here at the outset because I take a concealed conflict or tension between a certain professional circulation of terms and questions and an emergent model of disciplinarity for art history to be a crucial feature of much contemporary discussion.

1. History and Theory
Let me begin then with what may well appear a rather abstract, slash-and-burn, approach to the questions initially put to the College Art Association panel. I can only hope the reader will be able to bear in mind that "slash-and-burn" names a method of cultivation and not, say, a form of warfare.

The question begins, evidently, with two terms: "history" and "theory." The abstracts submitted and the papers delivered reflected a bundle of sometimes divergent and sometimes convergent intutions about their relationship. To list at least some of these:

1. History is opposed to theory as the empirical to the speculative. Or, at least, this was once the case. Or was once believed to be the case.
2. History is deeply informed by theory at the same time that theory itself is nothing if not historically determined.
3. History is opposed to theory as real to ideal, each robbing the other of its purchase.

The terms in play are obviously exceedingly slippery: "history" sometimes means what happened and sometimes our attempts at saying or accounting for what happened; it is sometimes imagined as more or less coextensive with sociology and sometimes distinctly aimed at that peculiar region called "the past." And the slipperiness of the contemporary use of the term "theory" hardly needs underlining—it is apparently capable of taking in anything the explanation of which involves the speaking of a French proper name along the way,

whether that thing casts itself in the traditional form of a theory "proper" (i.e., a form that entails talk of propositions, proof, perhaps even predictability) or not. Somewhere in this region we are likely to come across that other term that will inevitably figure in any discussions of such matters: rhetoric, variously taken as the art of persuasion or as a quasi-autonomous logic of tropes (it is in this second form that it will eventually enter my argument).

I run over these things quickly not to claim that the question put to the panel was ill-formed or that it could be settled by parsing out the various senses at play and assigning them distinguishing subscripts, but simply to point out how professionally entrenched a certain feel for this distinction is. I don't know whether to attribute this evident fact to the recent history of the discipline or to some deeply shared, if inexplicit, theoretical agreement, or both.

Certainly, it is worth recalling the polemics that arose around "theory" when we still called it just "structuralism,"[2] and here I would instance in particular the exchange between Sartre and Lévi-Strauss over what one might call "the right to history"—Sartre insisting on the right of non-Western, so-called "primitive" peoples to enter history, to be transformed in that way, against Lévi-Strauss's insistence that what Sartre was calling history was but one more cultural grid analytically indistinguishable from that of the myths he studied, and offering no privileged ground for human existence or action.

Structuralism tended to divvy things up this way: where Saussurean and Jakobsonian linguistics offers a number of analytically distinct oppositions—between langue and parole, message and code, between syntagm and paradigm, metaphor and metonymy, between synchronic and diachronic, between signifier and signified—Lévi-Strauss, Lacan, and, to a lesser extent, Foucault all tend to take them as aspects of a single distinction in which langue, paradigm, synchrony, and the signifier line up on one side over and against parole, syntagm, diachrony, and the signified. It's as if people committed to history, living their lives there or thinking to do so, imagine themselves to make consecutive sense in their utterances while the demystifying bad news from the structuralist camp is that there is no history in which to live, and the utterances we proffer volatilize themselves into what is unsaid before they can fill out their periods.

Presumably this mood is succeeded by another, registered in the term "poststructuralism." While it seems right to say that this happens, so to speak, after Lévi-Strauss, it would seem too much to say that it happens after Lacan or after Foucault—although it pretty clearly has happened by the time Derrida turns his critical procedures on Lévi-Strauss and Saussure. How are we to understand this transition?

The view I like—the one that I think might matter to art history—is that such break as there is happens primarily as an increasing explicitness about the proximity of what initially appeared as an anti-Sartrean and linguistic turn to the course plotted out by Martin Heidegger. It's possible, I think, to see this proximity even in Lévi-Strauss's work, and it is certainly explicit in Lacan's. The work frequently considered Foucault's most structuralist—*The Order of Things*—is arguably also the most Heideggerean.

What I want, of course, to suggest then is that the opposition of history and theory has its origins in a debate that is but a mask for a deeper and more serious opposition, emblematically between Heidegger and Marx, both of whom mean, in no small part, to undo any easy opposition between history and theory in favor of a renewed emphasis on materially embedded practice. This is, I think, the deep opposition that traverses much of what is currently called "theory," and I don't expect there is a great deal of surprise in my arriving at it. What may be at least clarifying if not surprising about the way in which I have come to it, is how grossly miscast it is when we take it as an opposition between "history" and "theory." One good question, on which I hope this essay can be seen as working, is why the profession is so drawn to taking things this way. A further question, to which I will not be able to return, is why we are inclined to cast this also as an opposition between the political and the apolitical; Heidegger's politics were detestable but he can hardly be said to have opposed the politicization of knowledge or the university.[3]

For the present, I have no real interest in trying to characterize this opposition more closely. It is perhaps enough to say that insofar as art history takes as its object a historically and social produced category—art—it seems necessary and inevitable that attention to that object be torn between its apparent autonomy and the equally apparent fact of its social embeddedness. If I choose to follow out here the

implications of the Heideggerean side of this pairing (through the figure of Hans-Georg Gadamer) it is, in some part, because of a suspicion that Marxism has tended to reproduce within itself the very history/theory distinction it means to overcome.[4]

Perhaps the easiest way to establish the pertinence of Gadamer's work to art history is to introduce it as an alternative to or radicalization of the terms and strategies Panofsky so powerfully offers in "Iconography and Iconology."[5] From the vantage point of *Truth and Method*,[6] it is simple to diagnose the ways in which Panofsky, anchoring himself at once in appeals to humanistic understanding and to scientific rigor, works to blunt the impact and conceal the depth of the radically interpretive dimension into which he has in fact moved.[7]

But this way of introducing Gadamer also brings with it a problem with which Gadamer himself must struggle throughout *Truth and Method*: it can lead one to believe that Gadamer and Panofsky share an object, called "meaning" and about the nature of which or the conditions of our access to which they might be imagined to hold different theories. This is by no means obviously false, which is why it is a serious matter for Gadamer's own exposition. In many ways, this belief continues to inform a great many arguments within contemporary theory, generating a range of increasingly familiar arguments—about the pertinence of intention, about whether or not there is any core of meaning that constrains hermeneutic freedom, about the relative weights of proof and persuasion in the work of interpretation, and so on. Without wanting to deny the value of these arguments (and of getting them right), I want to suggest that their persistence, like the persistence of the opposition between "theory" and "history," is itself in need of some diagnosis. To put it somewhat more strongly: the drift of these arguments is always toward the interpreter, toward his or her freedom and his or her choices before the object and what will be claimed, on one ground or another, as its meaning. Which is to say that these arguments implicitly reawaken, once more, the problematic urge to pose "theory" here, "history" there, and then to worry about their connection.

What I take to be the deepest motives and arguments in *Truth and Method* oppose this radically. They cluster around such key terms as "prejudice," "authority," "tradition," and (the more Heideggerean)

"thrownness," and they insist on our relative lack of interpretive freedom, our relative lack of choice before the works that engage us. This last phrase is the key one: it is, on Gadamer's account, works or objects or texts that engage us, not we who engage them. It is in our misrecognition of this situation that we take ourselves as "theorists," and so find ourselves drawn into the chain of arguments so characteristic of contemporary discussion.

In contemporary theoretical discussion, the term "misrecognition" inevitably carries with it psychoanalytic resonances; these will need some address, but for the most part I want simply to unpack some of its more obvious features. If we can be said to "misrecognize" our situation, that must be because we are, in fact, within a situation: Gadamer's is first of all an account of the permanence of situations over and against the abstraction and freedom of method. And insofar as situations are permanent, Gadamer's elaboration of the structure of interpretation is an attempt not to persuade us of how we should proceed but to make visible the terms in which we do in fact already proceed, have been proceeding all along. Even our deep misrecognition of our activity does not change the activity itself, although it may render it deeply incomprehensible to us. And this certainly is something Gadamer wants to say (and Heidegger wants to say more fiercely): it is possible for the real stuff of our activity to become so foreign to us that we can no longer recognize it. As will become apparent later, I take Nietzsche to be doing something similar in *The Birth of Tragedy*: it is not that Socrates and his co-conspirator Sophocles break with the play of Apollo and Dionysus (because nothing can), but that they, as it were, turn that play's resources of concealment against the play itself—so it continues, but it does so invisibly until Nietzsche undertakes to rewrite its history as tragedy. If I'm getting things about right, then it should be clear that we cannot expect Gadamer to be offering something like theoretical grounds for certain actions: action itself is the ground, and "theory," if we are to use the word, is a consequence—variously, a continuation of or a turn against that ground, and to be judged as such.

I'm putting a heavy emphasis on the priority of hermeneutic activity over and against our theoretical reconstructions of it, in part so as to bring out the central force of one of Gadamer's key terms,

wirkungsgeshichte. The trouble it has given his translators is instructive: the initial translation renders it "effective history," which is nice insofar as it captures the dimension I've been stressing: the work actively prolongs itself through interpretation, through its engagements of us. The revised version opts for "history of effects," and that is nice insofar as it stresses the point toward which I have been working ever since entering the comparison with Panofsky: that "meaning" is not at the origin of this activity but is its constant and constantly altering effect. Gadamer and Panofsky do not, finally, share an object. For Panofsky, the work of art belongs to the history of human meaning; for Gadamer it does not: if anything the history of human meaning belongs to it.

This is what is really worrying about the so-called "hermeneutic circle"—not that it is circular, but that it is empty, or at least empty of meaning, that what calls for interpretation is something that is itself meaningless, something that effects meaning while never delivering itself wholly over to it (is this like, for example, Manet's *Olympia* in 1865?). Panofsky can be relatively comfortable with the circularity of interpretation—he takes that circle to be the movement through which a meaning is, as it were, surrounded, and the only active worry is about the breadth or scope of the circle. Gadamer, by contrast, airs enough of its essential emptiness to threaten the adequacy of the image of the circle altogether, and it is hardly surprising that those who have worked hardest to make explicit what we might call the antihermeneutics at the heart of Gadamer's enterprise—I'm thinking now of figures like Lacan, and Foucault, and Derrida—have been inclined to dispense with it in favor of more complex and uneasy figures. There is also this: once meaning drops away from the center of the hermeneutic enterprise, what we have been calling interpretation reveals itself as a process through which objects are constituted—or, conversely, as a process through which principles are constituted in the face of objects. *Truth and Method* can be said to lay out an understanding of disciplinarity or objectivity, the general shape of which is, as Gadamer clearly recognizes, Aristotelian—but this is an Aristotelianism that has passed through the fire of history and can maintain itself only in such flux. One might grant this the name of "theory," but the opposition to history from which I set out would not be available to it.

I said at the beginning this would be slash-and-burn, and a mark of that is the number of "not this but that" constructions generated as I've moved quite rapidly through a number of interlinked oppositions. This obviously will not really do; its good, if it has any, must be to mark clearly certain shifting accents and rhythms that will work any piece of art historical writing and that it will presumably be helpful to be able to hear because hearing those rhythms can change our sense of the point or urgency of various professionally recognizable debates and terms of argument.

The risk of proceeding as I have is of setting up too clean a picture. I have, for example, been content to play off a bundle of intuitions that oppose the terms "history" and "theory" against a reading of Gadamer that opens a space not structured by their opposition, and the result can come across as a nice, clean choice: old humanistico-scientific fussiness against a paradise of pure post-Nietzschean practice, as if this were something we should or could choose. And it would be a swell choice: we would be choosing to cease choosing, making of our culture and history the second nature that so haunts the Idealist tradition.

But it is integral to the position I've been trying to outline that we can't choose this. There is no, as it were, higher passivity, and that itself is a consequence of our relative dependence on and passivity with respect to the past. This is, I suppose, one way of saying about us, as we discuss these questions, that we are irreducibly modern, and that this condition imposes manners of speaking on us. Gadamer, for example, cannot say what he wants to say about the temporal horizon within which interpretation unfolds except by speaking of a "fusion of horizons"—even as he continues to argue, quite rightly, that strictly speaking there are no separate horizons of past and present to fuse. Similarly, he cannot simply step—cannot step at all—outside the continuing effectiveness of meaning to some place where it is only an effect and nothing more.[8] The various "misrecognitions" on which I have touched are, to pick up at last on the psychoanalytic resonance, constitutive; there is no transparent prior cognition to which we might return or appeal, nothing that can deliver us from our misrecognitions. Misrecognition, when it is constitutive, can only be acknowledged and cannot be set aside, can only be submitted to alteration and cannot be defeated.

All of this is to say [1] that we are obliged to understand our practice as essentially critical, a work or practice of writing attached to an object in such a way that it cannot be, as it were, prized loose and delivered over fully to theoretical understanding, and [2] that no matter how I might wish it were otherwise, nothing in this practice can guarantee our release from what we are obliged to imagine of ourselves and our situations—in this instance, our intuitions of the incompatibility of "history" and "theory"—because such imaginations are part and parcel of those situations. If, as I've suggested, this in some sense masks other issues, there is no reason to think that such masks can be put on or taken off at will. We would not be given to masquerade were it not already at work in our simpler facings of one another.

2. Judgment and History

Given such a valorization of the place of criticism, defined as "attachment to an object," within the discipline of art history, it makes sense to explore what it might be to imagine something called "aesthetic judgment" as central to that discipline. If we are to stay on the path that got us this far, this will entail taking a particular interest in the relation of such judgment to the activity of interpretation.

One might think the question of aesthetic judgment to be one the discipline of art history either has disposed of already or is in the process of disposing of at last. In the mood captured by the first of these alternatives, one will perhaps feel that art history has become what it is—profession, science, or discipline—precisely by disburdening itself of such concerns and forming itself as the study of a particular region of human meaning. In the mood captured by the second alternative, one may well feel that this first moment did not so much disburden the discipline of judgment as generalize and disperse across it a rhetoric of genius, monumentality and related terms in such a way that this insistence of the aesthetic can now only be fully purged from the field through some fundamental transformation of it beyond the implicit judgment manifest in the continuing centrality of the term "art." Such transformation would presumably make it explicit that the real object of art history can be fully thought only under some new rubric: perhaps that of "representation" or of "material culture" or "visual practice," etc.

I will try to characterize some of the issues at stake in these two moods a bit later. But for the moment I want simply to note their central presence in the field into which I am inserting a question about judgment. The question of judgment evidently arises within art history at a certain complex and moving margin that locates it in three more or less interlocking ways: [1] It is a question put by the activity of criticism insofar as it claims for itself a certain priority in the practical and theoretical self-understanding of art history, which priority is generally either unacknowledged or explicitly disallowed by the dominant tendencies within the profession; [2] it is a question that is repeatedly put to the discipline from the study of those regions of artistic practice that have that practice as an essential question, which is to say that it is above all a question put to art history by those who are involved with modernist and postmodernist, or at least contemporary, work; and [3] it is a question most likely to be raised by figures who, regardless of their insitutional affiliation, are likely to be regarded by the profession at large as in some sense not fully or simply art historians.

Rather than run through a list of those whose work I take to be consistently raising or more simply exhibiting the continuing pertinence of this question, I want to point to one figure in the recent past who seems both emblematic of this moving margin as well as causal in the perpetuation of its question: Clement Greenberg. The Greenberg I am invoking here is not quite the critical demon that now haunts so many critical and historical accounts of American art in the fifties and sixties; rather he is a figure I would suggest the profession knows neither how to own nor how to disown, a figure we cannot quite read in the settled ways we would like. He will not stay merely historical but reasserts himself as the partial author of the stories about modern art in which we would contain him.[9] While never writing under any other identity than that of a critic, he has nonetheless earned himself an uneasy place as an art historian who cannot quite be addressed as such and who does not quite address us as such. To take him seriously, whether positively or negatively, is to find oneself inheriting the complex position from which he speaks. This means, especially in certain professional contexts, that this inheritance carries with it a deep and sustained uncertainty about for and to whom one imagines oneself speaking.

There is certainly more than one way to phrase the lure of Greenberg. The ones that interest me insofar as I am trying to read something of the history and current situation of art history in terms other than those that divide it too simply into oppositions of "theory" and "history" or even "theoretical" and "traditional" would be ones that allow us to see how his writing captures and renews certain impulses that apparently lie at the very foundation of art history. The crucial recognition here would be of Greenberg less as the Kantian he so often proclaimed himself to be than as the Hegelian that emerges from the rubbing of Kant against Marx in his writings. On such a view, Greenberg has been difficult and powerful in relation to art history just because of his ability to hold together within a single practice both the discreteness of aesthetic judgment and the continuity of historical progression and development. Which is to say he has been difficult and powerful just because of his apparent ability to understand or display a way in which the terms "art" and "history" can find themselves justifiably conjoined as the title of a single field. In this way he can appear to have renewed the Hegelian claims and challenges that faced the modern founders of the history of art.

The great critical and historical weakness of this synthesis is that it cannot outlive its moment and finds itself, beyond that moment, obliged either to distance itself from current practice as a practice no longer recognizably "of art" or to cling to such practice only by describing it as posthistorical and therefore no longer accountable in historical ways. The recent writings of Arthur Danto and Jean-François Lyotard—both very much a part of the moving margin of the discipline—can perhaps serve as emblems of this double crisis. In taking it that the profession has a stake, perhaps a major one, in this marginal crisis, I am suggesting that if the rupture it marks between "art" and "history" were to prove irresolvable, the question would then become whether or not this rupture could itself be grasped as the abyssal ground of what might nonetheless be called, and imagined as, a discipline.

As I've noted, there are various ways in which the discipline can claim either to have disposed of already or to be currently in the process of disposing of the question of judgment that I would have the reader see as so problematically embedded in the very designation "art history," so these perhaps stand in need of some exploration.

The first of them—the thought that the discipline has taken its modern, serious form precisely by purging itself of judgment—seems to me to follow very largely from Erwin Panofsky's highly persuasive elaboration of the history of art as essentially bound to the history of human meaning in general. The position is, I take it, familiar enough not to need review here. Its complex inner machinery has recently been magnificently illuminated by Michael Holly and Michael Podro in the U.S. and England and Georges Didi-Hubermann in France, and I will only pause to underline two of the many things that they have clearly shown: first, Panofsky's definitive relocation of the central questions of art history from the aesthetic field of reflective judgment opened by Immanuel Kant's Third Critique to the normative and methodological field established by the First; and, second, the turn, coincident with Panofsky's passage to the United States, away from what was, in 1930, a possible dialogue with the ultimately anti-humanist hermeneutics of Martin Heidegger.[10]

Panofsky's achievement has recently found itself under pressure from two reasonably distinct regions, both of which figure under the name of "theory" and both of which place the notion of a general history of human meaning in question—one through its insistent recognition of the priority of the inhuman over the human and the other through its insistence on reading what Panofsky called "meaning" as the effects of relations of power, production, and so on.

It is the first of these breaks that is of primary interest to me, but advocates of both tendencies have been led, in seeking a way beyond Panofsky's restricted hermeneutics, to appeal to the work of Gadamer insofar as it seems to open the prospect of a more open-ended and historically relative notion of the way meaning might be at work in art history and the history of art. Gadamer's intention as it appears in this light is, in important part, to deliver us from worries about certain loosely positivist questions that so often seem entailed by historical and interpretive inquiry. Gadamerian hermeneutics offers to defeat our methodological self-understanding as exterior to the "tradition" we presume to form our object, and so to return us to an essentially Aristotelean position as participants in an ongoing business of practical judgment or *phronesis*. The explicit opposition here is to a modern self-understanding Gadamer explicitly attributes to Kant that separates theoretical and objective, or subsumptive, judgment from sub-

jective and aesthetic, or reflective, judgment.[11] It is perhaps implicit in the argument of the first section of this essay that Gadamer misses how far the Heideggerean formulations he is systematizing and extending in *Truth and Method* depend upon a radicalization of the kind of judgment Kant called reflective.

Like so many attempts to relieve us of the vicious exchanges between positivist adequacy and skeptical doubt, Gadamer's effort ends by renewing in a shifted register the very conflict it means to undo. This renewal is inevitable; it is what is marked or remarked by the necessity that Gadamer couch his argument in terms of a "fusion of horizons" and so also that he offer a picture of interpretive success that the argument itself must reject: the actual argument is that horizons are always already fused and that there is accordingly no need to effect such a fusion. Were this wholly true of our situation, there would be no need for Gadamer's argument. Were it simply false, Gadamer would have no claim on our interest. Gadamer's writing, one can say, happens in a place where the mutual convertibility of "attachment to" and "detachment from" stands in need of peculiar acknowledgment. Nonetheless, one predictable if not inevitable outcome has been that Gadamer's argument, or versions of it as read and transformed by a variety of contemporary theorists, has wound up being taken to authorize the priority of the interpretive present over and against an unreachable or unknowable past. What Gadamer poses as critical has been reformulated as methodological, thus opening the ground for the questions of "theory and history" from which this paper set out. But now we have returned to it on the deeper ground of the competing interests of "theory" and "judgment" in art history.

There are within contemporary theory any number of variations on this theme of the priority of the interpretive present; I am going to focus on just one particular moment of one recent art historical controversy in order to bring out the stakes more fully. This is the 1988 exchange between Michael Fried and Linda Nochlin around the issue Fried poses in terms of Gustave Courbet's femininity.[12] In choosing to focus on this argument, I will be exclusively interested in certain aspects of the methodological claims advanced by each writer on behalf of his or her position. I feel somewhat uneasy in singling out this exchange for extended attention, since it has been my expe-

rience that estimates of its pertinence, intelligence, and weight vary wildly within the profession.[13] Nonetheless, the shape of the methodological claims advanced in it seems to me exemplary—as does the fact that both writers claim to be drawing the implications of roughly the same range of work in contemporary theory.[14]

Nochlin's essay is structured explicitly by a certain grasp of her present such that she can distinguish in the writing of her essay between several different discursive and interpretive "positions" she successively occupies—that of the normal art historian; that of an art historian "closed off from the circle of interpretation" by its apparent success according to familiar, more or less Panofskian standards; that of a woman reading art history and the history of art; that of a woman writing such history; and, finally, that of an art historian reading and writing in the wake of the transformations operated by her movement through each of the previous positions. It is at this final point that she offers the following view of what authorizes her interpretation:

> If the place where a work is shown bears a crucial relationship to its meaning, then the new location of the Painter's Studio in the Musé d'Orsay rather than the Louvre would seem to demand new readings.[15]

One can easily grant Nochlin's anger and impatience remain too close to the surface in her essay. Such interpretation as she does finally offer is explicitly willful and polemic, unaccompanied by the scholarly gloss and justification one would normally expect. But for my purposes this only underscores her commitment to her methodological axioms and can perhaps serve to sharpen our focus on the presumably more elaborate instances in which we more easily take these same axioms to have nonetheless played out in a construction that feels more fully historical.

Fried's position as an interpreter is evidently quite different. As the concluding chapter of his book on Courbet[16] makes clear, he is not about to put forward any claim to historical objectivity on his own behalf—indeed, he closes the book by raising, in some detail, a question about how far he believes his own interpretations. As he phrases this question it is about how far he finds them "compelling" and not about how far he finds them "adequate," so a question one can well have about his procedures is about what difference that

choice of criterion makes, and what the relations between it and Nochlin's criterion are. Behind these questions about how far he believes his own interpretations there is presumably a further question about how much, in doing art history, it matters to believe an interpretation (or even about what it means to "believe" an interpretation); and these questions presumably must unfold into the further question of how far the business of art history is to be thought of in terms of meanings at all. The difficult thing here is that Fried seems, on the one hand, to be simply neutral with respect to questions about the "objectivity" of his interpretations, and yet sufficiently passionate about the Courbet those interpretations yield to not want to claim it as simply his present construction or situation of Courbet.

There is a turn of phrase in Fried's short response to Nochlin through which it may be interesting to draw the issues: this is a reference to her "literalist rhetoric." In the immediate context of the debate between them it is natural and sensible to take this as directed toward what Fried takes to be an unearned certainty in Nochlin about where one gender stops and another begins. Fried takes just such an uncertainty to constitute Courbet's interest for feminist art history; Nochlin's failing, in his eyes, is evidently that she cannot see gender as a matter of figuration (although she is clearly willing, in her own interpretation, to take it as matter for figuration).

But the term "literalist" is hardly new in Fried's writing, and I want to explore the thought that his use of it here is connected with his much more notorious use of it in the 1968 essay "Art and Objecthood."[17] To connect the two directly would entail saying that Fried sees Nochlin occupying a position in art history directly equivalent to the position held by minimalism in the history of art. And indeed the analogy seems reasonably strong here: both minimalist practice and Nochlin's statement of justification take it that what authorizes the work of art and any interpretation of it is above all its placement and, consequently, our placement before it. What she would share with minimalism would then be both its orientation toward meaning and the conviction of its absence (or its dependence on the viewer).

And of course this would also mean that Fried sees himself as an art historical interpreter of Courbet in something like the way he saw himself as a critical champion of Caro or Stella over and against a

certain minimalist misconstrual of modernist art. In this context it may be useful to recall one of Fried's ways of phrasing his rejection of minimalism with a view to the questions I am trying to pose about how we are currently inclined to understand the bearing of recent theory on the practice of interpretation—in particular, Fried's assertion that minimalism is a response to the same developments as the work he champions, but that those developments are read otherwise, in a way that is already turned toward what he calls "theatricality" and that he construes as, above all, a certain "literalism."

Here is one way of putting the relevant contrast: Nochlin's self-understanding as an interpreter remains wholly committed to the recovery of meaning from a past understood to be distant and in need of theoretical comprehension; her break with the dominant paradigm consists above all in the freedom she reads in contemporary theory from what more traditional historians would value as the actual meaning for the past. Fried, by contrast, appears to see in contemporary theory a way neither to recover meaning nor to produce new meanings but a way to grasp objects insofar as they are capable of exerting effects, art historical effects above all. He thus understands himself to be subjected to his object, to be struck by it. He understands himself, then, to be writing from the position of a Kantian, or at least quasi-Kantian, judge.[18]

In describing Fried's activity in this way, I am trying to stress how his formalist critical orientation plays out in an understanding of interpretation that pulls Gadamer in the direction he has been, in effect, taken by Jacques Derrida and others. This is, as I understand it, a position in which objects are grasped as effecting meaning rather than as bearers of it, and in which the actual—that is, historically realized—fusion of horizons takes priority over the contemporary sense of their separation, rendering one's claim to address the work and the work's claim to address its interpreter indivisible. Or, to put it in a way that seems distinctly opposed to this talk of fusion and which is nonetheless crucially continuous with it: it is a position in which the work's separation from itself is the ground of the detachment that is the actual form of our attachment to it or of its availablity to us.

One tempting way to understand this (and finally to misunderstand it) would be in terms of a strong distinction between descrip-

tion and interpretation. If meaning is merely an effect, then the primary object of the critic or historian would seem to lie in describing that which causes that effect rather than entering into it by engaging in the process of interpretation. This is the project generally and correctly associated with structuralism, and its appeal for formalist criticism has been clear for some time. It will, of course, be particularly appealing where one wants to argue, as Greenberg seems to have wanted to do, that the crucial thing about a work, a painting for example, is simply that it *is* and not that it means. Ultimately this position will be wary of calling its work "interpretation" at all since it will tend to see all claims to meaning, in art or criticism, as "literary." This distinction between "being" and "meaning" has repeatedly appeared as central to the modernist project, and there is good reason to see Fried as deeply oriented to it. On such account there would be no essential conflict between Fried and Nochlin because they are doing fundamentally different things—she is interpreting it and he is not.

But of course this is not true: Fried *is* interpreting Courbet and he is in some kind of competition as an interpreter and a theorist of interpretation with Nochlin.

Can we then find our way to the sense of Fried's position by saying that his activity as an interpreter follows from a fundamental failure inherent in painting? That is, the demand that supports our interest in painting is that it should *be*, but painting itself, in all its instances and by necessity, falls short of meeting this demand. Paintings never happen, never quite are. But now we have moved through the Gadamer that shares a problematic of meaning with Panofsky to the Gadamer that draws upon, and cannot for all his efforts disentangle himself fully from, the ontological problematic set in motion by Heidegger. This is a problematic in which interpretation is primordial and finally not human, in which what things are seen as is not a matter of our decision but of their being.

Imagine then three things one might say about a painting, a modern painting in particular:

1. This painting is compelling.
2. This painting strikes me as a compelling painting.
3. This painting is a compelling representation of painting.

The first of these means to capture the pure formalist impulse to say that the painting simply *is* and that this sheer being is the source of its power as well as the determinant of our essentially descriptive address to it. The third means to capture the counterveiling impulse to say that paintings are primarily bearers of meaning and, in the case of modernist work, bearers of self-referential meaning above all. As such they call for interpretation. One's approach to a work of art can continue to be structured in these terms even where one has good reason to believe that the meaning is either absent or unavailable; this would be the position of Nochlin and a number of other people working in relation to contemporary theory. The middle proposition is the tough one; it asserts something close to the first proposition but it does so only through the delay of "as a painting," a delay that opens the painting to something like interpretation without quite putting us in a position to imagine that, having produced our interpretation, we have completed our dealings with the work.[19]

Let me put this a slightly different way that will begin to move this long digression back toward the matter of judgment. The first of my propositions is a version of the Kantian judgment of taste—"That is beautiful"—but on Kant's account such judgments can be occasioned only by natural objects. We cannot fully make such assertions of products of human art. The third is a way of refusing the Kantian problematic altogether. The middle one is an attempt to articulate what remains of the Kantian judgment of natural beauty in the region of human artifacts, and it does its work by accepting as permanent feature of the judgment a certain veering toward figuration. The beautiful Kantian flower is, at least in the first instance, simply beautiful and does not need to, as it were, repeat itself in our judgment of it. But the compelling painting is in a curious way bound to its own repetition in our judgment. And yet it is so bound not because it is in any sense about itself or has itself as its meaning, but simply because its work is to be by appearing, to appear *as* itself—and therefore to appear as always caught up within a certain transformative movement of figuration that opens it inexorably to interpretation or, as we might also now say, alteration. Interpretation, as it emerges here, is answerable neither to the meaning of the work nor the absence of such meaning; it answers only to the work's appearance, its appearing. And it cannot do so except by putting meaning

into play in ways that cannot be recaptured by any normative histor-
ical assurance and yet that cannot be taken as anything other than
historical.

This would be, then, one example of what it might mean to grasp
the rupture between "art" and "history" as the properly abyssal
ground of a discipline we can, when it strikes us, call "ours." I suggest
that the path thus marked out does not so much offer us a way of set-
tling our conflicts of interpretation as it gives us a way of reading the
necessity of those conflicts insofar as we find ourselves obliged always
to write art history from a position at once within and without that
discipline because at once within and without that history and that
practice. Such a position is not something we can hold because we
just are, as historians and interpreters, its tearing away from itself.

3. The Impasse of Theoretical Perspectives

In the first section of this essay, I invoked, more or less in passing,
Nietzsche's *Birth of Tragedy* as a text concerned with structures of
recognition and misrecognition similar in certain respects with those
that concern Gadamer. In particular, given the permanent fact of sit-
uations, one is obliged to interpret certain apparent historical rup-
tures (for examples, the one Gadamer locates in Kant or the one
Nietzsche locates in Socrates and Sophocles) as not, finally, ruptures
but interpretations, the peculiar force of which lies in their ability to
conceal themselves as interpretations.

The Nietzschean case here is perhaps the most easily stated: if
the world is the play of Dionysus and Apollo, it cannot cease to be
that play. It can however come to pass that this play ceases to be vis-
ible as such, becomes something that cannot be acknowledged. And
this will be inevitable if what is at play within or between Dionysus
and Apollo just is the performance of Dionysian primal unity and
contradiction, a performance in which the violence of contradiction
forces the unity to break asunder and into division, which division, in
its turn, reasserts the unity from which it has broken away (the whole
complex movement Niezsche summarizes under the sign of "the
Dionysian chorus which ever anew discharges itself in an Apollinian
world of images"[20]).

If this is indeed Nietzsche's understanding it is clear that he can
work to show this to be—to have been—the case, and he can write

that demonstration in such a way that it bids to revise the break with tragedy as itself but a further moment of tragedy now demanding acknowledgment. But he cannot put a stop to the Socratic "mistake." It is itself inscribed within the very situation he means to show, and so also reinscribed within his own text, whose reception, both by Nietzsche himself and by his readers, testifies amply to the permanence of the misrecognitions that are the constitutive matrix of both tragedy and its collapse.

So the language of masks that appears as if in coda to the opening argument of this essay is not accidental but a continuation of the earlier invocation of *The Birth of Tragedy*. And likewise, we can perhaps now see that something of Nietzsche's logic was at work as well, hidden within or behind the talk of painting's "failure to be"—talk we can now reread in terms of the Dionysian failure to be and its obligation to merely appear, masked and Apollonian. More particularly, we can say this: Nietzsche finds himself writing in a present dependent upon a past in which art has been fundamentally mistaken in a way that should not be taken to mark its end but its continuation on invisibly shifted ground, and he writes in order to make that shift and its cost visible. We can, that is, say of Sophocles and Socrates as Nietzsche sees them, precisely what Fried says of the literalist work against which "Art and Objecthood is written: that they, or it, arise "from the same developments read otherwise."

In 1967, Fried seems to imagine he can stop that shift from taking place; it is only with the 1991 book on Courbet that the nexus between achievement in painting and its impossibility reaches adequate expression, and it is tempting to suggest that this happens in part because Fried now cannot but know himself to be writing in a present for which the loss of art, of painting, is an integral component of our continuing recognition of its achievement.

I have no desire to press this analogy between Fried and Nietzsche any further than it will sensibly reach, but I hope I have made enough of it to plausibly claim to have hunted the interlocking issues of judgment and interpretation, history and theory, home— that is, to the place where appeals to perspective and position are important only because the field in which they are deployed is irreducible to any spatial imagining: it is a field of loss and belatedness, so also of judgment and interpretive excess. It is not one well ordered

by, for example, metaphors of landscape (if you position yourself here, you can see the overlooked village of the excluded) or of architecture (you think you are seeing the whole building, but it is only the front).

If we try to collect the elements in this paper that work to suggest a different texture to our vision of art history, they might include a renewed interest in the play of haptic and optic insofar as they offer to refigure the terms of our attachment to and detachment from visual work; a certain imagination of our exposure to things as a condition of their visibility to us; and an emphasis on writing as the means by which art history accomplishes the seeing of its object. It is perhaps by means of such figures that art history will find its way to making theory its own—the divided stuff of a discipline rather than the abstract methodology of a science.

1995

CHAPTER FIVE
PSYCHOANALYSIS
AND THE PLACE
OF *JOUISSANCE*

La psychanalyse, à supposer, se trouve.
Quand on croit la trouver, c'est elle, à
supposer, qui se trouve.
Quand elle trouve, à supposer, elle se
trouve—quelque chose.

—JACQUES DERRIDA

1

Jacques Lacan's explorations in the formalization of psychoanalysis grew simultaneously more prominent and more obscure over the course of his career, especially during the last decade or so of his teaching, and at least certain of his formalizations—the mapping of "The Four Discourses" most especially—have taken on the status of central tests for and markers of Lacanianism. Among the several divisions within American interest which were exemplified in a 1985 meeting on Lacan's legacy at the University of Massachusetts, Amherst, one of the most striking was between those claiming some kind of direct inheritance from Lacan, supporting themselves with what I am tempted to call an absolute reference to the mathemes of the four discourses (and showing as well a marked interest in the datability of Lacan's utterances), and those taking what one might loosely call a more literary interest in Lacan—and some part of that "literariness" is perhaps signaled in a resolute avoidance of Lacan's mathematical and symbolic excursions. This division was not without its tensions and minor dramas, most centered on Jacques-Alain Miller, very much the official inheritor of Lacan as he extended an uneasy welcome to Lacan's American audience—a welcome that combined talk about who was and was not

"one of us" with a plea that his own remarks be taken not as "dog-matic" but simply "axiomatic."

I offer these preliminary observations in order to underline the ways in which psychoanalysis is troubled not only in its movement beyond itself into other places but in its relation to itself, to its own place. Psychoanalysis finds its object in *ein anderer Schauplatz*. It is in the name of its privileged access to this other place that psychoanaly-sis moves into other disciplines and appropriates their objects to its own. But such a movement depends first of all on the ability of this presumed science to secure itself; its own place is not directly given but must be achieved. For Lacan, the post-Freudian, primarily American history of the discipline more than adequately testified to the fragility of psychoanalytic self-relation or self-mastery, and he repeatedly described his enterprise as one of returning psychoanaly-sis to its place.

Psychoanalysis has, in the very nature of its object, an interest in and difficulty with the concept of place as well as an interest in and difficulty with the logic of place, topology. The Unconscious can thus seem to give rise to a certain prospect of mathesis or formaliza-tion; and such formalization, achieved, would offer a ground for the psychoanalytic claim to scientific knowledge relatively independent of empirical questions and approaching the condition of mathemat-ics. This might then seem to have been Lacan's wager in organizing the researches of his *école* around works of theoretical elaboration rather than clinical study; certainly some such notion must underlie Miller's claim to be "axiomatic."[1]

In this paper I want to explore some of Lacan's formalizations as they are unfolded in the seminar *Encore*. (I will also draw some mate-rial from the interview transcript *Télévision* and Lacan's appearances at Yale University in 1975.)[2] I will in effect be looking at the place of place or places in psychoanalysis—in particular, I will be looking at the place of *jouissance* in Lacan's psychoanalysis and at the places of what Lacan punningly calls *jouis-sens*. The joint problematic here might be called one of "enjoymeant," combining the logic of plea-sure with the pleasure of logic. For Lacan, questions of *jouissance*, however punned, are questions of unity and selfhood, so in examin-ing the reciprocal play of pleasure and sense I will be examining how Lacanian psychoanalysis secures itself in place. This last topic

touches implicitly in *Encore* on questions of legacy and inheritance, so in the end I will also have something to say about the limits Lacan's formalizations would impose on our enjoyment of Freud. I should note in advance that *Encore*, Lacan's seminar of 1972–73, is an extraordinarily compact and involuted text, even by his standards, and of a corresponding richness, weaving sustained meditations on such figures as Georges Bataille, Roman Jakobson, Kierkegaard, and Aquinas with "mathemystical" digressions on sexuality, discourse, Borromean knots, and the like. The reading offered here is perforce schematic.

2

One of the earliest American responses to Lacan came from an understandably frustrated Angus Fletcher:

> Freud was really a very simple man. . . . He didn't try to float on the surface of words. What you're doing is like a spider; you're making a very delicate web without any human reality in it. For example, you were speaking of joy (*joie, jouissance*). In French one of the meanings of *jouir* is the orgasm—I think that is most important here—why not say so? All the talk I have heard here has been so abstract! . . . All this metaphysics is not necessary. The diagram was very interesting, but it doesn't seem to have any connection with the reality of our actions, with eating, sexual intercourse, and so on.[3]

No response to Fletcher is reported in the transcript. In the years since there have been a number of attempts to make out the sense of *jouissance* for Lacan, and some texts relevant to the discussion have been translated, but there has been little sustained effort to show how the things Fletcher was asking about do indeed hang together.[4]

Fletcher was asking where the bedrock of psychoanalysis is. He was asking what Lacan makes of its brutest facts: orgasm, pleasure, discharge. And the answer is that for Lacan there are no such brute facts and energetics at the bottom of psychoanalysis; it is the image of a science possessed of such objects that led Freud away from his own discoveries, and it is the replacement of this image with that of linguistics—or "linguisterie" [*E*, p. 92]—that will lead us back.

If we are speaking of sex, the important thing is that we are in fact speaking of it—we may even speak just to say that it is natural but

our need to say *that* already places it elsewhere, condemns it to "cul-ture." It is a fact of human being that a difference between, for exam-ple, the "clitoral" and the "vaginal" will not rest within the anatomical or physiological but can come to bear a weight we call political.

So Lacan's fundamental proposition is that there is no immedi-ate or instinctual sexual relationship in some first instance which would then become subject to degeneration or detour or other hurt. What is human is precisely the absence of such relationship, the need for it to be constructed from or upon what is instinctual—hunger, evacuation, reproduction. When psychoanalysis speaks of "compo-nent drives" it points at the way in which sexuality emerges on the occasion and surface of that which is instinctive.[5] For such a view, Freud's insistence on the phallus, on Oedipus, on the "masculinity" of the libido, are to be read as answering not to considerations of instinct or naturalness or biological destiny but to a logic proper to the emergence and deployment of human sexuality, the sexuality of beings that speak. Sexuality is a matter of logic and inscription. Referring to a version of the table of contraries he will put up on the seminar's blackboard, Lacan says,

> On the whole one takes up this [masculine] side by choice, women being free to do so if they choose. Everyone knows that there are phallic women and that the phallic function does not prevent men from being homosexual. [*FS*, p. 143][6]

Lacan begins to expound his table "on the side where all x is a function of Φx, that is, on the side of the man":

(1) $\qquad\qquad\qquad\qquad \forall x \quad \Phi x$

A logician reads this: all x is Φ. Lacan reads: all x is a function of Φx. I translate: all x answers to the phallus. What we cannot substitute for in attempting the translation here is the "x"; if we were to do so, we might come up with something like this: everything we want to take as human being, as human meaning, as my meaning or being—all that I most deeply want to be and say—answers to the phallus. We are, that is, given over in our inmost being to a function of which we are not masters; our self is organized elsewhere; there is an inmixing

of otherness. This might then lead us to write another proposition or pseudoproposition concealed within or behind the first and on which our meaning and being would then depend, through which we would recover ourselves from this otherness:

$$(2) \qquad \exists x \qquad \overline{\Phi x}$$

The logician's reading says: there is an x that is not Φ. Our elaboration says: *that* is what I really am—beneath my surfaces and roles and socializations, beyond my sex and my childhood, away from everything that conspires to keep me from saying what I really am, *there*, in that x that does exist. Together the two propositions seem to capture something of the primordial and constitutive alienation that Lacan takes to characterize human being.

Logically the two assertions are convertible into two others without loss or change of meaning:

(2)	$\exists x$	$\overline{\Phi x}$	$\overline{\exists x} \quad \overline{\Phi x}$	(3)
(1)	$\forall x$	Φx	$\overline{\forall x} \quad \Phi x$	(4)

Proposition (3) reads: there is no x that is not Φ. Proposition (4) reads: not all x is Φ. The two together reproduce the same universe as the first pair, generating a law on the one hand (that everything is submitted to the phallus) and its more individuated contrary (something is exempt) on the other—"I is an other, but I'm still me somewhere . . ." The two systems are logically equivalent. Lacan, however, insists on scanning each proposition separately—he does not, that is, handle them logically. He would, for example, have us remark that the Law formulated in (1) is universally quantified (\forall), whereas in (3) it is given existentially (\exists) and then doubly negated. If we simply read the things aloud, we read them differently.

This table is intended to chart a universe of sexual difference, and it should come as no or small surprise that if one "chooses" to inscribe oneself as "woman," one is going to find herself caught up with propositions (3) and (4) rather than (1) and (2). Since there is no logical difference here and no room for any question of biological difference, what there is of sexual difference has to do with how one inscribes oneself or is inscribed within this system of contraries and equivalents. Lacan treats his propositions as, in effect, dialectically

charged: the "bars" over the various elements are understood less as simple logical negations than as quasi-Hegelian determinate negations. These formulas are no more subject to properly logical handling than Lacan's apparent fractions are subject to properly arithmetic manipulation. These things are not the stuff of which syllogisms are made. I will eventually say something about what they are made of, but for the moment I want to dwell somewhat longer on what they are trying to say.

This is the full table as given by Lacan.[7] Some of the notation may be familiar: $ indicates, as elsewhere in Lacan, the subject in its radical inaccessibility; the *a* is, as always, the object of desire; and Φ is the phallus. The *a* is further specified in *Encore* as the *plus-de-jouir*, which might be rendered "the more-than-enjoyment-of" but might also be rendered as "the end" or "the no-more-of-pleasure"; the two possibilities conspire toward a reassertion of the object of desire as it holds itself—is constituted—beyond any possible satisfaction as well as beyond any conceivable coincidence of pleasure and utility. The place of the Other is marked by A, and the S indicates the signifier of that place, a place which is itself barred, uninhabitable, a hole or loss that can only be signified: S(A̶). L̶a is L̶a Femme, W̶oman.

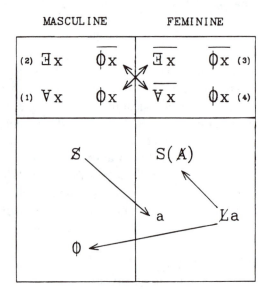

MASCULINE FEMININE

The upper and lower parts of the table can be thought of as overlying one another so that \cancel{S} answers to or covers the proposition (2) $\exists x \overline{\Phi x}$ just as Φ answers to (1) $\forall x\ \Phi x$. That is, the barred and impossible subject is the same exception to the phallic law that (4) $\overline{\forall x}\ \Phi x$ is to (3) $\overline{\exists x \Phi x}$: in each couple the opposition is between the Law on the one hand and the claim to an exceptional reserve of subjectivity on the other. The opposite side of the table shows a similar set of duplications, S(\cancel{A}) echoing (3) $\overline{\exists x \Phi x}$; and \cancel{L}a responding to (4) $\overline{\forall x}$ Φx. Following out the full network of correspondences leads to an implicit equation of Φ and S(\cancel{A}) insofar as both are formulations of the Law. (In the better known Schema R this identity is marked in the lower right corner.)

If this attempt to read by symmetries is valid, it follows that \cancel{S} and \cancel{L}a are the "same" in the way that Φ and S(\cancel{A}) are and that the various corresponding propositions are. In particular, both \cancel{S} and \cancel{L}a are sites of the claim to radical subjectivity and exception to the Law. They differ in their grammar: the masculine position, \cancel{S}, is existentially quantified—"There is . . ." or, for our purposes, "I, really, am . . ."—while the position labeled feminine is universally quantified—"all . . ." Further, the first proposition is positive and direct: "I am (not this)," while the second is negative: "Not all are . . ." We could say then that the masculine position is one that thinks—poses—itself punctually and directly: "I am" (for example) "not a slave"; whereas the reserve of feminine subjectivity asserts itself only mediately, through a unity which it is not: "Not all women are slaves (and I am not all)." It is this "not-all," *pas-tout*, that Lacan takes to define woman.

The \cancel{L}a of \cancel{L}a Femme is then barred precisely because that which would be La Femme (unbarred) defines itself from the outset as *pas-tout*, not-all. As if to say: women cannot be thought except by thinking Woman; but to think Woman ("as such") is to fail to think women, who are, precisely, not-Woman. The *pas-tout* can be appropriated as an essentialist notion—Luce Irigaray seems to do this— but Lacan's point seems both intended and most powerful as a grammatical remark, a means of diagnosing the ambiguities and contradictions that may arise within any discussion of gender.[8]

The logic of feminine inscription described by Lacan demands reference to an other, not as the object of desire, *a*, but as radically

other, A, and even S(\cancel{A}), the Other for which there is no other, a hole or whole that can only be signified:

> Nothing can be said of the woman. The woman relates to S(\cancel{A}), which means that she is already doubled, and is not all, since on the other hand she can also relate to Φ. [FS, p. 152]9

In a sense there is then nothing special about woman, which is why nothing can be said of her—we are all *né(e)s pas tout(e)s, hommelettes* all. But it is also the case that \cancel{L}a Femme, the subject to which a woman would lay claim, is submitted peculiarly to the Phallus and the Law, doubly and in division: the claim can never be punctual, is always already detoured.

In addressing here the way in which beings that speak, human beings, construct themselves as sexual in the absence of any immediate determination, in addressing the way in which such beings are engendered, Lacan is implicitly talking about how we come to our pleasure and, more particularly, about how a woman comes to hers. He is talking about *la jouissance de la femme, la jouissance de \cancel{L}a Femme*.

> There is a jouissance proper to her, to this "her" which does not exist and which signifies nothing. There is a *jouissance* proper to her and of which she herself may know nothing, except that she experiences it—that much she does know. She knows it of course when it happens.

Lacan goes on to disparage those

> petty considerations about clitoral orgasm or the *jouissance* designated as best one can, the other one precisely, which I am trying to get you to along the path of logic, since, to date, there is no other. [FS, pp. 145–46]10

An Other Orgasm belongs, then, to the grammar of feminine pleasure—the grammar through which a sexuality that, as such, does not exist (that is, is not given in nature) is nonetheless deployed. If the physiologists and sexologists cannot find this Other Orgasm, there is no reason why they should; and if they do find it, they cannot know what they have found. No such discovery will make it central, other than other.

The masculine side of things is, on Lacan's account, no less divided in its pleasures—but the division is differently registered, as a certain Don Juanism, the pursuit, more or less, of another orgasm. The diagram we have been working from thus divides $\text{\L}a$ between Φ and $S(\text{\AA})$ while the line of sexual difference divides $\text{\$}$ from its object in a.[11] Shoshana Felman and Marie Balmary have in different ways recently explored the effects of this Don Juanism on the structure of psychoanalytic knowledge.[12]

For Lacan the question of orgasm is not answerable apart from the abstraction of his diagrams. What Fletcher called "the reality of our actions" Lacan knows only as the Real of our actions—and the Real is a register of psychoanalytic sense and not a brute fact on which one could take one's stand.[13] Faced with the desire that psychoanalysis should have some orgasmic bedrock, Lacan runs full tilt the other way:

> What was tried at the end of the last century, at the time of Freud, by all kinds of worthy people in the circle of Charcot and the rest, was an attempt to reduce the mystical to questions of fucking. If you look carefully, this is not what it is all about. Might not this *jouissance* which one experiences and knows nothing of, be that which puts us on the path of ex-istence? And why not interpret one face of the Other, the God face, as supported by feminine *jouissance*?
>
> In other words, it is not by chance that Kierkegaard discovered existence in a little tale of seduction. . . . This desire for a good at one remove, a good not caused by a *petit a*, perhaps it was through the intermediary of Régine that he came to it. [*FS*, pp. 147–48][14]

3

If we have reached a point from which we can say that the feminine orgasm is somehow grounded through Kierkegaard in God, we are perhaps well enough prepared for the more orthodox Freudian insight that everything we take to be meaning reaches downward into sex. We are interested in this notion because we want to understand the status of the propositions to which Lacan has recourse in his account of feminine sexuality. If we have been examining orgasm, *jouissance*, the logic of pleasure, we want now to look at diagrams, mathemes, the spider in his web of words—*jouis-sens*, the pleasure of logic.

When Lacan offers his seminar the table of sexual difference, he warns that "after what I have just put up on the board for you, you might think that you know it all" (*FS*, p. 149). The burden of the warning seems to be that if we want psychoanalysis to know something for us, to give us something we can copy down and carry away, then what it will know is sex, and, knowing that, we will think we know it all. But sex is not where you think it is, and in the end you know nothing, psychoanalysis least of all. This is to say that we desire before we know, that we desire to know, and that our knowings are inscribed already within the psychoanalytic field in such a way that we know nothing until we have submitted our desire to know to analysis. So opens the structural trap proper to psychoanalysis: its claim to science and knowledge must be passed through its own critique of the desire of science.

We can put this either as a question of theory and epistemology or as a problem about the formation of the analyst. I am going to follow it here primarily as a theoretical matter with only an occasional glance at the question of training. I take it that the central issue for teaching and training must be whether the analyst is to be formed through the reception of a knowledge or through the acknowledgment of a desire. If we opt for the latter, we are left asking how that acknowledgment is to be accomplished except on the basis of a privileged knowledge derived from psychoanalysis.[15]

Both ways of setting the problem ultimately lead to the same task: psychoanalysis is called upon to provide itself with a theory of discourse as it is variously subtended by knowledge and desire. This is one of the projects of *Encore*, and Lacan has another chart to lay out his theory of discursive modes.[16] It looks like this:

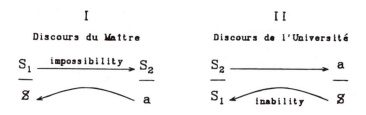

$$
\begin{array}{cc}
\text{I} & \text{II} \\
\text{Discours du Maître} & \text{Discours de l'Université}
\end{array}
$$

$$
\frac{S_1}{\not{S}} \xrightarrow{\text{impossibility}} \frac{S_2}{a} \qquad \frac{S_2}{S_1} \xrightarrow{} \frac{a}{\not{S}}
$$

III
Discours de l'Hystérique

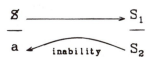

IV
Discours de l'Analyste

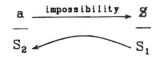

Positions:

agent	other
truth	production

Terms:

S_1: the master signifier

S_2: knowledge

\mathcal{S}: the subject

a: *le plus-de-jouir*

Although the S/s notation may look familiar enough at first glance, a second glance will show that it is being used in neither linguistic nor arithmetic senses, however attenuated. The distinction of places and terms suggests that we are being given a species of grammatical template. I suggest that the abstract form reads something like this:

The (impossibility of the) relation of speaker to receiver is supported by the (failure of the) production of truth.

The parentheses stake out two possible positions of negation: either the relation between speaker and receiver is impossible, or its possibility is supported by a certain failure in the production of truth. On this basis we might attempt some translations:

I. The impossibility of the master's communicating knowledge to the other is supported by the other's production of him or her self as inaccessible truth.

II. The possibility of communicating knowledge to the other is supported by the inability of the subject to produce his or her master-signifier as truth.

III. The subject's location of master-signification in the place of the other depends on the inability of knowledge to locate pleasure in the place of truth.

IV. The impossibility of the analyst's attaining to the radical truth

of the subject is supported by the master-signifier's production of knowledge in the place of truth.

I will not dwell on either the relative opacity of these translations or the equivocations grace of which they have been constructed (although we will see in the end that such equivocation, such need for voicing, is essential to Lacan's project). I want instead to look particularly closely at the last of them, since it is the discourse of the analyst to which Lacan devoted most of his energy and which thus offers the best case for testing and elaborating these translations.

We know, for example, that the discourse of the analyst is for Lacan the discourse of "the one-who-is-supposed-to-know" (*l'un supposé savoir*)—that is, of the one who is taken to have true knowledge, knowledge in the place of truth. Using the terms and places of the table, the analyst appears as $\dfrac{a}{S_2} \rightarrow$. And this analyst has as a goal producing in the patient a recognition of the relation between what insists opaquely and powerfully in his or her discourse and the knowledge it conceals or denies: $\rightarrow \dfrac{\$}{S_1}$. It should be clear that we are now in the process of creating something that is in many respects a rewrite of (IV), but which could also be reduced to a simpler form:

$$\frac{a}{S_2} \rightarrow \frac{\$}{S_1}$$

This is the form in which it appears later in *Encore*.

As we play in and on such notations, they shift and throw different aspects of Lacanian theory and practice into the light. The difference between, for example, (IV) and its layered reconstruction ought to show something of what it means for—in the Lacanian catchphrase—the sender to receive his message from the receiver in inverted form. So the play here between $\$$, S_1, and S_2 also ought to show us something of the radically and necessarily intersubjective dimensions of what we are perhaps more accustomed to seeing as a stack of signifiers displaying the metaphorical structure of repression, that is, $\dfrac{S'}{\dfrac{S}{x}}$.[17]

Just as we can reduce (IV) to a simpler form, we can also expand it into greater complexity:

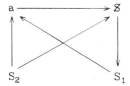

If this expansion is right (and it may not be: it is my derivation from some parallel algorithms in *Télévision* which I will consider shortly)—if this expansion is right, then we can recognize in the curved lines in Lacan's table of discursive modes (the supports for his bridge of discourse) a shorthand for a more complex interaction in which otherness is so inmixed that it only, as it were, averages into an interaction of two people facing one another.

I do not want to work through the other figures in the table in any detail here, but we do need to pause at least briefly over the discourse of the master. As I understand Lacan's table, the master is defined as the one who is capable of fully taking up into signification the radical truth of subjectivity. He is in this way an inversion of the hysteric in (III). If the patient is the one who is spoken by the Unconscious, the master is the one we place in the position of speaking the Unconscious—Lacan can be *heard* as *le maître*. The master is one who is heard, and is heard by the one who places knowledge in the place of the other and so makes of that other the producer of truth. The discourse of the master—as Lacan both argues and illustrates—represents a special risk for the teaching and practice of psychoanalysis. Insofar as the analyst represents himself—or allows himself to be represented—as the holder of the key to the subjectivity of the analysand (who then knows himself only from and as that other), the analyst ends as the master, shaping the patient's self in inevitable conformity with his own.

There is a complicity between the discourse of the university and that of the master. The glyph S_2/S_1 in the university figure offers the possibility of a transparent scientific knowledge that, in its turn, positions the bearer of that knowledge as the master ($S_1/\$$). Lacan wanted in the long run to close off this dream of transparency, radi-

cally distinguishing the discourse of psychoanalysis from that of the university, in part to widen the gap between the analyst and the master. To mistake psychoanalysis for that kind of science is to mistake the analyst for that kind of knowing subject. It is in the face of this dream of science that Lacan will insist, frustratingly and problematically, that science is for him just "what is done with little letters"— nothing more or less. Lacan's fascination with the theory of the mathemes (if "theory" is the proper word) emerges here.

The table of discursive modes is complete only on the assumption that the terms are not freely substitutable through the places. That is, it is constructed by rotating a chain, a closed loop, through the system of places. This chain is $S_1 - S_2 - a - \$ - S_1 \ldots$ This means that each of these discourses tends to turn into the other, or that all discourse tends to turn through the system without any subject being the master of it (including, of course and above all, he who would speak as master).[18] The entire system could be described as a charting of the vicissitudes of any attempt to find one's proper and fully meaningful name—one's final signifier, one's meaning, the end of one's desire, one's deepest self: a self that invariably turns back into one's signifier, at once escaping and imprisoning itself.

These structures are radically complex. They work at the level of intersubjectivity and are concerned with the manner in which the logic of intersubjectivity "speaks" those caught up in it. "I" cannot choose to be the master; perhaps more important, I cannot choose not to speak—not to be heard in any case—as the master. The circuit of these structures is a description of the Symbolic order and, like the meditation on Markov chains appended to the "Seminar on 'The Purloined Letter,'" it can can be read as intended to account for the way in which a destiny inevitably captures us, putting us always in our place.

We are left then with the matter of the little letters, the mathemes that have become the passwords of contemporary Lacanian orthodoxy. Much of the discussion after Lacan's 1975 lecture at Yale seems to have turned on Lacan's view of the nature of the psychoanalytic claim to scientific status, and the discussion seems to have been as frustrating to that audience or parts of it as his remarks at Johns Hopkins ten years earlier had been to some there. The definition on which he insisted is: "Science is that which holds itself in its relation

to the real by virtue of the use of little letters."[19] He clung to this throughout the ensuing discussion, ending with the following exchange:

> DUPRÉ: But that's the problem. What is the exact status of the symbolism of the mathemes? Is it a universal symbolism or a . . .
> LACAN: It is a symbolism elaborated, always elaborated, by means of letters.
> HARTMAN: But *quid* of words? Even if analytic science contains mathemes, there is the question of practice and of the translation of such mathemes in analytic practice, which is verbal, isn't it?
> LACAN: There is nevertheless a world between the word and the letter.
> HARTMAN: But it is their link that you want to show . . .
> LACAN: Yes, and that amuses me. ["KS," pp. 30–31]

At issue here is the science Lacan would oppose to the mistaken Freudian dream of thermodynamics and with which he would return psychoanalysis to its place. There are, I think, two points to be remarked right away. The first is that Lacan's science is, here, a matter of pleasure, of *ce qui m'amuse* and, I would suggest, even of *jouissance*. What has to be said of the mathemes is not separable from what Lacan says elsewhere of the signifying chains that constitute the Unconscious:

> These chains are not of *sens* but of *jouis-sens*, to write as you please in conformity with the equivocation that composes the law of the signifier.20

Our problem is to engage this equivocation at the level at which the signifier, the little letter, pretends—both claims and feigns—to formalize psychoanalytic theory.

The second point is implicit in what may well appear as the childishness with which Lacan approaches the whole business. There is something in the way he talks about the mathemes and his little letters that has all the naiveté of a child's imitation of the incomprehensible activity of the adults around him. Lacan knows this well enough.

> I tried to write a certain formula, that I expressed as well as I could, with a big S which represents the subject and which has to be barred ($), then a little sign (◊) and finally an (*a*). The whole put in parentheses.

It is an attempt to imitate science. Because I think that science can begin only in that way. ["KS," p. 26][21]

If we look back at how we have handled the various little letters Lacan has sent us, it should be clear that they bear little relation to any normal project of scientific mathesis. Lacan rips off bits of this and that, giving us "notations" that have a certain validity within a highly restricted region. The manipulations to which they are submitted appear radically unprincipled, and their relevant features vary from the highly formal to the crudely pictorial. There is no ground for suspecting the existence of a systematic Lacanian algebra of some kind behind the various mathemes and charts. He is not dreaming that dream. He is dreaming a more dreamerly dream, in *ein anderer Schauplatz*, in which it is important precisely that these letters are ripped off, displaced, borrowed, imitative.

Lacan means his little letters to function as letters in the strictest of senses, as material supports for meanings or as pure signifiers.[22] In *Encore* he says—or writes—

> La formalisation mathématique est notre but, notre idéal. Pourquoi?—parce que seule elle est mathème, c'est-à-dire capable de transmettre intégralement. La formalisation mathématique, c'est de l'écrit, mais qui ne subsiste que si j'emploie à le présenter la langue dont j'use. C'est là qu'est l'objection—nullè formalisation de la langue n'est transmissible sans l'usage de la langue elle-même. C'est par mon dire que cette formalisation, idéal métalanguage, je la fais ex-sister. [*E*, p. 108]

> Mathematical formalization is our goal, our ideal. Why?—because only it is mathemic, that is, capable of transmitting integrally. Mathematical formalization is writing, but writing that subsists only if I use and use up my language in presenting it. That is where the objection arises—no formalization of language is transmissible without the use of language itself. It is through my speech that I make this formalization, this ideal metalanguage, come into existence. [My translation]

We have remarked that there is no logical difference between Lacan's masculine and feminine fields of inscription; such of sexual difference as there is insists in our reading of the logical negations that circumscribe the table of contraries within which we live. *Encore* defines the Unconscious as, above all, *ce qui lit*, that which reads, and we are now saying—and Lacan is saying, in 1972–73, at a certain point in his career, in a context in which transmission has

come to matter, in which he means to post these letters—that the little letters are, precisely, letters that must be read. The claim seems then to be that such letters, being read, cannot but reach their destinations. These little letters are "pure signifiers" capable of meaning or transmitting everything precisely because in their purity they mean nothing—apart from Lacan's voice. The flip side of this, willingly avowed by Lacan at Yale, is that "we have no way of knowing if the Unconscious exists outside of psychoanalysis" ("KS," p. 25) (and I take it the ambiguities of this formulation are to be embraced).

Formalization matters to Lacan not because it offers a way for psychoanalysis to attain the condition of mathematics (or to attain the condition of a certain ideal of mathematics) but precisely because psychoanalysis is unable to do so: it inevitably falls back into, is dependent upon, mere language and voice, tangled in the circuits of desire and the particularities of the psychoanalytic object. The mathemes are a means of making visible the "pure signifier" as that which organizes a "science" the objectivity of which is disciplinary and hermeneutic, operating in a region apart from, untouched by, and proofed against traditional discussions of the scientific standing of psychoanalysis.

We thus enter a universe in which logic does not act as a guarantee of truth; instead truth acts to guarantee the comprehensibility of logic (a Heideggerian kind of universe, then), harnessing the letter into a dialectic whose very openness is its best guarantee of closure. "La lettre, ça se lit," Lacan writes—but this writing is already read, needs no reading from us, and is enclosed in pure self-affection. Lacan's Unconscious, even in its other place, reads itself with all the transparency of the *Phenomenology*'s Spirit, whose speculative logic *Encore* at once replicates and inverts.

With this the prospect of metalanguage collapses, leaving in its stead a problem of imitation and a vision of psychoanalysis as only infinitely prospective and subjunctive science—*un discours qui ne serait pas du semblant*, as the title of an unpublished seminar has it. This may tempt us to a mathemic "neographism" of our own—*le discours analytique*—and this in its turn may lead us to recognize that Lacan's science is adequately described as *pas-tout*, its truth elusively and familiarly figured as woman, everywhere and nowhere, not-all. It

is in the literal coincidence of *jouissance* and *jouis-sens* that psycho-analysis contains itself:

> Le but, c'est que la jouissance s'avoue, et justement en ceci qu'elle peut être inavouable. . . . la jouissance ne s'interpelle, ne s'évoque, ne se traque, ne s'élabore qu'à partir d'un semblant. [*E*, p. 85]

> The goal is that the *jouissance* avow itself and precisely in this—that it may be unavowable. . . . *Jouissance* is not called forth or evoked or hunted down or elaborated and celebrated except through a semblance. [My translation]

Early in *Encore* Lacan writes that

> ce qu'on appelle la jouissance sexuelle est marqué, dominé, par l'impossibilité d'établir comme tel, nulle part dans l'énonçable, ce seul Un qui nous intéresse, l'Un de la relation *rapport sexuel*. [*E*, p. 13]

> What we call *la jouissance sexuelle* is marked, dominated, by the impossibility of establishing as such, anywhere in the enunciable, that Unity which uniquely interests us, the Unity of the sexual relationship. [My translation]

We can—and must—read this now as a statement about what we are entitled to call *le jouis-sens scientifique* as well; and when Lacan goes on to write that the "signifier is the cause of *jouissance* . . . the signifier is what puts an end to *jouissance*," we should see that these assertions are reversible (*E*, p. 27; my translation). *Jouissance/jouis-sens* names the limits of psychoanalysis and marks out that impasse of formalization in which psychoanalysis claims to find itself and its proper theoretical world.

> C'est là que le réel se distingue. Le réel ne saurait s'inscrire que d'une impasse de la formalisation. . . . Cette formalisation mathématique de la signifiance se fait au contraire du sens, j'allais presque dire à *contre-sens*. [*E*, p. 85]

> It is thus that the real is distinguished. The real cannot be inscribed except as an impasse of formalization. . . . This mathematical formalization of signification is accomplished against the grain of sense—I very nearly said *à contre-sens*—the wrong way, by misinterpretation, absurdly. [My translation]

Lacan elsewhere characterizes the Real as an impasse of the pleasure principle. Most commonly, however, he speaks of the Real in

terms of its "fullness" and defines it as "that which always comes back to the same place."[23] What we have to see here is that this apparent invocation of place amounts in fact to the eradication of the notion of place itself ("There is no topology that does not have to be supported by some artifice"[24]). Psychoanalysis, *pas-tout*, finds itself in place everywhere, *partout*, and so claims to master itself without bound or limit—not so much out of as beyond all place.

5

I have said that this problematic of enjoymeat becomes explicit at a certain moment in Lacan's career and in relation to a certain interest.[25] One might note also that it emerges under a title—*Encore*—that seems to remark a certain perturbation within Lacan's project of return, as if it were no longer clear whether psychoanalysis en core and psychoanalysis encore, the thing and the return to it, converge or diverge. I suggest that what is happening is that Lacan is discovering himself to be read, exposed beyond the reach of his voice, his signifiers not waiting upon his *dire*. This is perhaps most explicit in his concern with Philippe Lacoue-Labarthe and Jean-Luc Nancy's *Le Titre de la lettre* (a text whose mere existence seems to threaten Lacan's carefully nurtured distinction between those who are and those who are not of his audience), barely veiled in his worries about the reading and readability of the Unconscious, and implicit in all the phrasings and worries that work to present *Encore* as marking a certain ending.[26] In *Encore* Lacan is receiving not himself but his reception—his reception by Derrida most particularly. This reception mimes the circularity of the letter, exemplifying and contesting the impossible truth of Lacanian notions of communication (we need neither simply Lacan nor simply Derrida to understand this; we need their argument).

It is tempting to say that Lacan's reception cannot exist outside his movement of return, that he has himself no real property to pass on, having had but the usufruct, the enjoyment, the *jouissance* of Freud and of psychoanalysis. Here I am again reading *Encore*, in a certain sense and from a certain distance—the distance perhaps of reverie, perhaps of a certain floating attention. I am reading above all its opening pages, which tangle together considerations of the end of

teaching, the end of analysis, and the law school setting in which
Lacan speaks. I suppose I am taking this seminar as a will.[27] These
opening pages offer the seminar's first use of the word *jouissance*: it is
a legal use, and with it questions of inheritance, reception, and return
are routed and rerouted by sexual difference. We might note, for
example, that it is above all men who bequeath. (That is why we have
the word "posthumous," born after the death of the father—it points
to a difficulty in the structure of inheritance; although it may bear
remarking the derivation from *post*—"after" and *humare*—"to bury"
is a folk construct, the original form in fact being *posthumus*, the
superlative of "post-".)

Kant points out in *The Metaphysical Elements of Justice* that "the
rank of nobility is inherited by male descendants and is also acquired
by their wives who are not nobly born. However, a woman born to
the nobility does not convey her rank to a husband not nobly born;
instead she herself returns to the class of common citizens (the peo-
ple)."[28] This is one more version of *la jouissance de la femme* and a les-
son in the enjoyment of women. *Encore*'s elaboration of *jouissance, la
jouissance de la femme*, and the *jouis-sens* of psychoanalysis now seems
a way of returning Lacan's psychoanalytic property to him, an elision
of legacy in which woman may figure as aim but self is finally the
goal—nothing is given away.[29]

The post-Kantian is, we might say, alien to Kant. He does not
participate in it. It is left to his survivors. Hegel, later, numbering
himself among his own survivors, receives his own legacy and makes
an issue of the belatedness of his work ("Philosophy in any case
always comes on the scene too late. . . . The owl of Minerva spreads
its wings only with the falling of the dusk"[30]). He survives himself and
makes that mean that he survives philosophy as well: we might call
certain of his works posthumous. Thinking about Kant and Hegel we
may be tempted to say that Kant, holding himself to the philoso-
pher's business of argument, meant to move always toward philoso-
phy. If he made any discovery about himself, it would have been that
in his preliminaries he was in fact already there. Hegel, in contrast,
wrote, and discovered himself in rereading, finding that in attempt-
ing to be there, in philosophy, he was already past it. Pre- and post-:
philosophy somehow slips between, done by no one at no time, its
place increasingly its problem.

Usufruct is all but inconceivable for Hegel as he constructs his *Philosophy of Right* on the far side of the Napoleonic divide. He can see in it only an "insanity of the personality" because, he writes, " 'mine' as applied to a single object would have to mean the direct presence in it of both my single exclusive will and also the single exclusive will of someone else."[31] The thought of usufruct seems to demand something like an unconscious, and family, property, and selfhood knot together in Hegel's text against such thoughts, pledging us to lucidity. It is in Hegel's wake, as Hegel's readers, that we are driven to think again about the enjoyment of science, the complexity of our disciplines and objectivities.

Modern philosophers, post-Hegelian philosophers, caught in this cleft, are obliged to their own reception. We—or they (reception confounds these terms)—divide their careers: the early Nietzsche and the late, Heidegger I and Heidegger II, the Wittgenstein of the *Tractatus* and the other Wittgenstein, the one who, like Heidegger II, may be no longer a philosopher if not yet a poet. Post-Heideggerian seems just to mean Heideggerian—but not the way post-Aristotelian means Aristotelian; the first has time inside it in a way the second does not (Heidegger, like Wittgenstein, like Nietzsche, participates in his own legacy, breaking with himself, mourning that self, that work).[32]

We might think to escape the closure of the system's interlocking circular syllogisms by writing our science on a Moebius strip. Writing so, we would think to name our post-Hegelian modernity, our slippage from ourselves; Lacan has without doubt been one of the great theorists of this complexity. The science he would capture in the space of *jouissance/jouis-sens* means to be adequate to this modernity.

It is perhaps a mark of Lacan's difference from philosophy (and of his ambition to it—his mode, then, of assuming its legacy) that he divides himself not as father and son, legator and legatee, but otherwise, as masculine and feminine, catching himself between legacy and return, and so recovering himself from his reception. This is a strange movement, folding filiation back into alliance and working to render Lacan essentially irreceivable.[33] The inevitable failure of this movement is at once obvious and elusive, inherent in the simple act of reading. This is perhaps why Lacan in his seminar seems so puzzled by the mixture of accuracy and critique in *Le Titre de la lettre*.

If this reverie, in its general cast and rhythm, seems loosely deconstructive, what should then be of interest is that the Derridian exists above all as a reading, a remarking, of the Lacanian—exists only as an exposure of its irrecuperable *readability*, its permanent openness to our placement and displacement. Our enjoyment of Lacan's letters always exceeds and wastes them, and in so doing re-marks them with the temporality they claimed to master, showing the Lacanian always unfolded into the post-Lacanian, the psychoan-alytic always caught outside itself, in another place, unable to guar-antee its self-enclosure, unable ever fully to fold its family back into itself. If there is a moral to this, it is, I suppose, first of all that Lacan's mathemes offer no support for an idea of psychoanalysis as an axiom-atizable science and that to take them as such is only to mystify the more difficult and deeply problematic claims Lacan is making— claims whose radical inwardness render the apparently simpler ques-tion of empirical evidence and support profoundly obscure. More generally, the moral is that we have psychoanalysis in its place, haunting the margins of our knowledge, only for so long as we con-test, displace, and replace it—finding it not everywhere but always somewhere.

1986

CHAPTER SIX
DIVISION OF THE GAZE, OR, REMARKS ON THE COLOR AND TENOR OF CONTEMPORARY "THEORY"

A new or renewed focus on questions of vision seems to be a significant feature of the development over the past ten years or so of the field variously called "theory" or "cultural studies." The immediate causes of this focus appear to be multiple, but it seems hard not to instance at least the ongoing tendency of theory to understand itself as a critique of representation, the increasing interest among literary scholars in film study, and a growing awareness within the discipline of art history of developments in adjacent fields. Typically, this interest in the visual has taken the form of a "critique of vision"—a systematic suspicion of the apparent transparency and naturalness of vision. Among the various works that inform this critique one might note such influential works as Laura Mulvey's "Visual Pleasure and Narrative Cinema," Michel Foucault's *Discipline and Punish*, and the various books and essays in which Norman Bryson attempts to dismantle "the natural attitude" in art history.[1]

There are a lot of questions one can put to this development—questions about the sense of the field in which it appears to emerge, the particular cast of the critical project, or the adequacy of the term "critique of vision" to cover the various activities apparently conducted in its name. For the most part this chapter is given over to an exploration of two French discussions of "the gaze" that have exerted a considerable shaping influence on the current discussions, so it may be useful to say at the outset that the tour is conducted with a

view toward opening or reopening some of these larger questions.[2] One consequence of this is that the essay will turn, in a manner that may strike some readers as abrupt, from questions about vision and theories of vision to questions of theory *tout court*. The essay's title thus means to signal in advance a relation between its own divided interests and the division of the gaze from which it sets out—as if no theory of vision were adequately elaborated unless taken to the point at which it renders explicit its vision of theory.[3]

Certainly one of the strongest statements of the current critique of vision is to be found in the very first sentence of Fredric Jameson's *Signatures of the Visible*. This sentence reads: "The visual is essentially pornographic, which is to say that it has its end in rapt, mindless fascination; thinking about its attributes becomes an adjunct to that, if it is unwilling to betray its object. . . . Pornographic films are thus only the potentiation of films in general, which ask us to stare at the world as though it were a naked body." Against this hold of vision, Jameson advances a proposition both clear and familiar: only good, solid, essentially political history can rescue us from this fascination and its mindlessness (only this will cure us of the curse of the Westin Bonaventure).[4]

It is important to recognize this view as essentially Sartrean. Here, for example, is one of the central examples from Jean-Paul Sartre's discussion of "the Look" in *Being and Nothingness*:

> Let us imagine that moved by jealousy, curiosity, or vice I have just glued my ear to the door and looked through a keyhole. I am alone and on the level of a non-thetic self-consciousness. This means first of all that there is no self to inhabit my consciousness, nothing therefore to which I can refer my acts in order to qualify them. They are in no way known; I am my acts and hence they carry in themselves their whole justification. I am a pure consciousness of things, and things, caught up in the circuit of my selfness, offer to me their potentialities as the proof of . . . my own possibilities.

That's the first moment of the narrative: rapt, fascinating, mindless, and as purely free as anything in Sartre.

> But all of a sudden I hear footsteps in the hall. Someone is looking at me! What does this mean? It means that I am suddenly affected in my being and that essential modifications appear in my structure.[5]

The name Sartre gives these "essential modifications" is "shame," and shame, he says, "is shame of self; it is the recognition of the fact that I am indeed that object which the Other is looking at and judging. I can be ashamed only as my freedom escapes me in order to become a given object." Still later, Sartre says, "in order for me to be what I am, it suffices merely that the Other look at me," or again, "My original fall is the existence of the Other. Shame—like pride—is the apprehension of myself as a nature although that very nature escapes me and is unknowable as such. Strictly speaking, it is not that I perceive myself losing my freedom in order to become a thing, but my nature is—over there, outside my lived freedom—as a given attribute of this being which I am for the Other."[6]

He who looks is free; and he (or she, because Sartre's narrative implicitly places a woman beyond the keyhole even as it is a woman who provides the first example of the objectifying force of the look[7]) who is looked upon falls into nature, mere being, shame and mortification (to be what you are is, for Sartre, finally to be dead).

I have quoted Sartre at some length partly because I will later turn to another narrative that is constructed in clear awareness of and opposition to Sartre's and partly because there is a lot going on in these passages. Beyond what is obviously being said about the objectifying force of the Look, there is a certain amount of important Sartrean machinery on display: for example, the marked contrast between my inside, where I am free and of a piece with my acts, and my outside, where I am seen and my freedom stolen; and then there is the oddness of the whole scenario—three persons lined up, each enclosing another in its cone of vision in such a way that only one ever figures as a person—first Sartre in his freedom and then the Other in his. Between object and person, between "I" and "him" there is no second person, or, perhaps more accurately, every approach to "you" reduces, like a complex fraction, into a simpler product of "I" and "him" or "he" and "me." There is an implicit theology here (and that no doubt is why the "original fall" enters into the account): the Other, with a large "O," is he who sees without being seen and his is the only real first person, before which all others are merely others with a small "o." And, of course, one does not want to miss the work of the images themselves: if we see these people enclosed with one another's cones of vision it is at least in part

because vision has been given to us as an opening out from a point-source—my keyhole, his eyes—and the door through which Sartre peers locates him as forcefully outside his object's lived freedom as his own body locates the Other outside his.

This story is a deeply familiar one in contemporary theory. We know it from a now strongly established line of feminist criticism that has gained its fullest theoretical articulation in film study and, more recently, in art history: the male gaze is that through which the feminine is made object and stripped of its freedom. And we know it through Michel Foucault's work on the panopticon and its various architectural and scientifico-technical offspring: my submission is secured through the imposition of visibility on me. And we can probably continue to recognize it, despite the shift in register, in Louis Althusser's notion of interpellation: my naming calls me into visibility and so, in his double sense, subjects me, rendering me a subject. "Recognition" is appropriation: when you call me worker, then I am a worker; when you call me nigger, then I am black.[8]

But here we are beginning to tip into a different narrative about vision, one in which visibility is no longer a brute condition but a consequence of something else, of our possession of or by language. This difference between interpellation and the imposition of vision will, however, not cut terribly deep until and unless the basic interpersonal logic of the initial scenario is changed in some deeper way. Any critique of vision predicated on the Sartrean scenario will never be more than a critique of recognition in general. It seems to me that there are strong and wide currents in contemporary theory that follow this course. Their general and distinctly non-trivial work is the undoing of stereotypes—that is, blocking or at least placing in question a broad range of contemporary recognitions, typically by asking who is being recognized and who is granting or imposing that recognition. If this line is, at least in terms of its French lineage, Sartrean, it is plausible to suggest that its academic fortunes in America are linked as well to the afterlife of what used to be called the New Left, particularly to the Marcusean critique of repressive tolerance with its argument that recognition can constitute a form of subjection. There are also some serious troubles that come with pursuing this line—most notably the political difficulties that accompany any radical orientation to identity and the epistemological difficulties that follow

from any effort to absolutely separate (real) identity and (imposed) recognition.[9]

Sartre's name is not often invoked in contemporary theoretical discussions of vision. The name one most often hears is that of the psychoanalyst Jacques Lacan. But Lacan's stories about vision are very different from the one we've just reviewed and, in fact, open a very different theoretical prospect. Of the two stories I mean to treat, one is quite well known (which will not keep me from reviewing it here). The other, although some attention has been paid to it, has not typically been taken up in the context of vision. The first of these—a story about the young Jacques Lacan trying to become a man of the people—is told in a context that makes it, in part, a counternarrative to Sartre's.[10] The second is interestingly seen in such a context but is presented primarily as a puzzle about time and logic as they appear in psychoanalysis; if one wants to give it a larger philosophical context, the best candidate probably would be something like Hegel's way of trying to tie time and logic together—which might have the virtue of reminding us that in Hegel the early incomplete dialectic of failed recognition, the dialectic of master and slave, is completed later, in more complex circumstances, in a moment of mutual recognition.

To the first story.[11] Young Jacques is afloat with a group of Breton fishermen. They are making their more or less difficult living, and he, presumably, is "identifying" with them. He may even be working, but it's not his living—it's his summer. One of them points to a sardine can glinting on the waves and says, "You see that? Well, it doesn't see you!" Presumably the other fishermen have a good laugh, and Lacan has to decide—the joke demands of him something like a decision, but it also seems that if he actually has to make a "decision," he will, so to speak, miss the boat—how to participate in that laughter (or how to withdraw from it). As in Sartre's story, a certain upsurge of vision brings a certain distance or alienation in its wake. But if Lacan has been deprived of anything, it is not his freedom—just a fiction of solidarity that can be reaffirmed if he finds the right way to join in the laughter it calls forth. It is perhaps hard to describe what would be "the right laughter" here. Not laughing surely renders the fiction untenable, but too quick or too easy laughter would ring hollow, undermining the very community it means to affirm or reconstruct. What's wanted is perhaps a laugh-

ter that admits what has been undone while affirming a shared general awareness of the undoing or undone-ness of any presumed community; it would also be a laughter that in some sense affirms both the right of the fisherman to identify Lacan and the justice of that identification—even as it also moves to contest or transform or undo it.

But the moral that most directly interests Lacan is the visual one. Lacan, the fisherman, and the sardine can form a trio counterposed to Sartre's. The looks and recognitions that flash among them are triangular, and if there is any one agent whose vision embraces the others, that agent is not remotely human. And even here we risk going too far: if there is anything like agency to be associated with the flashing sardine can, it is not its own but the sun's (the story has then Bataillean roots of some sort). It is, in general, a story about being seen, about visibility apart from human seeing of the Sartrean kind.

The second story is about three prisoners, who are called into the warden's office. The warden then says:

> For reasons I don't have to go into now, I've got to free one of you. In order to decide which one, I've set a sort of test for you to take, if you agree.
> There are three of you. Here are five disks differing only in color: three are white, and two black. Without letting you know which one, I am going to place one of these disks on each of you, between your shoulder blades where you cannot see it directly—nor indirectly since there are no mirrors here.
> Then you will have all the time you want to examine your companions and the disks each is wearing—but of course you will not be allowed to speak to one another. Besides your own interest will prohibit you from doing so: the first one able to deduce his own color will gain the liberty I can dispose of.
> However, it is necessary that your conclusion be grounded in logic, not mere probability. To this end, we ask that when one of you has reached a conclusion, he walk through that door where, separated from the others, he will be judged on his response.[12]

The warden then puts a white disk on each of his prisoners. Can they solve their problem? How?

The initial solution is this: after examining one another for a time, all three go toward the door. Each reasons as follows: "I can see

that the other two are white. If I were black, each of the others would be saying of himself, 'If I were black, the other would have seen the two black disks and left already. Since he hasn't, I can't be black.' Since both of them would have followed the same chain of reasoning, they would then have left together, each knowing himself to be white. But they haven't done that, so all three of us must be wearing white, so I'll leave."

For those who enjoy such puzzles, this is all very elegant. But Lacan suggests that it is not quite adequate. Given the role each assigns in his chain of reasoning to movement on the part of the other two, the moment they all move to the door together is a moment of crisis, since it also realizes that movement whose absence is crucial to the deduction. So they will all three stop together— before seeing that this very hesitation is itself a confirmation of their individual deductions. And then they will all, finally, proceed out together.

Lacan's primary interest in this puzzle is in questions about the role of time in psychoanalysis—particularly in the relations among times he distinguishes as proper to "recognition," "understanding," and "concluding."[13] But it is, in part, a visual puzzle, and one whose solution consists in refusing—or, in this case, being defeated by—the first evidences of the visual in favor of the evidences of one's visibility. And here, unlike in Sartre's story, giving oneself over to visibility and its coding is the hesitant means to freedom. The mutual and indirect recognition the prisoners attain depends absolutely on the triangularity of the situation: whereas in their deductions they take themselves as twos, the thread on which their lives and freedom hang is made of each prisoner's ability to take those pairs as existing always in view of a third.

One could of course add to these stories Lacan's most famous story—the one he tells in and around Poe's "Purloined Letter"[14]— which is also in some measure a story about vision, the visible and the invisible, and the inadequacy of dual relations to their articulation. Here the point would be, most simply, that the story depends on the recognition that there is nothing behind the visible (that, for example, the symbolic is not behind the imaginary, that these registers are imbricated otherwise, on or as a single surface). All three of these stories come to the same set of points: that vision and visibility are asym-

metrical—that is, if it is always someone who sees, it is not always by someone that one is seen or to someone that one is exposed—and that this asymmetry is bound up with our ability to imagine our selves and the relations amongst ourselves as fully social.[15] Taken together these points mean that the real terms of our sociability are grounded in the inhuman: we have three persons because there is something at work in our mutual facing of one another that is not simply ourselves, that plays "he or she" to our "I" and "you" and that plays "it" to "he" and "she" in just the same way. This last point brings us to the same fact of a gendering of vision that comes more directly, if less comprehensibly, on the Sartrean route.[16]

It is because there is this inhuman element at work in our sociability that one cannot imagine or theorize that fact without some appeal to, for example, dead fathers—and it is because of this also that the "psyche" of "psychoanalysis" is perhaps best translated as "soul" (rather than, say, "mind" or "personality"). Certainly one of the things that interest me deeply here is the way in which Lacan's general schemas all force a distinction of some sort between recognition and acknowledgment. It is recognition that mortifies in Sartre and those who follow his lead—just as for Hegel it is Christianity that can, in the end, deliver us from the mortification of imposed misrecognition into the region of mutual recognition. But Lacan's nondialectical grasp of these matters can find its only end not in recognition but in acknowledgment (that is, for example, the force his laughter with the fishermen should carry if he is to carry on with them).

If we want, now, to be relentlessly explicit about Lacan's tale of a tub it seems to me that we can say either that Lacan and Petit Jean represent the *infans* and its mirror image as they discover one another by grace of the caregiver whose unheard voice is that of the Father or that they stand to each other as Mother and child before the voice of the Father. The first way of filling out the allegory stresses the unacknowledged symbolic substructure of the mirror's scene of recognition; the second stresses the Oedipal demand for acknowledgment of that structure. That the sardine can is explicitly not human is a way of registering that the Father, as Father, is dead (speaks for and from language and not as a subject employing it). The sun that is marginally present in the narrative only as that which the sardine can reflects

would then be well enough understood as something like the brute fact of reproduction insofar as it exists, unremarked and unremarkable, in some world other than ours—as the mere general condition for the continuation of a species by the production of new individuals. Our reality has always already passed this moment (this is the great lesson Lacan draws from Lévi-Strauss's *Elementary Structures of Kinship*, allowing him to pin Freud's family drama to the fact of language). We may, just as Lacan and Petit Jean do, actually stand in the light of this sun—owe our being to it—but our access to it comes only by virtue of its refraction through signification, displacing us in relation to it.[17] The sardine can is the material remarking of the sun, as language is the material remarking of our unaccountable contingency; as such, it is the condition under which we become visible to—and so divided from or in—ourselves. In this sense the sardine can marks the difference between paternity—a particular node in a system of exchanges that articulates filiation and alliance—and what one might call "siring," a biological function not so marked (this repeats in relation to vision a more general argument I've tried to make about how Lacan's three registers work: from the moment the real gives itself as remarkable—becomes, then, the Real—we have access to it only through the play of the imaginary and symbolic it sets in motion).[18]

This would also suggest that the laugh I offer as Lacan's best response should be understood as an accession to castration as the condition of explicit entry into a social (rather than species) existence. It is, I think, a version of Bataille's laugh (and so presumably related to Foucault's as well). The comedy is just that, standing in the light, we remain, like Lacan and Petit Jean, invisible to one another, merely lucid one might say, until that lucidity is remarked and restricted, and with that our intimacy with one another appears as lost (this is Bataille's urgent comic vision of sacrifice and the sun, the impossibility of the general and the inadequacy of the restricted[19]). All of this is perhaps worth saying just because it can show something about how the Bataille-based exchange between Blanchot and Nancy on community can find one important expression, as it does in *The Inoperative Community*, in a thought of "exposure," a word not limited to questions of the visual and the visible but also not fully separable from them.[20]

This account places something of a premium on a contrast between "recognition" and "acknowledgment" which perhaps stands in need of some glossing. I take acknowledgment to be irreducibly an act—happening not in the visual instant of recognition[21] but necessarily in time and as a relation of at least two moments. It takes up what has been offered, it hesitates, it corrects an earlier response: in all its forms it carries a certain belatedness or dependency at its core. This rhythm derives from the way in which that which is acknowledged is always something other than the subject and not finally subsumable under the subject's preexisting repertoires—but also something from which the subject cannot simply turn away or disentangle itself. As Stanley Cavell notes, a failure of acknowledgment is something for which one is responsible in ways one is not for a failure of recognition.[22]

It seems to me that this contrast between recognition and acknowledgment provides a useful way to frame the other text to which Lacan's most sustained meditation on vision overtly responds—Maurice Merleau-Ponty's *The Visible and the Invisible*.[23] The text of "Seminar XI" makes it clear that Lacan's remarks are occasioned by the posthumous publication of *The Visible and the Invisible* and that at the outset he intended little more than a brief digression. Reading the published text, one can easily follow Lacan as he moves from *The Visible and the Invisible* back to *The Phenomenology of Perception* and then forward again to the late essays of *Signs, Sense and Nonsense*, and *The Primacy of Perception*—so it is worth asking what there is in Merleau-Ponty's work generally, and his late work especially, that so draws Lacan on.[24]

The Visible and the Invisible is far from a finished text; in general it licenses us less to speak of Merleau-Ponty's "theory of vision" than of his struggle toward such a theory and toward the terms in which such a theory could be expressed. These two issues are clearly closely intertwined for Merleau-Ponty. It seems at least roughly right to say that his methodological orientation toward something he calls "hyper-reflection" cannot be thought through except by his thinking through the apparent visuality embedded in words like "reflection" and "self-reflection"—so that Merleau-Ponty's repeated worrying over the phenomenology of, for example, his touching one finger with another is continuous with his struggle to bring vision to words. And lurking in the background of this struggle, as in all of Merleau-Ponty's late work, is his awareness of the challenges posed to his phe-

nomenological approach by both psychoanalysis and the contemporary turn toward linguistic models. This awareness is no doubt most explicit in the passage in which he works both to acknowledge the force of the Lacanian proposition that "the unconscious is structured as a language" and to blunt its force by drawing a sharp distinction between "ready-made language, the secondary and empirical operation of translation, of coding and decoding, the artificial languages, the technical relation between a sound and a meaning which are joined only by express convention" and "the speaking word, the assuming of the conventions of his native language as something natural by him who lives that language"—a distinction Lacan, in 1964, would surely reject.[25]

At the heart of what Merleau-Ponty wants to say about vision there are the following thoughts:

- Vision happens in the world, as one of its facts. We do not simply see the world, it also shows itself to us. We are, in these terms, the place through which the world comes to visibility, and our seeing of it is therefore not simply our own. Vision is a chiasm in the world, a site of its interlacing in and through itself.

- This chiasm cannot be articulated in purely visual terms. We are the place the world sees or shows itself because we are of the world, continuous with it.

- What needs then to be thought through is the way in which our belonging to the world is manifested as our visual separation from it, our having it as objects within a horizon from which we are significantly but not absolutely distant.[26] Vision is the place where our continuity with the world conceals itself, the place where we mistake our contact for distance, imagining that seeing is a substitute for, rather than a mode of, touching—and it is this anesthesia, this senselessness, at the heart of transparency that demands our acknowledgment and pushes our dealings with the visual beyond recognition.

Merleau-Ponty thus repeatedly circles back to the figure of the painter—Cézanne above all—whose canvases offer up to us the continuity of seeing and touching. In doing so he implicitly links his work

with the complex meditations on vision that inform the writings of such early modern art historians as Alois Riegl and Heinrich Wölfflin—meditations that distinguish within the visual between the haptic and the optic and that attempt to understand this internal opposition as centrally informing our notions both of the work of art and of its historicity, apparently separate topics that can be subsumed under the single question of the appearing of the work of art.[27]

Lacan takes over a good bit of this. He too poses vision as essentially chiasmatic,[28] although what Merleau-Ponty calls "Flesh" Lacan takes as the Symbolic; what Merleau-Ponty phrases as continuity Lacan rephrases as displacement;[29] and what Merleau-Ponty explores as an essentially asocial encounter of self and world Lacan rewrites in fully social terms. This is and is not a sea change: what remains constant is the sense that visibility itself is enigmatic, that the task at hand is not that of getting behind it but of staying within its duplicity.[30] As Lacan puts it, "The picture does not compete with appearance, it competes with what Plato designates for us beyond appearance as being the Idea. It is because the picture is the appearance that says it is that which gives appearance that Plato attacks painting as if it were an activity competing with his own."[31]

This passage is perhaps a good enough hook on which to hang the most palpable contrast between Sartre on the one hand and Lacan and Merleau-Ponty on the other as theorists of vision—which is, quite simply, that Sartre can say what he has to say about vision without reference to painting. This is something that neither Lacan nor Merleau-Ponty can do: we can say for both of them either that painting obliges us to acknowledge that which the visual both overlooks and depends upon, or that human seeing (the seeing of speaking, embodied, and desiring beings) will always find itself in a world in which there will be paintings. That these paintings may then function or be taken at times in the ways that so concern Sartre, Jameson, Bryson, and others may still be true, but this would be a modification of or defense against the inner complexity of the visual and not an account of it.[32]

This sense of an abiding problem within, or even as, the very visibility of the visible is not peculiar to Lacan and Merleau-Ponty. It deeply informs the writing of Jean-François Lyotard (most notably in *Discours, Figure*, which finds its starting point in Merleau-Ponty, but

also in the transformed problematic of the sublime and the unpresentable that organizes *The Inhuman*) and can be registered as well, albeit more obliquely, in the work of Maurice Blanchot (*La Folie du Jour*) and Jacques Derrida.[33] In the cases of Blanchot and Derrida, any direct debt to Merleau-Ponty seems less important than a common derivation from Martin Heidegger, whose question, "How is there something rather than nothing?" expressly aims to shift our attention from questions of what is behind what (as, say, ideas might seem to be behind appearances) to questions about what it is for something to appear.

One of Heidegger's favorite ways of putting this notion is in terms of things coming into light, entering or withdrawing from a "clearing" (*Lichtung*), and this image can serve as a useful guide to another significant context for Lacan's excursus on vision. Here one would want to speak, beyond any explicit authorization in Lacan's text, of Goethe's *Theory of Colour*.

There are, I think, two ways to imagine the relation between Lacan and Goethe. The first is to say that Lacan inherits a certain rhetoric of light embedded in post-Goethean German philosophy and works to recover it as theory within the register of psychoanalysis. The second is to say that Goethe and Lacan share a sense, implicit for Goethe and explicit for Lacan, of the visual field as a field transfigured by language.

In thinking about a certain inheritance of Goethe, it would be important that Hegel followed Goethe on light and that he ordered his use of visual metaphor to that theory in such a way that those metaphors became centrally informative of much post-Hegelian German philosophy.[34] Heidegger's *Lichtung* is not Newtonian, not an empty space traversed by lines of light, but a welling up of light in an interplay with darkness that is generative of a multicolored world of things, and Lacan, no doubt with a push from Bataille, is also fundamentally oriented to this space or place of light (light is something we enter or that enters us, not something that shines upon us).[35] This is the point of Lacan's strictures on Descartes, Diderot, and "geometral perspective"—all of which are in his view as in Goethe's—"simply the mapping of space, not sight."[36]

At the level of what one might imagine as a shared intuition into the rhetoricity of vision—what I have been describing as its division

from itself, the insistence of a certain heterogeneity at the heart of its transparency—I would point to Lacan and Goethe's joint insistence that the field of vision is above all a play of light and opacity arising from bodies and images in displacement. This applies whether we think of how Lacan is and is not in the picture in his parable of the sardine can or of his remarks about the screen or stain or mask, or turn to Goethe's extraordinary assertion that, "to produce colour, an object must be so displaced that the light edges be apparently carried over the dark surface, the dark edges over a light surface, the figure over its boundary, the boundary over the figure."[37] It is the complex relation of figure and boundary Goethe tries to illuminate here that perhaps permits our speaking of the rhetoricity of vision—and it will be of some importance to be clear about the difference between this way of posing the linguistic constitution of vision and any more directly semiotic approach to it.

These remarks are, of course, speculative at best and would need to be considerably fleshed out, preferably in both historical and theoretical terms, to be fully persuasive, but they do, I think, help open out the sense of Lacan's passage from "The Split Between the Eye and the Gaze" through "Anamorphosis" and "The Line and Light" to "What Is a Picture?" The experience of a picture is, above all, an experience of light in its materiality and in its radical difference from the lines by which we can, blindly, claim to map a space imagined to exist apart from us and to which we are not essentially exposed.[38]

One general outcome here may be the recognition that Lacan's theory is deeply responsive to the various modes of self-division in the visual that are repeatedly registered both in the history of art and in art history's attempts to understand its object—not only Wölfflin and Riegl or Goethe against Newton but also all those contests of line and color, painting and sculpture, North and South—so many complex instances of vision's incessant and constitutive turn against itself. This turn continues to shape, as it must, the most powerful of contemporary art criticism and art history—for example, Rosalind Krauss's complex negotiations with sculpture and photography, Lacan and Lyotard, surrealism and Greenbergian modernism.[39]

If we see this work as participating in a certain critique of vision, it will not be Sartre's and Jameson's, and it will not take the shape of

a critique of representation. It will have the shape of (and my phrasing here is, in the context of current art criticism, tendentious but I hope nonetheless justified) "radical self-criticism," where self-criticism does not name a reductive movement toward an essence but the very structure of the thing in question.[40]

One last point can turn us toward some thoughts about how we "theorists" now stand toward or find ourselves within "the gaze" and how we have come to that position. And this is that Goethe, Heidegger, Lacan, and Merleau-Ponty as well as others I've mentioned (Blanchot, Derrida, Lyotard) all take it that there is a direct connection between what they want to say about vision and the question of its saying or writing. That is, they argue that any writing that would show what is to be seen about vision cannot advance itself as either transparent or reflective in the usual way. They have an interest in opacity. To put it slightly differently: they are obliged to cash in the ancient chip that ties "theory" to spectatorship.[41]

It remains then to ask why, if Sartre and Lacan are as different as I have claimed them to be, contemporary theory so insistently conflates them, so repeatedly reproduces Sartre under the name of Lacan. Presumably one could offer, as my marginal remark about Nietzsche suggests (see note 41), an answer at the scale of Western thought itself. And one can also offer, as Joan Copjec brilliantly does in "The Orthopsychic Subject," an answer scaled to the particular twists and turns of the complex relations among Althusser, Bachelard, Foucault, Lacan, and others.[42] What I will offer are a few unjustified and suspicious remarks about the reception and contemporary situation of French theory in the United States.

In general, Lacan has been overread as the theorist of "the mirror stage." More particularly, there has been a strong desire to see the four seminar sessions devoted to vision as expanding upon or elucidating the earlier work. In a sense they do so—but not by further exploring the logic of the Imaginary. Instead, they offer an account of the Symbolic underpinnings of the visual Imaginary— not what the mirror seems to show but the seams that do not show, the stains or inscriptions that are the invisible condition of its apparently transparent reflectivity (for example, the Mother's words as he holds her child up to the mirror: "See, Chris, that's you").

But we are, evidently, interested in the Imaginary, in the mirror; we cling to it—as we cling to other moments of theory: for example, Foucault's *Discipline and Punish*, which is repeatedly read as if it contained a theory of vision. It does not. What it does contain is an account of the emergence of a practice of vision that finds its fulfillment in, among other things, the contemporary social sciences, of which *Discipline and Punish* is an explicit critique, and Sartre's theory of vision, of which it would seem to be an implicit critique. Foucault himself holds, at least on the evidence of that text, no "theory of vision." That we want him to is perhaps a measure or symptom of our own attachment to theory. It is as if we have staked some significant part of our grasp of theory's work in the figure of the prison-house, or in the twin figures of prison and mirror insofar as they jointly fill out a sense of the way language, at least as we take it to have been explored in the tendencies we now call "theory," seems to seal us away from the world or enclose us in our selves. We were, for example, prepared to take the prison to be a figure for the news and consequence of theory well before Foucault came to examine its history; when he did so, we were surprisingly ready to take his history for theory, discarding along the way the more complex and much more overtly Heideggerean Foucault of *The Order of Things* in favor of this new crypto-Sartrean.[43] "Theory" and the means and objects of its critiques become oddly conflated here—as if the prisoner were to imagine he would be free if only he could watch himself more closely than even the jailer can (and isn't this just what the prisoner, on Foucault's account, will inevitably come to believe?).

The obvious conclusion here is that our insistence on theory and our attachment to these tropes of isolation and separation go hand in hand—even, and perhaps most especially, where we take the task of theory to be to break us out of such isolation. Theory so construed— the theory we seem to want—would operate in the same field and according to essentially the same logic as the social sciences themselves; its deepest stakes would continue to be in surveillance and punishment, the composition of forces, normalization, and examination. And our attachment to these things would be, as Foucault argues, the very form of our contemporary attachment to ourselves, our willingness to remain transfixed before the mirror, absurdly willing it to deliver us to our naked selves, at once visible and our own,

wholly appropriated and wholly alienated (this would be the pornography of the theoretical gaze).

The interest that drives the repeated transformation of Lacan back into Sartre and that insists upon Lacan as above all the theorist of the Imaginary is then not separable from a certain interest in or ambition for "theory"—that theory should at once capture its object and leave it free, render it visible and leave it in its proper privacy. What, one might say, "theory" above all wants is not to be touched by its object—as if a permanent and unmeasurable distance were to be secretly maintained as the condition of what we nonetheless claim as theory's approach to its object.

It is possible that in Merleau-Ponty and Lacan, as in Derrida and Lyotard, all of this is being configured otherwise—neither prison nor mirror, not theory but displacement. This would be the sense of their writerly practices.[44] But if it is so, then the work of that writing would be a work not of subjects but of objects, passing over themselves and one another.

I have insisted here and there both on the signal importance of a reference to painting in both Merleau-Ponty and Lacan and on a certain relation between their discussions and those that animate the origins of modern art history. I have done so because I take the special insistence on a certain objectivity (a certain having or touching of an object) at work in the former and the movement at once within and without disciplinary boundaries implicit in the latter's refusal of any simple self-containment of the visual, to be important parameters for an exercise of theory that does not allow itself the imagination of a subject before whose gaze there might or might not be a world. Instead, such an exercise of theory is committed to understanding how it is that subjects find themselves appropriated to— touched by—what one might call the look of things.[45]

On this view, we are asked to grasp our apparent theoretical or visual appropriation of and distance from objects as a peculiar modification of a prior attachment to them or of their prior attachment to us. This particular modification may not be entirely or always desirable—especially since it is a modification, like Euripides' modification of his attachment to his predecessors, which does not break that attachment but does succeed in rendering it invisible and unthinkable, and which does so in and as its very claim to lucidity. That this

is always possible is one lesson, and that it is therefore always actual is another. That we remain, as a consequence of this very duplicity, pledged to the impossible articulation of the world is the third. None of these lessons would be "metatheoretical"—they do not take the form of a reflection on theory—which is why there is no end to their saying or the occasions of their saying. They are objective—by which I mean that they are a consequence of the fact that we can find ourselves in no other place or way than in our exposure to what is, in or beyond us, other.

1996

*S*o we begin in the midst, with Jacques Derrida's words and writings. It is a well-known characteristic of these writings that they are everywhere marked by a variety of neologisms, neographisms, and what he calls "paleonymies" or, following the psychoanalysts Nicolas Abraham and Maria Torok, "anasemies": One thinks easily enough of *differance*, "supplement," "graft," "trait," as well as more obscure formulations like "+R" or "gl," and so on. These coinages and turnings are invariably accompanied by warnings to the effect that what they register is "neither a word nor a concept" and that they ought not be hypostatized beyond the terms of the reading in which they are set to work.[1] These graphemes presumably are themselves offshoots or refractions of the major coinage of "deconstruction" and are justified at least in part as attempts to at once underline and enact the consequences of a fundamental instability within the name of "deconstruction," itself a term that Derrida has, at least at times, never meant as a noun. What matters is the activity, and that activity is chameleon, in and of itself hostile to nomination and fixity. Derrida thus frequently insists on speaking of deconstructions, in the plural. At the same time, and despite certain obvious and interesting affinities, deconstruction is not dada. Derrida's writings surely mean to make something happen—to exert, as he puts it, effects, and these effects are not conceived as simply random. Nor is the event they set in motion anything so apocalyptic as an end to meaning *tout court*; Derrida has been vigorous from the outset in refusing any simple ascription of "nihilism" to the various things, his own and others, that he calls "deconstructive."

The term "deconstruction" is itself willingly less than novel; it has, in fact, both a legitimate French history, given in Littré, and a particular philosophical pedigree that makes it an aggressive translation of a nest of terms in the work of Heidegger, most signally *Abbau*.[2] This inherent conservatism within the term is the obverse of what Derrida has always known within, and despite, his insistent attempts to outflank that knowledge: that "deconstruction" and all its dispersed refractions will end as nouns and names. More particularly, "deconstruction" cannot avoid—but only delay—the moment in which it comes to name a project and a more or less stable practice.

This moment has—the American academy has played no small part in this perverse testimony to the strength of what Derrida aims to contest—come exceedingly quickly. "Deconstruction," worn to transparency and beyond, is widely taken as a project and a method: "We all" know how to find the binary, reverse its hierarchy, and decenter the opposition. Some of "us" have indeed already begun to imagine writing and teaching "after deconstruction," as if some project had been completed, or at least sufficiently elaborated that one might imagine what things will look like on the far side of its completion.[3] Others look to the extension of that project to new regions—film, the visual arts, and so on.

All of this comes inevitably with the practice of deconstruction; the fate of its name is of a piece with the more general fate of writing, and the name cannot be recalled from its dispersion or corruption through any appeal to some meaning held to be stable and secure apart from it. All that was already in ruins; "deconstruction" can look to make this explicit but cannot exempt itself from all it displays and diagnoses.

All of this has, of course, been said before, by Derrida and by others. But that hardly makes it irrelevant to an enterprise as strongly nominative and projective as a volume dedicated to "deconstruction and the visual arts." What, after all, is one to expect under such a title? The deconstruction of visual works? Visual works that are deconstructed? A ruination of the visual as such? Should one expect an account of a new method? A new art? The collapse of disciplines? What extraordinary transformations are in the offing here? And what is to be transformed?

One plausible response to these questions—perhaps the one most native to our thinking about such matters—would be to imagine the

arts or the discipline of their history as the object of some deconstructive transformation. There are serious, inviting, and finally inevitable possibilities here. But if Derrida's resistance to method, project, and so on is serious, we should also imagine that "deconstruction itself" might be what is transformed in this encounter.

Matters of Method

We begin again, then, gazing through the late transparency of deconstruction at the possibilities of method it seems to offer:

1. If deconstruction now presents itself above all as a method that art history might take up, that method seems susceptible to a number of different descriptions, each of which will give rise to a significantly different understanding of its possible purchase on the visual arts.

There is, for example, a very widespread understanding of deconstruction as a practice of demystification, usually in service to a larger project of ideology critique, and this understanding presumably would renew itself within art history by continuing the project of rereading realism already well established in literary studies. One might look here to Catherine Belsey's use of the example of painting in the opening pages of her *Critical Practice*.[4] Insofar as it seems repeatedly oriented to undoing the apparent epistemological authority of fiction, the work of Paul de Man might appear to offer a more "rigorous" model for this kind of activity (although it is not intuitively clear exactly how de Manian analysis might be carried over to, say, paintings—certainly one might imagine a de Manian undoing of various programs of iconographic interpretation).

There is also an understanding of deconstruction in which language plays a crucial role (*il n'y a pas d'hors-texte* seems on this view to mean that "everything is language"[5]). The extension of deconstruction into the visual arts here would depend on the prior reduction of those arts to the status of linguistic or semiotic practices. This general path has, of course, been opened for art history by Meyer Schapiro, but undoubtedly the leading contemporary, version of it is that found in the work of Norman Bryson.

Then there is an understanding of deconstruction that ties it directly to the aporias of self-reflection and a concern for the limits of self-consciousness, offering a route toward visual art that would bypass semiotic considerations and move more or less directly to the

scrutiny of those moments in which visual works can be said to place themselves *en abyme*. A couple of years ago at a conference in Irvine, J. Hillis Miller took this path, scrutinizing the representation of the sun on the sail in Turner's *The Sun of Venice Going Out to Sea*.[6]

Clearly, none of these projects is in general illegitimate; the worst that can be said of them is that they are all "theoretical"—that is, they take deconstruction to be first of all a method and then seek to find within the visual arts the site or sites at which the method can be put most productively to work. And, of course, each of these approaches will have its particular shortcomings and problems. The demystificatory approach is overtly an appropriation and takes up deconstructive maneuvers only so long as they serve the ultimate ends of a project defined elsewhere and itself withheld from deconstructive attention.[7] The linguistic or semiotic approach demands a prior semiotization of art that looks at present to be bound to a particularly narrow cultural and historical range[8] and is further troubled by questions of color, which would appear to lend itself to semiosis only on the grounds of a return through more obdurately art-historical facts—for example, that what painting for the most part knows is not "blue" and "red" nor even, at least until very recently, "cobalt blue" or "alizarin red," but "Giotto's blue" and "Titian's red"—so the semiotic construal never quite fights its way free of the art-historical ground it means to undo or overmaster.[9] And finally, the chasing down of the odd *mise en abyme* seems motivated only by a sense that reflexivity is the name of the deconstructive game and does not appear justified by anything parallel to the sustained meditation on the materiality of writing that gave rise to deconstructive practices in literary and philosophical contexts. What we will count as either reflexivity or, more crucially, its disruption within the contexts of painting or sculpture remains unclear.

2. One might then choose to back off from these methodological construals of deconstruction in favor of raising questions about visual artifacts that might be said to be deconstructive. In doing so, one would, in effect, pass out of art history and enter instead into the contemporary, more or less "postmodern" arena of artistic production and criticism. Here the questions one would pose would not be on the order of "What constitutes a deconstructive (or deconstructed) art history?" but that of "What constitutes a deconstructive (or deconstructed) art object?" And, of course, behind such questions

would be the further question of whether or not there is any sense speaking of objects in this way.

Derrida's own writings seem to suggest there is. In the work of Valerio Adami, Gérard Titus-Carmel, and François Loubrieu,[10] he seems willing and able to find acts of deconstruction. But his attention in these cases seems more occasional and less fully developed than usual (the essays on Adami and Loubrieu arose directly from their presentations of themselves as illustrators of Derrida's writings). If there has been a sustained encounter between Derrida and the stuff of the visual arts, thus far it has taken place above all in relation to architecture. It seems not wholly unfair to compare this engagement with Martin Heidegger's attachment to poetry. In each case—and despite significant differences—the art form taken up appears to offer the actual happening of a concrete truth the philosopher can only claim to preserve and prolong.[11] The privilege of architecture, for Derrida, arguably arises from the way in which it is the direct manifestation of what deconstruction is obliged to speak only as metaphor—the language of building and dwelling in Heidegger (*bauen, Ab-bau*) as it is translated into construction and deconstruction, and as both Heideggerian and Derridean constellations are explicitly recognized as themselves translations or revisions of a deep-seated philosophical self-apprehension caught in the prevalence of words like "ground" and "foundation" within philosophical writing as they are taken up or refracted in Kant's "architectonic," the crucial exemplarity of the tomb in Hegel, or even the founding play of inner and outer, *agora* and *oikos*, in and around Plato. Inside–outside has always been a privileged topos within deconstruction, and the passage to architecture seems at this level inevitable.

There are, however, at least two kinds of difficulties one might have with this way of placing deconstruction into relation with the visual arts. The first, most clearly signaled by what Eisenman takes to have been the failure of his collaboration with Derrida in the Parc de la Villette, is quite simply that it is not obvious that there has been any extension into the visual or architectural here at all. Derrida can appear to have too simply ensconced himself within the textual, contributing a merely programmatic reading of Plato's *Timacus*. As Eisenman remarks, "We finally forced Jacques to draw something"[12]—as if Derrida had been unwilling to lose his practice to this

alien act or region.[13] Derrida's attitude here is far from indefensible, but it is important, I think, that any defense of it will depend on some notion of what remains for Derrida philosophical—that is, some notion of the necessity Derrida takes to underlie his activity.

Perhaps more centrally problematic is the basic notion that there is some "deconstructive architecture" to be recognized over and against some other architecture. This topic has recently been fairly widely discussed in England; in America, where "deconstructivist architecture" does not seem to have gained the same purchase, one finds similar discussions in and around the practice of what might be called "postpainterly postmodernism"—the work of image appropriators in the late 1970s and early 1980s and their later, often more Baudrillardian, followers in the contemporary art world. Does it make sense to speak of one object as deconstructed or deconstructive over and against another? Can something be a "deconstructed building"? Can a photograph be said to "deconstruct" something? If they can (and I do think there is a degree of sense in such formulations), are there any constraints on them?

3. One may well find oneself unhappy with the possibilities sketched so far—perhaps because they divide too neatly into questions of method over and against questions about objects. In such a mood, one may be tempted to cast the question of deconstruction and the visual arts in terms of a rereading of the "discourses of the visual." This is, I suspect, the dominant move in contemporary theory in general, and although it remains close to the project described earlier in terms of a thoroughgoing semiotization of art, it holds itself apart from that through a refusal to take the availability of the visual object for granted. Instead, it contends that vision is always "constructed," and it thus reads the (apparently) visual through a more embracing cultural grid. The general strengths of such an approach are obvious: In particular, it frees one of the art-historical equivalent of New Criticism's bondage to a certain understanding of the autonomous text. The visual is now to be understood from the outset as thoroughly caught up in an order of signification that opens it to the world and the full range of analyses that come with such openness—psychoanalytic, sociological, and so on.

Such discursive analysis promises as well the kind of antagonistic relation to the disciplines of the visual that we have come to expect of

"advanced theory" in the face of any disciplinary formation.[14] "Art history," as a major instance of such disciplining, might be shown to be founded on a series of binary oppositions—for example, the haptic and the optic in Riegl, or the classic and baroque in Wölfflin—that can themselves be submitted to an aporetic reading capable of shifting or overthrowing those foundations.[15]

With this last formulation, we may feel ourselves moving into a region in which deconstruction might recognize itself. These are regions of which deconstruction does well to be wary; the cost of self-recognition, as always, may be the inability to recognize or touch what is other—in this case, deconstruction's presumed objects, which would be regularly replaced by their discursive representation and a certain critique of that representation (simply for being a representation).[16] It is an important fact about the shape of contemporary theory in its various forms that this cost either will not be perceived as such or will be considered eminently worth paying by any number of theorists, historians, and critics. Indeed, many will claim that this transformation of the structure of the field of study from objects to discourses is the signal advance made by theory. This essay, in contrast, does see it as a cost, and as a high one.

Notes on a Conversation
Not too long ago, the Tate Gallery sponsored, around the notion of "deconstructivist architecture," a series of events, among which were the showing of a videotaped interview of Jacques Derrida by Christopher Norris and a subsequent panel discussion among a number of those interested in the implications of deconstruction for the visual arts.[17] Norris's expression of his own doubts about the viability of the claim to deconstructivist architecture led Andrew Benjamin to a statement that reflects some of the kinds of unhappiness I have tried to sketch out in the preceding section:

> Part of the difficulty with this is trying to locate Deconstruction in an object. In other words, to say of a specific work of art or a specific architectural form that this is an instance of Deconstruction. . . . The question of the object returns in another way and it goes back to the point put to Derrida as to whether or not Deconstruction is something that comes to be enacted within an object or a way of reading objects or a way of reading texts. As is always the case with these things, it's clearly both; the question of enactment is problematic.

Commenting on this, Geoff Bennington added a notable extension: "Finally, I want to endorse Andrew when he says that Deconstruction is not in objects. I want to add the corollary that objects are in Deconstruction."[18] In a separate essay in the same volume ("Deconstruction is not what you think"), Bennington repeats this observation within the particular context of painting—"Colour is, in Deconstruction"[19]—and in making the punctuation explicit he attaches the question of the object firmly to Derrida's Heideggerian inheritance. The question of the object in and for deconstruction is a question not about *what* the object is, but about *how* or, even more simply, *that* it is. It is only on the basis of this recognition that we can understand why deconstruction refuses our ordinary grammars of criticism and knowledge and can insist justifiably on something those grammars can register only as, in Benjamin's phrase, "clearly both."

"In deconstruction" is not a methodological or theoretical place (as would be apparently the case with a phrase like "the object in psychoanalysis"), nor is it a particular state of some one object as opposed to others, nor is it simply a way of saying "in discourse." It is a name for how an object is—how, as it were, it *does* its being.[20] We may have reason to say under one circumstance or another that some objects are more explicit about their ontological stakes than others, or have at least been received with greater ontological explicitness. But this contrast, however useful, does not dig very deep; our urge to take it as significant is by and large continuous with the urge to recognize deconstruction as a mode of demystification.

When Heidegger reads Kant, he reads not a report on the world, but a "thought of Being," which is to say he reads Kant's text not as authored by a subject in the face of an object but as the production of a being that is peculiar insofar as it *is* only *as* the question of its Being, a being thus at once subject and object and, above all, the space between. It is this understanding of *Dasein* in its relation to thought and Being that licenses such interpretive violence as Heidegger's reading exercises (here as well as in his encounter with Van Gogh's *Old Boots with Laces*). Derrida's procedures and justifications are in the first instance not different from this; he too engages his objects just insofar as they are defined by—constituted by—their relation to the conditions of their appearance. The issue between Heidegger and Derrida is about how this is to be accomplished. Where Heidegger is repeat-

edly tempted by the notion of moving beyond the "merely ontic" (the region in which beings are as if simply present) to the ontological (the region in which we are obliged to speak of Being), Derrida is insistent about not letting the ontological emerge anywhere other than in and as the ontic: There is thus, for him, no prospect of a breakthrough to something that would be called "fundamental ontology,"[21] and the clearest marker of this in his writing is the rejection of Heidegger's talk of Being and its (self)forgetting in favor of the apparently more contingent and metaphysically modest talk of writing and its "repression." But it remains the case that to ask of a text how it understands its relation to its material conditions is to ask of it how it is—and it is to do so within the Heideggerian frame in which "to be" is always understood as "to be as . . .," a phrase that turns the apparent solidity of a thing always over to the fluidity of relation.

Recognition of this Heideggerian thread in Derrida's writings can make a major difference when one attempts to raise the question of deconstruction and the visual arts. Because Heidegger's thought moves relentlessly toward Being and its truth from each of its starting points, he is able to imagine a certain derivative project of regional ontologies organized by derivative modes of truth, and on this basis he can project a certain hierarchy of regions. Within the arts, for example, Heidegger is explicit about the privilege of poetry insofar as it is the very stuff of how things are for us: Language is "the dwelling house of Being," and the poet is the prime artificer of that house.[22] These are the figures that determine Derrida's stake in architecture, and his moves in this arena are best taken as attempts at reversing and undoing—or fundamentally complicating—them.

Deconstruction as I have described it cannot have the same access to notions of regional ontology because it does not have the same access to ontology *überhaupt*. What might count as "regions" are necessarily disseminated into the multiplicity of objects that might be found "in deconstruction," and no particular object or region of objects can in principle be privileged over another. Every object must appear as an occasion for a reinvention of deconstruction: Every object is different(ly). Within Derrida's work this demand is embedded in his own practice of renaming his enterprise and its key terms with each new text he reads, as well as in his recurrent expressions of unhappiness about the ways in which that mobil-

ity will inevitably be undone—the whole nexus of cautions and problems from which this essay began. If one were to stop here, deconstruction might be imagined as a peculiar and radical empiricism (and sometimes it is indeed taken as if it were just that). But this assumes a settlement of the meanings of "object" and "objectivity" for deconstruction to which we are not yet entitled. In particular, it forgets the Heideggerian conflation of "being" and "being as. . . ."

Renewing the Question

If what we are asked in the encounter of deconstruction with the visual arts seems to be neither "How (can, should, ought) one deconstruct art?" nor "How can one make (what counts as) deconstructive art?", then the question might seem better given a form like "What deconstructions can one recognize within the visual, and how is one to acknowledge those deconstructions?" Each part of this new question has its own difficulties, but it is at least worth being clear about the general tendency of the whole. Again I cite Geoff Bennington at the Tate exhibition:

> [T]he most traditional philosophic views of art as mimesis, and its most academic practice, have always necessarily left uneasily open a sense of art as a dangerous event in which something happens to disturb the integrity of "nature herself" (and not just respond to her), somewhere resisting the grasp of concept and commentary, and through the insufficiency of attempted explanations of this event in terms of talent, inspiration or genius, something of this deconstructive edge or "point," as Derrida says, has always been at work. To this extent, art has always already been in excess of its concepts, already deconstructive, and deconstruction the motor or movement or element of art. . . . "Deconstruction" . . . is in any case a provisional and necessarily improper name of the movement one of whose traditional names has been "art."

Bennington's implicit opposition of mimesis to event is perhaps closer to the work of Jean-François Lyotard,[23] a figure who necessarily haunts the region in which we are moving, than to Derridean problematics, which incline—as, for example, in the work of Philippe Lacoue-Labarthe[24]—more toward an opposition of mimesis to itself.[25] This, however, takes nothing away from Bennington's central point: Deconstruction does not in any direct way offer either

an approach or an alternative to something we might call the tradition of art—it (re)names that tradition. The peculiar difficulty is that in so doing, it is itself renamed, refigured, or reworked by that tradition: What is asked of deconstruction by art is something like self-recognition, and this "something like self-recognition" will have to be articulated in terms that do not undo deconstruction's refiguring of selfhood and its concomitant incapacity or refusal to reduce questions of recognition to questions of self-knowledge. This might mean that what is asked of deconstruction is that it lose itself in a new way.

It is just here that what we have earlier sketched as a demystifying and antidisciplinary analysis of the founding terms of art history can take a crucially different turn. Just insofar as the things we have described as founding binaries are not simply imposed on the brute stuff of art history but grow out of its own theoretical and artistic polemics—the *paragones* of sculpture and painting, the struggles of *disegno* and *colore*, Poussiniste and Rubéniste—they appear to offer an entry not simply into the arbitrariness of a discipline but into something we have to call its object. Such an approach would, in its fullest extension, pay off in a sustained investigation of the stability of the visual as such and not simply of its presumed discursive construction.[26] Such work would be friendly to Bryson's investigations without feeling constrained to a semiotization of art and would, in principle, be interested not so much in spotting the *mise en abyme* as in asking what in a given conjuncture carries the force of that problematic.

It will be clear that I find this way of working between the texts we know as deconstructive and the visual arts potentially extremely powerful, and the best work we have of this kind—I think especially of the writings of Rosalind Krauss and Michael Fried in English and those of Hubert Damisch and Thierry de Duve in French[27]—is some of the most powerfully deconstructive writing art history has produced. And just as I earlier suggested that it was important in reading Derrida on Adami and others to recall the philosophical grounds and motives of his activity, it seems to me equally important to invoke the properly art-historical grounds for the activities of these writers. In particular, it seems crucial to speak of what I will call their objectivity, by which I do not mean anything like the submission of their

analyses to overarching logical or empirical criteria of verifiability but more simply their aim at objects and their willingness to assume the demand to think or write them as such. It is important about these writings and about deconstructive writing in general that the demand to think objects "as such" is made within the context of a sharp distinction between "individuality" and "uniqueness,"[28] a distinction that follows from the identification of "being" with "being as . . ." and that steers the writing away from radical empiricism, at least as it is normally understood.

The recognition of the discipline of art history as a problematic prolongation of the *polemos* internal to its object—problematic just because that *polemos* is already a registration of the purloining of the object from itself—forces a reconstrual of the writer's relation to the object and does not permit any imagination of that relation as external or optional. Art history and the history of art write from within one another, binding art history to the actual and ongoing production of art (and vice versa). The choice between deconstructive approaches and deconstructive objects dissolves, and does so as a consequence of the deconstructive claim to objectivity.

Deconstruction is objective: It is committed to things and does not take place apart from their taking place. If it evinces a certain systematic and argued hostility toward the terms of modern science, and if it argues in the face of hermeneutic constraint for the permanence and significance of effects unthinkable in any register of recovery or integration—if, that is, it refuses to let its notion of objectivity be constrained by the dominant paradigms of truth—it nonetheless does not and cannot happen apart from the claim to read something other than and prior to itself.[29] The best general model we have for such an objectivity is that of a "discipline," which is to say a set of principles and an object that claim to pick each other out. Deconstruction does not sit comfortably within such a model—indeed it everywhere pushes it to and beyond its limits—but this is the model it recognizes in Hegel's temporalization of philosophy and Heidegger's hermeneutic radicalization of it, and the practices, motives, and effects of deconstruction remain incomprehensible apart from its assumption of such a disciplinary construal of objectivity.[30] If it knows that no thing takes place apart from language, it knows also that talk of linguistic "construc-

tion" does not exhaust our engagement with things (which is why it first finds or founds itself as a critique of semiology conducted within semiology, as if on behalf of—in the name of—the thing cryptically enfolded within what imagines itself a science constructed in the absence of things).[31] As deconstruction extends itself out from the explicitly textual terrain of philosophy and literary criticism, it runs in a new way up against what shows itself at the limit of any directly linguistic grasp—color, for example—and so exposes itself in a new way to the materiality of things. It cannot be imagined to simply extend its aegis over unclaimed or contested territory. It offers not a theory so much as a peculiar discovery of the impossibility of the terrains we nonetheless inhabit. If a certain image of "regionality" recurs here, it is one that has passed through the Nietzschean and Saussurian transformations of the thing from substance to relation. The space of the thing is neither a neutral void we cohabit with it nor a construction we impose upon it, but the complex structure of our attachment to and detachment from it. Thus the urgent complexities of Bennington's comma: "Color is, in deconstruction."

For Example
We know how to describe color in strictly physical terms. We know also something about how to analyze it semiotically, and indeed color can easily appear a prime candidate for semiological investiture, displaying the full force of "cultural construction." The physical phenomenon in its relation to our nomination of it seems to map directly onto Saussure's diagrammatic representation of the double continua of world and sound into which language cuts, freeing the prospect of articulation, and the arbitrariness of this cutting seems readily evident in the variety of color terms found in existing natural languages.[32] But color can also seem bottomlessly resistant to nomination, attaching itself absolutely to its own specificity and the surfaces on which it has or finds its visibility, even as it also appears subject to endless alteration arising through its juxtaposition with other colors. Subjective and objective, physically fixed and culturally constructed, absolutely proper and endlessly displaced, color can appear as an unthinkable scandal. The story of color and its theory

within the history of art is a history of oscillations between its reduction to charm or ornament and its valorization as the radical truth of painting. From these oscillations other vibrations are repeatedly set in motion that touch and disturb matters as purely art-historical as the complex interlocking borders among and within the individual arts and as culturally far-reaching as codings of race and gender and images of activity and passivity. This movement of color in painting is a movement in or of deconstruction. And if deconstruction can in some sense feel at home in reading the texts of color as they pass from the Renaissance through de Piles and Goethe and Chevreul, it is in a much harder place when it comes to actually speaking the work and play of color—not because that work and play are ineffable but because its "speaking" just is the work of art and its history.

We also know color only as everywhere bounded, and we may think to register this boundedness as its necessary submission to the prior constraint of design. But color repeatedly breaks free of or refuses such constraint,[33] and where it does so it awakens questions of frame and support as urgent issues for painting just insofar as they show themselves to be not prior to but emergent within color itself. Color is then no longer simply contained within the painting but is also that which, within the painting, assigns it its frame, even as it conceals itself as the source of that assignment. Insofar as color is and is not the historical bearer of a certain truth of painting that is and is not the truth of the frame in which it is contained, color bids to pass beyond itself. Color, in deconstruction, may appear as color-without-color, a hitch or problem in what one might call the look of things. Duchamp, in de Duve's powerful account, would be a central pivot here, but the problematic perhaps becomes fully explicit only with the postmodern move that seeks to pass definitively beyond painting in the name of drawing—only to turn itself over to Lacan's belated inheritance of Goethe and Hegel on light and the ontogeny of color. This could count as a history: We would, passing from Morris Louis through a certain engagement with sculpture to the postmodern centrality of photography, still be in the midst of a negotiation with color that we can only barely recognize as such.[34]

Insofar as we recognize color as an object-in-deconstruction, we

recognize its discipline (perhaps "art history," perhaps but one history among those we are obliged to count as the histories of art) as the ongoing demonstration of its radical lability and dispersion in, or as the prolongation of, its very objectivity, which is to say its necessary division from and transgressive framing of itself. Art history, we would say, constitutes itself by constituting an object (we are calling it "color" here) that lends itself to the discipline only as it is already in excess of any constructed or constructable punctuality and simplicity. The point is general: That by grace of which a discipline can imagine itself to be closed upon its object is, prior to that imagination, an openness "in" itself, a slippage, a parergonal unity in which rift and frame, differing, coincide.

The necessarily abyssal ground of deconstruction lies in that moment at which the intradisciplinary framing of the object is recognized as not so much an imposition *on* the object itself as a not wholly proper effect *of* the object itself. And at that point the discipline is obliged to pass beyond itself—to become interdiscipline. In so doing, it does not leave its own ground, neither passing over into some fuller science nor dissolving into sheer, unframed empiricity. One might say it ceases to own "its" ground. One might also say—a certain view of deconstruction would lead one to say—it becomes writing; and surely this is right, except that there is no general writing just as there is no inhabitable general economy: There is only the demand for restriction (the fact of economy) and the necessity of its overrunning. We do not know what art history calls writing. We do not know in advance and from the outside how to recognize what will count that way within the histories of art. Deconstruction cannot tell us this; it offers art history, as it offers philosophy and as it offers criticism, nothing other than its self. But the self thus offered is one that art history may not recognize, one that it will in any case not have in the mode of return or reappropriation.

What the postmodern polemics of the late 1970s and early 1980s valorized as "appropriation" is what Lacoue-Labarthe (and others) equally valorize as "depropriation," reserving "appropriation" for Platonic logics of participation. The problem of deconstruction and the visual arts is the problem of the absolute justice of this apparent misfire. At issue, finally, is not vocabulary, but grammar; and what

transpires between the texts of deconstruction as they currently stand and the visual arts, their criticism and history, is neither appropriation nor depropriation of the one activity or object to the other, but a warping in the grammar of propriety itself. One might then say that the demand is for the visual arts and their discipline to appropriate themselves otherwise. But the deeper demand is for them to acknowledge that they have always done so.

By Way of a Conclusion
The bundle of practices that have emerged over the past two decades under the general term "theory" are finally quite diverse, and many of them clearly carry interesting implications for art-historical study that will, no doubt, be worked out over time. Some of these implications are quite direct (feminists are, to take a central example, noticing in detail certain things, both formal and thematic, about pictures that have not been noticed before), and others appear to belong to a level of "metareflection" (history of art history and so on). I suppose that what I have tried to work through in these pages—what interests me about deconstruction in art history or art history in deconstruction—is that it refuses (one might also say "they" refuse) to separate observations about the discipline from observations about objects within the discipline, and that it does so, on my understanding, not by claiming to dissolve art history into some broader field—cultural studies and semiotics are certainly leading candidates—but by entering more deeply into how it is that there is a field: what it is that our knowledge can never take the final shape of some clear view across the whole terrain but must be built always out of a thick interplay of language, object, and discipline in which no one of the terms stands wholly inside or outside any of the others. These things then turn within and through each other, creating complex pockets and interlacings, skeins and foams and knots. (There are times when it is important to me to call this perfectly ordinary.)

If deconstruction promises something to art history, that promise remains bound to the conditions that bind all our promises: A promise is not made when I say "I promise" but when the other to whom I make that promise secures it from me. I have tried to sketch a strange movement of promising between what has been called

deconstruction and art history. It is not, on the face of it, the kind of movement that will end in something one could comfortably call "the new art history," but at the same time it is clearly not "the old art history," whatever we might imagine that to be. It is tempting to say that the same logic of fidelity and betrayal that governs the relations between an "old" art history and a "new" art history also governs the relations between deconstruction and art history in general—that is, a complex double movement of loss and rediscovery that Derrida sometimes describes as a movement of "contraband" and at other times discusses in terms of the necessity for both "signature" and "countersignature," neither one capable of closing accounts on its own and for itself, with the result that the account remains permanently open and divided.

I have tried in these remarks to hold myself to clarifying the sense and motives of deconstruction over and against certain other practices with which it is often linked. That is, I suppose, my moment of fidelity to deconstruction, but what follows from that clarification is always a demand for something like loss or infidelity: Deconstruction in art history cannot be known in advance; art history in deconstruction remains art history. What difference does deconstruction make, then?

One way to answer this would be to go on at some length about what deconstruction means by "difference," and so on. It's a serious answer, but perhaps a blunter approach can serve as well: Presumably, on my account at least, it does not make the kind of difference that leads one to say, "Once I was an art historian, but now I know better" (just as it has not led Derrida to say, "Once I was a philosopher, but now I know better"). Perhaps it is closer to the kind of difference one reports as something like self-discovery ("Now I know what it is that I am—have been—an art historian"). But of course it's hard in the event to tell the difference between these two—so maybe it's best to say that deconstruction is interested in the relations among such versions, conversions, and diversions of our selves and our objects.

That at least seems to move toward something I have been trying to do throughout, which is to indicate something of the way in which discipline and object, say art history and postmodernity, must sign and countersign for one another. There is no color outside of

such double writing, and in that writing its name divides. Color has not yet been named.[35] But then nothing has. This is what it is that things happen, in art history and elsewhere.

1994

CHAPTER EIGHT
NOTES ON THE REEMERGENCE OF ALLEGORY, THE FORGETTING OF MODERNISM, THE NECESSITY OF RHETORIC, AND THE CONDITIONS OF PUBLICITY IN ART AND CRITICISM

Another drawback of these grand constructions is that it is necessary to have recourse to allegory, so cold in poetry, so obscure and unbearable in painting. Fools willingly call allegory the poetry of painters; for my part, I think that nothing so testifies to an artist's lack of genius as resorting to allegory.
—Friedrich Melchior Grimm, as cited by Michael Fried in *Absorption and Theatricality*, Appendix A

Now I want to suggest that in the Homère récitant *that strategy has been carried further by the provision of an entire audience, from which the beholder feels himself to be excluded, listening to and presumably absorbed in Homer's recitation. In addition, the poet himself is depicted as aware of the presence of that audience, for which indeed he is performing. The position of the beholder in this regard is at once deprived and privileged, much like one backstage or in the wings at a theatrical production.*
—Michael Fried, *Absorption and Theatricality*, Appendix C

*T*hese notes are at once scattered and ambitious: that they are scattered will no doubt pass as a sign of the pluralist times; that criticism and theory of criticism appear here as the site for a certain kind of intellectual ambition may strike some as more deeply problematic. Robert Pincus-Witten once feared that criticism had become sophisticated and powerful enough to crush

"genuine" artistic ambition. This is nonsense (of a peculiarly critical sort)[1]—the deep risk for criticism is that it might crush or lose itself and that it might do so through its profoundest achievements. This is the central risk of the ambition embodied in these pages—that, as Paul de Man would have it, its insight is exactly its blindness as well. It will become apparent that these remarks are not a preliminary apology—with them we are already in midstream.

Merely a Grammar

Mere: A boundary; also, an object indicating a boundary, a landmark.
Mere: 1a. Of wine: Not mixed with water, Obs.
 1b. Of a people or their language:
 Pure, unmixed. Chiefly in Mere Irish . . .
now often misunderstood as a term of
disparagement, the adj. being apprehended
as in sense 5.
 1c. Of other things, material and
immaterial: Pure, unmixed. Obs.
 . . .
 5. Having no greater extent, range, value,
power, or importance than the designation
implies; that is barely or only what it is said to
be.
 Mere: . . .
 4. A marsh, a fen.
Mere: A mother.
—from the OED

The reemergence of "allegory" as a central term in recent criticism of literature and art is an event of some interest and complexity.[2] These notes are an attempt at charting some (perhaps neglected) aspects of this event.

The charting will take place to a perhaps surprisingly large extent within the terms and at the limits of the formalist program of the middle and late sixties (the terms and limits of "Art and Objecthood" above all)—and of the historical elaboration that program has received in Michael Fried's subsequent writings, particularly those collected under the title *Absorption and Theatricality: Painting and*

Beholder in the Age of Diderot. This essay takes this book as an oppor-
tunity to review an argument and a career.[3] Where this can claim to
be something more than a mere review, it can perhaps still be no more
than an appendix to Fried's work, to Fried's appendices especially.

My concern will be to explore the extent to which the formalist
program is and is not still that in which we move and write and
engage our issues—to explore the current condition of criticism at
least; how far formalism touches the condition of art may remain an
open and contested question.

Allegory has come to appear for us as "the trope of tropes"[4]—
and my concern is then with who we are now and what it means for
us to find ourselves before this appearance.

Allegory has come to appear for us as the trope of tropes—and
this should be astonishing. What we are inclined to forget is that for
most of us allegory has been—where it has been anything at all—a
term of denigration, a way of naming the merely rhetorical: the brute
fact of and constraint to ornament, convention, artifice—opposed
variously to the depth and integrity, spontaneity and organic holism,
of metaphor and symbol. Grimm's sense of cold and boring artifice
has been, by and large, our own as well:

> One thinks that one justifies these enormous constructions by
> saying that they are meant less to touch us than to arouse our admiration.
> But admiration is a rapid feeling, a sudden thrill that does not last and
> that becomes tiresome and cold as soon as one wants to prolong it. It is
> always produced by the simplicity and sublimity of a thought or work of
> poetry, in painting or in music, whereas those complicated works can
> cause only a kind of cold astonishment. The most artistically arranged
> brilliance soon bores and repels. This is not to mention the numerous
> added ornaments and inevitably out of place accessories that a
> composed work of a certain size entails.

Grimm goes on to remark that,

> these reflections necessarily lead to another. It is incredible how much
> havoc and harm have been wrought in all the arts by imitation. Imitation
> alone is responsible for the audacity and success of mediocre people,
> the timidity of men of true genius, and the discouragement the latter feel.[5]

Fried appends Grimm's text to his book because of its bearing on
"unity, instantaneousness, and related topics"—topics that underlie

and inform Fried's central distinction between "absorption" and "theatricality." We will be turning to this material shortly, but for the time being we do well to remark, in Grimm and in ourselves, the extent to which the recognition of "mere allegory" is embedded in a larger "mere structure" which links (as if necessarily) "mere allegory," "mere ornament," and "mere imitation." "Mere rhetoric" has its place in this chain; in England "mere Protestantism" holds a place in crucial adjacency to it. I am neither historian nor scholar enough to draw this picture in detail, but some of the central nodes in the history organized by this chain—some, for example, of the literary figures on whom the risk of "mereness" most nearly and powerfully pressed—are, I think, obvious enough: Sidney (who lived through the transformation of "mere" from the praise of "pure, unmixed" to its current and derogatory sense); Milton (of course); and (closest to us perhaps) those condemned to follow and find themselves in Milton's poetic wake. In the English tradition there are a certain number of texts that seem to draw their peculiar strength from the manner in which they are intertwined with the terms of this structure: sermons by Donne and Andrewes, Swift's *Tale of a Tub*, Carlyle's *Sartor Resartus*, the career and apology of Cardinal Newman. No doubt the idea and experience of America have their place here as well.

This "mere structure" is the logical concomitant of the twin (and in England simultaneous) movements of Reformation and Renascence. The risk inherent in such repetition and return to origin is that of "mere repetition" (a term to name the chain as well as figure in it). This is one way of fleshing out Stanley Cavell's skeletal characterization of modernism:

> The essential fact of (what I refer to as) the modern lies in the relation between the present practice of an enterprise and the history of that enterprise, in the fact that this relation has become problematic.[6]

An age whose relation to its past has become problematic in this way will be led to find and guarantee itself and its work through detour and delay—works and devices of indirection, complex barriers to and recoveries of presence. Implicit here is a notion of "necessary indirectness"—a notion Cavell has explored with some delicacy in an essay on Kierkegaard.

> This, then, is a very particular literary problem, a problem
> concerning a very particular situation of language, not one . . . in which
> there are alternative vehicles for expressing a thought, one of which can
> be said to convey it directly, the other indirectly; nor . . . a situation in
> which there is no alternative vehicle of expression for the thought and
> therefore no way in which it can be conveyed differently (directly or
> indirectly). It is one in which, while there is only one vehicle of
> expression, there are two thoughts it can express, and moveover the
> thoughts are incompatible, mutually defeating . . . [The] message is of
> such a form that the words which contain its truth may be said in a way
> which defeats that very truth.[7]

This we have called "irony." We are being taught now to see in
it "allegory" as well. Laurie Anderson speaks of the gesturing figure
on Apollo 10, "Do you think they will think his hand is permanently
attached that way? Or do you think they will read our signs? In our
country, good-bye looks just like hello?" Craig Owens comments:

> Two alternatives: either the extraterrestrial recipient of this message
> will assume that it is simply a picture, that is, an analogical likeness of the
> human figure, in which case he might logically conclude that male
> inhabitants of Earth walk around with their right arms permanently raised.
> Or he will somehow divine that this gesture is addressed to him and
> attempt to read it, in which case he will be stymied, since a single
> gesture signifies both greeting and farewell, and any reading of it must
> oscillate between these two extremes. The same gesture could also
> mean "Halt!" or represent the taking of an oath, but if Anderson's text
> does not consider these alternatives that is because it is not concerned
> with ambiguity, with multiple meanings engendered by a single sign;
> rather, two *clearly defined but mutually incompatible* readings are
> engaged in blind confrontation in such a way that it is impossible to
> choose between them . . . this works to problematize the activity of
> reading, which must remain forever suspended in its own uncertainty.[8]

"Allegory," as it (re)appears for us now, appears as a belated
rewriting of "irony."[9] What intervenes between the one and the
other, what is rediscovered between "irony" and "allegory," is just
the fact and necessity of reading, of criticism. Cavell wrote of
Kierkegaard,

> In using such words directly the relation between what one says and
> what there is in those words to be heard and understood is ironic, and,
> depending on the context and the consequences, comic or tragic.[10]

More recently he has had this to say (of Wittgenstein):

Putting together the ideas that noticing an aspect is being struck by a physiognomy; that words present familiar physiognomies; that they can be thought of as pictures of their meaning; that words have a life and can be dead for us; that "experiencing a word" is meant to call our attention to our relation to our words; that our relation to pictures is in some respects like our relation to what they are pictures of;—I would like to say that the topic of our attachment to our words is allegorical of our attachments to ourselves and to other persons. Something of this we were prepared for. My words are my expressions of my life; I respond to the words of others as their expressions, i.e., respond not merely to what their words mean but equally to their meaning of them. I take them to mean ("imply") something in or by their words; or to be speaking ironically, etc. Of course my expressions and my responses need not be accurate.[11]

Irony slides toward allegory as it recognizes its involvement with other minds and persons—and as it does so it confuses and complicates the line between what we might otherwise want to distinguish as, for example, literature and life. When Cavell writes that "the idea of the allegory of words is that human expressions, the human figure, to be grasped, must be *read*," he returns us to Laurie Anderson's rumination on our attempts to communicate with extraterrestrials. And when Cavell extends his meditation, by suggesting that "the human body is the best picture of the human soul"

—not, I feel like adding, primarily because it represents the soul but because it expresses it. The body is the field of expression of the soul. The body is *of* the soul; it is the soul's; a human soul *has* a human body. . . .

and when he goes on to recall Hegel's assertion that "[the] human shape [is] the sole sensuous phenomenon that is appropriate to mind," we should be recalled to "Art and Objecthood"'s terms of criticism:

. . . what is wrong with literalist work is not that it is anthropomorphic but that the meaning and, equally, the hiddenness of its anthropomorphism are incurably theatrical.[12]

What Fried objects to in the work of Tony Smith is the way in which it offers itself to its beholder as (not simply a person but) a

person who then refuses to allow one a human relation to itself—it is work that distances itself from (the subject it thereby forces to become merely) its beholder. It refuses to let itself mean—be taken as meaning; it is soulless, it enforces the condition Cavell calls "soul-blindness" on its viewer.[13] We have known people with this kind of irony—who would make us the decider of their ensouledness, who would make us decide for them the humanity of their expressions.

We are not (yet) Martians to ourselves, and if it is true that hello and goodbye look just the same in our country and that there are therefore senses in which our reading of one another is forever suspended in its own uncertainty, it is also and no less true that we do in fact read each other (felicitously or no). We wave back, greeting or parting or both. (As Derrida might sometimes have it: it is a condition of the mail's going astray that it be sometimes delivered.) We stand here in any case, our arms raised to modernism, to "Art and Objecthood," to Tony Smith and Vito Acconci and Robert Smithson, Stanley Cavell and Jacques Derrida, one another.

The Dialectics of Purity

> The task of self-criticism became to eliminate from the effects of each art any and every effect that might conceivably be borrowed from or by the medium of any other art. Thereby each art would be rendered "pure," and in its "purity" find the guarantee of its standards of quality as well as of its independence.
> —Greenberg, "Modernist Painting"

I have now to tell a double story, a history of purity and its vicissitudes and a history of the critical appreciation of the complexities of that purity.

Clement Greenberg's central formulation already hedges its bet. The scare-quotes set about "purity" mark a moment of hesitation, recoil, anxiety that becomes, in "Art and Objecthood," an extended unease, dividing and hiding itself between two well-separated footnotes. The first reads in part:

> . . . flatness and the delimitation of flatness ought not to be thought of as the "irreducible essence of pictorial art" but rather as something like *the minimal conditions for something's being seen as a painting*; and . . . the crucial question is not what these minimal and, so to speak, timeless conditions are, but rather what, at a given moment, is capable of compelling conviction, of succeeding as painting. This is not to say that painting *has no* essence; it *is* to claim that that essence—i.e. that which compels conviction—is largely determined by, and therefore changes continually in response to, the vital work of the recent past. The essence of painting is not something irreducible. Rather, the task of the modernist painter is to discover those conventions that, at a given moment, *alone* are capable of establishing his work's identity as painting.[14]

In the opening Fried gives us we should pause to note just how far the diverse works of the past decade have forced this—can the work of, for example, Vito Acconci be "seen as painting"? What would it mean to see it so—and would that be different from seeing it some other way (as theater or TV or poetry)? RoseLee Goldberg (among others) has tried to present performance as its own genre, backed with its own (short) historical pedigree; how far can we be inclined to buy this? How far are we inclined to see performance as answering always to the criteria—and problems—of some other art—painting, sculpture, (real) theater? And what of earthworks and conceptual art and process art and a hundred other forms of post-Minimalist enterprise? How seriously are we to take these activities, and on what terms? The questions end where Fried closes his opening on us.

> The truth is that the distinction between the frivolous and the serious becomes more urgent, even absolute, every day, and the enterprises of the modernist arts more purely motivated by the felt need to perpetuate the standards and values of the high art of the past.[15]

The "purity" that Fried thus surrenders with one hand is (almost) silently recovered with the other (and for those concerned with tracing the genealogy of a new allegorism it is far from irrelevant that the recuperating hand here is one concerned to fence the high and serious art of Morris Louis off from the degenerate and theatrical flatbed tableaux of Robert Rauschenberg). The uneven, stumbling rhythm at work between Fried's footnotes—the broken-legged, limping dialectic of "purity"—is crucial to the formalist program; it is between and

across purity's eclipse and recovery of itself that the work of this crit-
icism is achieved. Its work is that of separating, impossibly, the "mere"
from the "pure"; where its rhythm ceases, where the jagged hesita-
tions of "purity" are reduced to the punctual simplicity of "that which
is unique and absolutely fundamental" to every art, criticism is lost—
mere purity is the forgetting of modernism (if such a forgetting and
such an impulse to puritanism were not also a hallmark of what we call
modernism in its double impulse to repetition and origination).

But we are running ahead of ourselves here and likely to become
entangled in our own legs.

Michael Fried has, in support of "Art and Objecthood," a story
to tell. It is the story of painting's effort to purge itself of (what it
would call) the merely theatrical. It goes—schematized nearly to par-
ody—like this:

At a certain time and in a certain country, art saw—saw what? It
is not easy to say what it is that we are to take it that art somehow
obscurely glimpsed in its experience of and reflection on itself (it is
not even clear how far this "glimpsing" is to be taken literally, how
far metaphorically).—Art saw that it was seen, and it saw—in this
exposure of itself to an audience, a beholder—itself at risk (at risk,
then, just where it succeeds, when it succeeds). Painting came to fear
that it could lose itself and that it could lose itself as if in broad day-
light. Something of this fear and its difficulty is at work in the first of
the two footnotes we have cited from "Art and Objecthood," leading
Fried into the major complexities of:

> To begin with, it is not quite enough to say that a bare canvas
> tacked to a wall is not "necessarily" a successful picture; it would, I think,
> be less of an exaggeration to say that it is not conceivably one. It may be
> countered that future circumstances might be such as to make it a
> successful painting; but I would argue that, for that to happen, the
> enterprise of painting would have to change so drastically that nothing
> more than the name would remain.[16]

"Nothing more than the name would remain": How could we—
how can we—know that this has not in fact already happened? that it
is not in fact happening at every instant in the history and world of
painting? What if painting ("painting") is everywhere invaded by its
own loss—what would we then want to say about painting, and how?

Let us say, to get on with the story, that around the time of Diderot painting glimpsed a possible future in its recent and rococo past and saw that, in this future, it was—wallpaper, Muzak for the eyes, panels of vague and pleasant prettiness. What it thus saw is not without its truth. Painting is or was right to be scared; it is there only to be looked at and unless it could take control of this fact it would seem to be condemned to the merely decorative. (And then we have to note that the claim to an allegorical postmodernism is coincident with a new valorization of the decorative impulse and of pattern painting—these two movements can then appear to be the same, as any modernism and literalism can appear to be the same.)

Painting saw, in its experience of itself, something obscure, barely palpable, and dangerous—something about how it might lose itself. It could, of course, have been wrong (we all make mistakes). The history Fried has worked through would then reduce to an unfortunate error, a prolonged moment of overreaction to the Enlightenment and its rationalist "put up or shut up." Postmodernism would then name painting's recovery from its long night of anxiety—much, perhaps, as literary modernism sought to understand itself as the recovery of a certain poetry from its dark night of dissociation and groundless fear.

On such a view, painting will have always been secure in itself, its essential core safely buried inside itself all along, authenticating the work that continued to count and discounting the rest. This view reads "purity" as "that which is unique and absolutely fundamental" to each art. It assumes that "radical self-criticism" is the name of a certain test imposed by and in reaction to the "rational criticism" of the Enlightenment—a test that religion, for example, is taken to have failed, but which painting, in its (re)discovery of flatness will pass. It is the arid formalism against which so many artists and critics claimed to be reacting in the late sixties and the seventies; it is what we keep claiming to be beyond or outside.

That this sort of formalism is stifling and absurdly restrictive goes now without saying. But we still need to understand how it could ever have been a powerful guide to and for painting—what power we may be passing over in our anxiety for the recovery of a new beyond. We need to grasp the historical rhythm and complexity opened by the notion of purity before it subsided into the truth of painting (as we will need to grasp the rhythm of allegory before it too subsides into its own truth).

This is where Fried's work over the past decade counts profoundly. His deep story—as against the apparent tale in Greenberg—is not that of the truth of painting, but rather that of painting's continuing effort to recover itself through and across its denials and evasions of its necessary conditions. The story is dialectically charged, but is, in principle at least, not submitted to the authority of any Absolute. At the same time, it is a story that cannot be told except through the postulation of some Absolute somewhere. It would be radically existential, having us see how painting makes itself, but it cannot avoid having somewhere to assume a fixable—made—self. It is an account that, in its essence, is open to attack and controversy—but attacks that cannot reach at least as far as this inner openness to controversy will be without interest for it.

How, then, does the story go? Painting realized a certain possibility of loss of itself in the face of its presence to a beholder and undertook to expel that possibility from itself by refusing that very fact. The history begins with a denial of "the primordial convention that paintings are made to be beheld,"[17] and, as with any such denial, time tells of its failures, its inevitable betrayals of itself: one can, for example, deny the fact and fear of castration—but at the expense of the sanity of one's little finger.

Painting's little finger is its relation to theater and theatrical performance. This relation would be one of mere and mutual externality—two arts each organized around its own rational core. The only problem they face would be a certain tendency to confusion, a confusion to which adequate vigilance could put a stop. For painting, "theater" would be the name of a central failure—a failure that remains within the general sphere of the aesthetic and forecloses the possibility of any radical fall out of art altogether. The risk is not that the work might be taken for wallpaper but that its tableau might be misinterpreted as theatrical—might be taken to demand rather than to deny or absorb its beholder. The category of "theatricality" conceals and constrains a crossing between questions about whether something is art and about whether it is good art; this is part of what it means to write, as Fried does, that "what lies between the arts is theatre."[18]

Out of this nest of fictions, displacements, and deferrals, painting constructs for itself a project that can appear as one of rational self-criticism: the task of painting will be to cut itself off everywhere from

the merely theatrical—everywhere exclude from itself that which continues to pose the persistence of an exterior beholder—and so work always toward that in itself which is capable of absorbing its viewer.

As this project unfolds in time, it will necessarily have the character of a series of reinterpretations of the meaning of "absorption" as each given grasp of it falls before the inevitable and ineluctable fact of the beholder. The beholder, always there, gazing, is the silent motor that drives the history of modern painting forward, forcing it to find behind its ever more radical claims to absorption always the same brute fact of theater.

The details of this history are the critic's work, and I cannot pretend to do any justice to (let alone evaluate) Fried's analyses and readings. It is important, however, that we have some feel for the overall shape and logic of the story.

The project of absorptive painting begins, as if naturally, from the painterly idea that the most absorptive works are those that present absorption itself. This idea is itself open to a variety of realizations—sleep can appear as a paradigmatically absorbed state, but so also can states of waking reverie, or intense concentration, or deep emotion. What appears when as an adequate vehicle for this thematic approach to the project of absorbing the viewer will depend very much on what has appeared when and how it appeared then.—Can still life be a vehicle for absorptive painting? In principle anything can appear as such a vehicle, but only when it does (and when it does it will appear as an argument for its own necessity). The constraints are existential and historical.

Now (and here we collapse a complex history that is properly articulated only through the paintings that embody it into a single and ridiculous chain of tortured conditionals): if the representation of action, crucial action in particular, comes to seem an adequate vehicle for absorptive painting, then history painting (of a certain kind) will become a privileged genre; and if history painting becomes so privileged in a country whose political history is prone to pose itself more or less explicitly as a repetition of an earlier history (as the French the Roman), then that history painting will be, at least implicitly and so finally explicitly, a political painting as well, so that at a certain point it will have "Frenchness" as an issue internal to the project of painting itself and determining the history of absorptive painting as having

been all along a history essentially "French," thus encouraging the posing of the problem of authoritative painting as a problem of breaking out of "Frenchness" and regaining contact with the greatness of (what now appears as) European painting: so that at various points on the road to what appears in America in the mid-twentieth century as a formalist art and criticism the terms in which painting will have counted and will demand to be appreciated will vary from the thematic to the political to the art historical.[19] With respect to this history we can say either that "formalism" names only one, relatively late moment within it, or that "formalism," properly understood, entails a critical responsiveness to the way in which painting poses itself in itself and for itself in each given instance. "Form" and "medium" are correlatives, and if, as Cavell writes, "the medium is to be discovered or invented out of itself,"[20] "formalist" criticism is a criticism that must always rediscover and reinvent itself out of the work it considers.

Another feature of our history: inscribed within its initial logic is a moment in which the painter will come to realize that he stands himself as beholder to his own work (here we touch on the problematic metaphoricity of the claim that "painting sees . . .") and that the work will then inevitably remain theatrical unless it can come to absorb him as well—a moment of radical narcissism, self-portraiture, that marks also a shift from a thematic grasp of absorption to a more formal one.[21] There may well be ways in which we will want to see in much performance work a belated renewal and repetition of this moment; Courbet and Acconci may meet in an insistence that the empirical self, the artist's self, is not exempt from the notion of "radical self-criticism." (What Acconci gazing at his own body has to do with a history that assumes "painting sees. . . .")

Another feature: the history we have recounted is organized by its radical determination to maintain the fiction that painting is not submitted to a beholder and is related to the theater only externally and, as it were, accidentally. Sooner or later, there will be a corner to be turned—the corner of no longer trying to turn the corner into purely absorptive painting. For Fried, Manet is this corner—the point at which painting accepts the internality and inevitability of its relation to theater, acknowledges its own theatricality. Henceforth, paintings that continue to insist on the kind of abstract purity underlying the (traditional) project of absorption will now appear as irrecuperably

theatrical, and paintings that explicitly pose (and master) their own theatricality become capable of exercising the claim upon our attention that "absorption" had meant to name. This, of course, looks like the dialectical overcoming of Diderot's opposition—except that what "theatricality" has been naming all along is the inevitability of distance—between painting and its viewer at first, but now a distance acknowledged as internal to painting itself—which will always keep painting from the sort of radical coincidence with itself promised by dialectical closure. Painting continues to engage itself in, as it were, midair, held by its own bootstraps between theatricality and absorption, wall-paper and the Absolute. Painting prolongs itself as it purloins itself from itself: the punning is Derridean, and the formulation intends to recall the radical complications Derrida imposes upon any history or story that would claim to deliver its message to its proper receiver (stories too obviously built around a message they would deliver we frequently recognize as allegories).

From David to Couture to Courbet to Manet and on down to the controversies of the sixties, painting is submitted to an impulse to purity—to presentness—and to the transgression or critique of that impulse—and so also is criticism: neither within painting nor within criticism nor within the relation of the one to the other do purity and impurity exclude one another simply.

Three or Four Museums

> . . . it seems clear that starting around the middle of the eighteenth century in France the beholder's presence before the painting came increasingly to be conceived by critics and theorists as something that had to be accomplished or at least powerfully affirmed by the painting itself; and more generally that the existence of the beholder, which is to say the primordial convention that paintings are made to be beheld, emerged as problematic for painting as never before.
> —Fried, *Absorption and Theatricality*

From Fried's account, we can envision Diderot as imposing upon painting a simple test—a test of its "stopping power," its ability to

transfix and absorb in an instant its beholder. The application of this test—by, for example, a stroll through the salon—would end by distinguishing two groups of paintings; the successful—absorbing—paintings could then be gathered up and hung elsewhere where they would, together, figure as so many examples of, simultaneously, art and good art, painting and good painting—a simple and perfect museum.

This imaginary museum is, however, given the lie by the corruptions of time; nothing is more merely theatrical than yesterday's high and absorbing drama. Greuze gives way to David who gives way to Courbet. ... The shows must be changed ever faster and the very walls of the museum become unstable.

The museum/salon is supplanted, in this imaginary history, by the museum/encyclopedia—Manet's museum, as well as Flaubert's[22]—a museum that is organized as a bulwark against time and its undoing of power. It is a museum that would recover and maintain an openness to "the great art of the past," protecting painting from the provinciality of the moment and the region, offering painting (to) the European tradition (a museum that cannot take kindly to the intrusion of geological time and site).

The museum/salon argued nothing. Its license was, radically, the experience of paintings, and in each case the experience of presentness was sufficient justification for the work. Time existed in this museum only to the accidental extent that one had to get one's beholding self from moment of presentness to moment of presentness. The museum/encyclopedia would acknowledge the facts of time and master them (the "facts of time" are here a new name for the "primordial convention that paintings exist to be beheld"). Individual paintings surrender their claim to the simplicity of presence, taking instead their place within a tradition of painting, unfolding in time, through which all claims to presentness are mediated, either implicitly (in, for example, our attempts to recall the vanished power of Greuze) or explicitly (in, for example, Manet's work). In the latter instance, we see that the explicit recovery of time in and for painting is also its explicit acknowledgment of the inevitable theatricality of painting, in itself and in its relation to the past. We will be inclined to condemn as merely—that is, disguisedly—theatrical those works that do not take on time for themselves, but rather leave it in the hands of the viewer, to shape as he or she sees most fit:

> . . . the experience (of literalist art) *persists in time*, and the presentment
> of endlessness that, I have been claiming, is central to literalist art and
> theory is essentially a presentment of endless, or indefinite *duration*. . . .
> The literalist preoccupation with time—more precisely, with the *duration
> of the experience*—is, I suggest, paradigmatically theatrical: as though
> theatre confronts the beholder, and thereby isolates him, with the
> endlessness not just of objecthood but of *time*; or as though the sense
> which, at bottom, theatre addresses is a sense of temporality, of time
> both passing and to come, simultaneously *approaching and receding*, as
> if apprehended in an infinite perspective. . . . This preoccupation marks
> a profound difference between literalist work and modernist painting
> and sculpture. It is as though one's experience of the latter has no
> duration—not because one *in fact* experiences a picture by Noland or
> Olitski . . . in no time at all, but because *at every moment the work itself
> is wholly manifest*.[23]

The museum/encyclopedia has time as a problem, recognizing
that the corruptions to which the museum/salon was exposed were
not accidental: a theater was always there in advance of the drama of
the moment—how else could we have recognized it as drama?
Diderot's criticism as it is unfolded by Fried makes a knot of time and
theater such that the prospect of absorptive painting emerges
between the past (and present) theatricality of the stage and the
future possibility of that stage renewed by its discovery of the real
drama bodied forth in successful painting. The "tableau" is the diffi-
cult seam here between the canvas and the stage.

The museum/encyclopedia would exist without contradiction, at
once guaranteeing and guaranteed by the Tradition. The visitor
could then walk easily from painting to painting, recovering each
from each, experiencing newly not only the works on the wall but
also the space between, the space of art history, the sense and appre-
ciation of painting. There is in such a museum no deep scandal—no
outrage history cannot place and heal, place at heel.

"Art and Objecthood" and its attendant controversies might be
said to mark the end of this dream of a museum. It rides uneasily its
contradictions and those of the history it would close, protect, and
finally guarantee. It rests uneasily as well within its understanding of
itself as criticism.

"Art and Objecthood" figures for us here as an attempt to defend
the adequacy and integrity of the museum/encyclopedia—an attempt
to show that the coincidence of art and good art can be maintained.

We might say that the museum/encyclopedia has for its internal threat what appears as the "institutional theory of art"—the idea, most simply, that the museum means nothing, that art is nothing more than what makes it into the museum and that the appearance of the museum as at once guaranteeing and guaranteed by the history of art is simply and finally empty. Institutional theories would have us believe that there is nothing radically scandalous in art or its history—not because of the way art builds itself in and out of its history, but because the museum can absorb anything (*Fountain* is the proof). Against such a theory, the museum/encyclopedia proves itself through the historically and systematically grounded exclusion of that which is irredeemably theatrical: the scandal of Tony Smith or Donald Judd or Robert Rauschenberg.

The claim has now been advanced that we live in and on the ruins of this museum—in and on the failure of its exclusions—in the wake of "Art and Objecthood."[24] I suggest that we should recognize in these ruins what we have come to call "the artworld"—a complex and contradictory network of (among other things and persons) museums, galleries, alternative spaces, sites, nonsites—arenas of various and mutual exclusions. This "artworld" is, in a sense, the artworld of the institutional theorist, but brought down to earth and stripped of its simplicity and homogeneity—so that if at one level this artworld as a whole is capable of absorbing all the scandals with which it is presented, it can do so only by absorbing them as scandals, by taking internal controversy and radical dissension as proper to itself. To appreciate a work in this new "museum" is with a new explicitness to map its world, and to do so partially, with prejudice.

What is surrendered or radically transformed in the passage from museum/encyclopedia to artworld is any faith in the homogeneity, simplicity, or univocity of art history: the scene is ineradicably plural.

It it also and explicitly a scene—an acknowledgment of just how deeply and pervasively we are submitted to theater and theatricality. The emergence of the artworld marks an invasion of the museum, of art history and art criticism, by the very terms, problems, and crises it would more externally survey. This is what Smithson early and polemically picked out as the difficulty with "Art and Objecthood":

> Michael Fried has . . . declared a "war" on what he quixotically calls "theatricality." In a manner worthy of the most fanatical puritan, he provides the artworld with a long-overdue spectacle. . . . Fried has set the critical stage for *manneristic modernism*. . . . What Fried fears most is the consciousness of what he is doing—namely being himself theatrical.[25]

But it is important to see that Fried could not have said what had to be said except by exposing himself to just this charge. "Art and Objecthood" can accomplish its critical work only by posing a crisis for criticism to which it is not, by itself, adequate. The core of the issue has been brought out by Stanley Cavell:

> There are no such proofs possible for the assertion that the art accepted by a public is fraudulent; the artist himself may not know; and the critic may be shown up, not merely as incompetent, nor unjust in accusing the wrong man, but as taking others in (or out); that is, as an imposter. . . .
> He is part detective, part lawyer, part judge, in a country in which crimes and deeds of glory look alike, and in which the public not only, therefore, confuses the one with the other, but does not know that one or the other has been committed; not because the news has not got out, but because what counts as the one or the other cannot be defined until it happens; and when it has happened there is no sure way he can get the news out; and no way at all without risking something like a glory or a crime of his own.[26]

In this light, Smithson's attack seems accurate, but also too easy. If "Art and Objecthood" is significantly a piece of theatrical criticism, we are going to want to say also that "absorption" and "theatricality" end not as concepts recovered from and on behalf of the history of art and criticism, but as means to the staging of (a certain) history of modern art—devices of visibility and articulation, but also devices of invisibility and silence. What makes Smithson's attack too easy is his sense that in calling Fried "theatrical" he has managed to put him aside—in just the way Fried put Tony Smith aside. But of course Fried was "wrong," and so also was Smithson. We are no more free to walk away from the complications imposed on criticism by an acknowledgment of its theatricality than Fried is to walk away from the complications imposed on the history of art by the persistence of a Smith or a Rauschenberg. In each instance the stake is something that would proclaim itself in some sense "postmodern."

The Impossibility of Theater

> Brecht calls for new relations between an actor
> and his role, and between the actor and his
> audience: theater is to defeat theater. But in
> Beckett there is no role towards which the
> actor can maintain intelligence, and he has
> nothing more to tell his audience than his
> characters' words convey. Theater becomes
> the brute metaphysical fact of separateness;
> damnation lies not in a particular form of
> theater, but in theatricality as such. If against
> that awareness, theater were to defeat theater,
> then while theater loses, it thereby wins; we
> have not found our way outside, we have
> merely extended the walls.
> —Cavell, "Ending the Waiting Game"

What is "theatricality"? Like "absorption," it is a term caught up in a dialectic that everywhere redefines and transforms it—and it is so because it is, like "absorption," impossible.

"Theater" is what pure painting would exclude from itself—what it thus fails to exclude and is, in the end, obliged to acknowledge as its inward capacity to go always astray from itself (we could even say: to *be* always astray from itself). But, as Fried reads Diderot, this very theater can be divided against itself, sorted out into the merely theatrical and the truly dramatic. The stage—to name the neutral thing on which the dialectic both breaks and rests—shows forth not only the threat to or failure of painting, but also that which is most powerful and absorbing in it:

> The recognition that the art of painting was inescapably addressed to an
> audience that must be gathered corresponds to the exactly concurrent
> recognition that the theater's audience was a gathering not simply of
> auditors but of beholders . . . in both cases the problems were to be
> resolved by the instrumentality of the *tableau*, whose significance for
> each art was in a sense complementary to its sense for the other.[27]

For Diderot, if theater names the dumping ground of painterly failure, painting reserves the right to name the success of theater: this is the source of the "complementarity" Fried finds in the twin val-

orizations of the *tableau*. A theater of the *tableau* would be, for Diderot, a theater purged of theatricality—a pure theater such as exists nowhere and such as could come into existence only at its own cost, unable to recognize itself. A certain impossibility of theater undergirds what Fried presents as Diderot's "Supreme Fiction"— and we will see that if there has been something (in art, in criticism) like a turn from the modern to the postmodern, that turn has taken place within the shelter of this impossibility.

Fried writes:

> Diderot's advocacy of *tableaux* as opposed to *coups de théâtre* is to be understood chiefly in this light. "Un incident imprévu qui se passe en action, et qui change subitement l'état des personnages, est un coup de théâtre," he writes in the *Entretiens*. "Une disposition de ces personnages sur la scène, si naturelle et si vraie que, rendue fidèlement par un peintre, elle me plairaît sur la toile, est un tableau." . . . A *tableau* was visible, it could be said to exist at all, only from the beholder's point of view. But precisely because this was so, it helped to persuade the beholder that the actors themselves were unconscious of his presence.
>
> Diderot's use of the term *théâtre* in this connection reveals the depth of his revulsion against the conventions then prevailing in the dramatic arts. But it also suggests that he despaired that those conventions, and the consciousness of the beholder they embodied, would ever be fully overcome for once and for all. . . . Presumably Diderot felt that if the theater were to be reformed along the lines proposed in the *Entretiens* and the *Discourse*, painters would be able to look to the stage for inspiration without dooming themselves to mediocrity or worse. But he continued to express his distaste for the theater as he knew it and in his writings on painting used the term *le théâtral*, the theatrical, implying consciousness of being beheld, as synonymous with falseness.[28]

It is important to see in such passages how profoundly complicated the negotiations between theater and painting have become—how deeply purity and impossibility, achievement and failure, have become entangled with one another—and how the *tableau* emerges as the lie that binds. It is just here that we want to cite Craig Owens on the roots of Robert Wilson's theater—and we do so in order to see both what is powerful in its insight and what it too easily passes over:

> As I have written elsewhere, Wilson is indeed Artaud's heir, but the priority he assigns to visual imagery over written text aligns his work more

with the history of recent art than with that of theater or, rather, points to a crucial link between the two—the tableau.

In French, of course, "tableau" signifies both a painting and a theatrical scene; this semantic overlap is not without its consequences for both arts, as Roland Barthes observes: "As is well known, the whole of Diderot's aesthetic rests on the identification of theatrical scene and pictorial tableau: the perfect play is a succession of tableaux, that is, a gallery, an exhibition." This link between painting and theater was, however, suppressed with the ascendancy of modernism in the arts. Brecht was the last theatrical artist to conceive his works as successions of tableaux, and modernist painters in their single-minded pursuit of medium-specificity, have sought to distinguish their art from other arts, theater in particular. Thus Michael Fried, in his famous 1967 attack on Minimalism, "Art and Objecthood," could claim with impunity that "art degenerates as it approaches the condition of theater"—a pronouncement which, in the late 60s, gave rise to a storm of controversy over theatricality in art. It was into this polemical atmosphere that Wilson, who had studied painting with George McNeil and taken a degree in architecture at Pratt, emerged. In works like *Deafman Glance* (1971) and *The Life and Times of Joseph Stalin* (1973) he unequivocally identified the tableau as the meeting ground of painting and theater.[29]

If this statement appears both powerful and powerfully problematic, it is because we are now able to read an essay like "Art and Objecthood" with a much greater awareness of its internal complexity and historical depth. What should interest us is that the closer we get to what we mean or want to mean by "postmodernism" the closer we also get to the heart of Fried's critical and historical project. A summary statement from the end of "Toward a Supreme Fiction" points to the final, metaphysical stakes of this project:

As we have seen, the recognition that paintings are made to be beheld and therefore presuppose the existence of a beholder led to the demand for the actualization of his presence: a painting, it was insisted, had to attract the beholder, to stop him in front of itself, and to hold him there in a perfect trance of involvement. At the same time . . . it was only by negating the beholder's presence that this could be achieved; only by establishing the fiction of his absence or nonexistence could his actual placement before and enthrallment by the painting be secured. This paradox directs attention to the problematic character not only of the painting-beholder relationship but of something still more fundamental—the *object*-beholder (one is tempted to say object-"subject") relationship which the painting-beholder relationship epitomizes. In Diderot's writings on painting and drama the object-beholder relationship as such, the very condition of spectatordom,

stands indicted as theatrical, a medium of dislocation and estrangement rather than of absorption, sympathy, self-transcendence; and the success of both arts, in fact their continued functioning as major expressions of the human spirit, are held to depend upon whether or not painter and dramatist are able to undo that state of affairs, to *detheatricalize beholding* and so make it once again a mode of access to truth and conviction. . . . What is called for, in other words, is at one and the same time the creation of a new sort of object—the fully realized tableau—and the constitution of a new sort of beholder—a new "subject"—whose innermost nature would consist precisely in the conviction of his absence from the scene of representation.[30]

Diderot's dream, Fried's dream, is finally of a world to which we can be simply present and in which we can be simply present to one another, undivided and unposed, graceful. These are dreams about the possibility at once of community and integrity. And here we have to say that if theater and painting are two separate arts in search of their individual, pure, and detheatricalized selves, it is no longer clear that or how they are separate—even as it remains clear that there is no overcoming of their individualities. Their intercourse is complex. As they name in each other their various perils and promises, they show themselves to be so entangled that there cannot but come a time in which painting (for example) will have to recognize its theatricality not only as risk inherent in its still proper "inside," but as an "exterior" entanglement as well: the path of painting will inevitably cross that of a really existing theater (as my path crosses yours).

Radical self-criticism cannot stop short of acting itself out on the occasion of and in terms of empirical selves (even if this is not its real achievement). So also the painterly acknowledgment of theatricality has, at its limits, an interest in theater as such—and especially in that theater most deeply engaged in its own self-criticism—a theater caught up in—confused and torn by—the demand for detheatricalization precisely insofar as that demand is at once means and barrier to the realization of theater: a theater that would then ground itself on the display of its own impossibility; a theater that would show itself in and through the failure of theatricality, its inability to count as theater; Artaud's theater perhaps—an impossible theater that counts for painting in a way no other theater can.

In an essay on "the theater of cruelty and the closure of representation," Jacques Derrida writes:

Perhaps we can now ask, not about the conditions under which a modern theater would be faithful to Artaud, but in what cases it surely is unfaithful to him. What might the themes of infidelity be, even among those who invoke Artaud in the militant and noisy fashion we all know? We will content ourselves with naming those themes. Without a doubt, foreign to the theater of cruelty are:

1. All non-sacred theater.

2. All theater that privileges speech or rather the verb, all theater of words . . .

3. All abstract theater which excludes something from the totality of art, and thus, from the totality of life and its resources of signification: dance, music, volume, depth of plasticity, visible images, sonority, phonicity, etc. . . .

4. All theater of alienation . . . [Derrida's gloss touches Diderot and is worth noting: "There is no longer spectator or spectacle, but *festival*. All the limits furrowing classical theatricality . . . were ethico-metaphysical prohibitions, wrinkles, grimaces, rictuses—the symptoms of fear before the dangers of festival."]

5. All non-political theater . . .

6. All ideological theater, all cultural theater, all communicative, interpretive . . . theater seeking to transmit a content, or to deliver a message . . . that would make a discourse's meaning intelligible for its listeners; a message that would not be totally exhausted in the *act* and *present tense* of the stage, that would not coincide with the stage, that would not be repeated without it.[31]

Artaud too dreams the dream of presence. What real theater could exist within the limits of this dream? Derrida remarks that "Artaud kept himself as close as possible to the limit: the possibility and impossibility of pure theater." To the extent that Artaud committed himself wholly to such purity, the theater of cruelty exists only as the theory of its own impossibility, with neither instance nor legacy.

> I, Antonin Artaud, am my son
> my father, my mother,
> and myself.
>
> From this pure incest there is no issue:
>
> And now I am going to say something which, perhaps
> is going to stupefy many people.
> I am the enemy
> of theater.
> I have always been.
> As much as I love the theater,
> I am, for this very reason, equally its enemy.[32]

The uneven dialectic of "purity" is at work in these lines—even in their shape—so that even as Artaud would choke off the possibility of theater altogether, he reopens it once again. The possibility of (what would be) a pure theater is, in effect, recovered across the admission of its impurity: the theater of cruelty (re)appears as a theater always already torn from itself, and as a theater whose cruelty is first of all a cruelty toward itself—a measure of its division from itself. Derrida writes: "Presence, in order to be presence and self-presence, has always already begun to represent itself, has always already been penetrated."[33] The scene of representation persists. Call this a theater of images—a theater that cannot be a theater, that must be counted elsewhere.

If we can say convincingly (and we can) that "Wilson is indeed Artaud's heir," this is in large measure because both are joint heirs to a much more complex and divided legacy—a legacy the testamentary conditions of which are tangled by incest and cross-marriage, bizarre codicils and intervening deaths and disappearances (a legacy coincident with real history) to the point that it will never emerge from probate (not, at least, until its resources and those of its contestants are spent). Within this legacy there are terms under which theater, in its impossibility, can appear for painting—count for painting—in a way that it cannot for itself. (And in this play between the arts, the notion of audience and of beholder takes on a new depth of complication.)

The tableau is the seam along which modern theater and painting have been historically bound to one another. The undoing of this seam would presumably free painting from the threat of theatricality; but this would also release painting from itself, from its possibility of achievement. We recognize Wilson's theater as relevant to the current situation of painting to the extent that it appears to us as a theater of tableaux—a theater willing to find itself within a certain complex nonpresence to itself. Such a theater, appearing for an audience given (whether it will it or no) to finding itself in the wake of "Art and Objecthood," appears to decenter or deconstruct the play of mere presence and pure presentness through which Fried would have excluded the radical theater of Minimalist literalism. The slippage between his two terms—a slippage Fried implicitly claims to control, to be able to sort adequately into an experience of theater and a counterposed experience of grace—this slippage now appears as deeply internal to this theater of images (so that what is perhaps being undone

or rethought is the mythology of presence and presentness, transcendence and temporality, that underlay both sides of the earlier controversy—a present already penetrated by something other will find itself neither in a moment of grace nor in the experience of duration).

Wilson's theater would make allegorists of us—and would do so whether we interest ourselves in it as painters or as critics; allegory has always been a mode of both reading and writing, creation and criticism inextricably mixed. The painterly claim to the recovery of allegory unfolds into the situation of criticism as well. (But then every event in the history of painting Fried recounts rebounds upon and determines its criticism—what is new then is just the way this connection is displayed for [even forced upon] us now, the way in which criticism is newly called upon to acknowledge its relation to the work that is its occasion. It may be that we needed a rediscovery of allegory in order to see that Fried has been saying this all along.)

How Things Seam

> The new difficulty which comes to light in the modernist situation is that of maintaining one's belief in one's own enterprise, for the past and the present become problematic together. I believe that philosophy shares the modernist difficulty now everywhere evident in the major arts, the difficulty of making one's present effort become a part of the present history of the enterprise to which one has committed one's mind, such as it is. (Modernizers, bent merely on newness, do not have history as a problem, that is, as a commitment . . .)
> —Cavell, Foreword to *Must We Mean What We Say?*

> "*There is no there for you, where objects are. There are no individual exits from the world of objects into your dream. There are no individual marks or features by virtue of which you can pick out the real from the unreal. Criteria come to an end. Hallucination and dreaming happen all at once, seamlessly; they are world-creating, hence they are world-depriving . . .*"

I find that I do not accept this idea of the seamlessness of projection.

. . .

The others do not vanish when a given case fails me. My experience continues to affix its seam.

—Cavell, *The Claim of Reason*

The claim we are considering is that "over the past decade we have witnessed a radical break with the modernist tradition, effected precisely by a preoccupation with the 'theatrical.'"[34] On this account, the break with modernism has been effected through a shattering of the "integrity of modernist painting and sculpture" which makes it "clear that the actual characteristics of the medium, per se, cannot any longer tell us much about an artist's activity." This obliteration of boundaries has opened art's way to theater and its privileged experience of temporality. This is, very generally, the picture we have assumed and complicated throughout these notes. We do well to note not only that Fried's criterion of "seriousness" continues to preside over this development, but also that the claim made by Crimp on behalf of the new "aesthetic activities" that transcend or confuse media—the claim that these activities free us from a literal construal of the notion of medium—repeats exactly Fried's distinction of himself from Greenberg in the passage cited from "Art and Objecthood" at the very beginning of this essay. This should lead us to keep an eye on the peregrinations of the literal in Crimp's summary of the current situation:

An art whose strategies are thus grounded in the literal temporality and presence of theater has been the crucial formulating experience for a group of artists currently beginning to exhibit in New York. The extent to which this experience fully pervades their work is not, however, immediately apparent, for its theatrical dimensions have been transformed, and, quite unexpectedly, reinvested in the pictorial image. If many of these artists can be said to have been apprenticed in the field of performance as it issued from minimalism, they have nevertheless begun to reverse its priorities, making of the literal situation and duration of the performed event a tableau whose presence and temporality are utterly psychologized; performance becomes just one of a number of ways of "staging" a picture.[35]

One can be tempted to name this passage "Fried's Revenge." Perhaps even "Greenberg's Revenge." (Who put the scare-quotes on "staging" and to what effect? It happens in families that members are disinherited or otherwise excluded, and that children born to such members are nonetheless acknowledged and welcomed back into the bosom of the larger family.)

Michael Fried's writing is, in any case, interesting now in a way that it may not have seemed to have been for the past ten years or so. Its claim upon our attention has been renewed and it has been renewed by picturing's recovery of itself from the theatrical. As Crimp's paragraph continues, we should remark not only the presence of Artaud (in the wings as it were), but also the persistence of a problematic of beholding behind the phrase "conditions of intelligibility."

> Thus the performances of Jack Goldstein do not, as had usually been the case, involve an artist's performing the work, but rather the presentation of an event in such a manner and at such a distance that it is apprehended as representation—representation not, however, conceived as the *re*-presentation of that which is prior, but as the unavoidable condition of intelligibility of even that which is present.

It is this presentation of representation, this insistence on surrendering presence—of any kind—to its permeation by something other than itself, that lies at the heart of what is now being called "allegory."

"Postmodernism"—insofar as it is characterized by its allegorical impulse—represents the freeing of painting from its prison of opticality as well as its recovery of subject matter beyond itself and the logic of its medium. But we do well to see how small a liberation this is. If it is true that the past fifteen or twenty years have seen the hegemony of the optical dismantled, it is still true also that "paintings are made to be beheld"—"opticality" is but one name for, interpretation of, this "primordial convention" (just as the literal construal of the medium is but one construal among others of the medium of painting).

We cast "postmodernism" at a deeper level if we say that the allegorical impulse is one which would acknowledge explicitly the futility

of trying to sort the "mere" from the "pure"—an impulse to embrace the heteronomy of painting.[36] Such an acknowledgment demands that we accept—as best we can—that the field we call "painting" includes, and cannot now be defined without reference to, its violations and excesses—performance work in particular. (Performance continues then to lie between the arts and has always to be asked what it counts as—for whom it counts. We will want to say—in this context at least—that performance is not [yet] an art in itself, but a way in which various arts may find themselves outside themselves. It is not clear to me what it would take for performance to establish itself as an art— what, that is, its "proper" medium is. The undeniable fact that performance has established itself as an artistic practice, even a central practice, tells us nothing about how and where it counts.)

If we thus say that painting is now to be defined through its discontinuity with itself, its inability to attain a presence that is not also represented and deferred, the history of painting becomes open to us in new ways. We might remark here, for example, the ways in which abstract expressionism is becoming newly available—its period and sense newly readable. For some, abstract expressionism has become interesting not as a step on the road to the Absolute of the Allover, but as an attempt to gain access to and present deep and private images and symbols of the self (and this may mean that Pollock is no longer the necessary genius and achievement of the movement—figures like Gottlieb and Baziotes and Stamos may take on new interest, and the itinerary of a Philip Guston can become exemplary for others). By the same token, a parallel demystifying impulse may choose to read in Pollock's drips mere and empty signs of freedom, bearing away their own implicit claim to spontaneity and depth. In either case we are rewriting failure and achievement out of our own impulse to heterology—creating a history to which an allegorical painting can be responsive. The duplicity of this rewriting should remind us that "allegory" has always been—and in the hands of a critic especially— a trope of both demystification and revalorization. It replaces the exclusive duality of the mere and the pure with the inclusive puzzle of what a thing "really" is, what the story really is.

Allegorical painting, as it has emerged for recent criticism, is bound particularly to time and to story, to narrative. Sherman's mock

film stills and Longo's drawings and reliefs (I would have you call these things "paintings") are understood as exemplary presentations of "hinges" whose significance is neither simply present nor simply borne away into story, but is rather given (not here, now now) as an undecidable crossing of possible narratives—stories of death or dancing, histories of menace or aspiration.

To the extent that these paintings are for us the occasion of new and deep recognitions of painting as it constitutes itself in the intertwining of history and convention, they can recall us to "the essential fact of (what I refer to as) the modern" as it "lies in the relation between the present practice of an enterprise and the history of that enterprise, in the fact that this relation has become problematic."[37] Allegory has its way of insisting on this problematic—on the uncertainty, at every moment, of the relation between a given present or claim to presence and the narratives—stories and histories—by which it is traversed and in which it could figure. The painting that matters will matter as it figures just such complex shuttling within and "between" the history of painting. It lets us say that one of the essential facts of the modern, now newly visible, is that from within it the relation between the practice of an enterprise and its past has always already become problematic: modernism has always already invaded the history and tradition from which it would distinguish itself, and so is capable of finding itself wherever it looks within that history (a point of muddled controversy between Greenberg and Steinberg).

There are then ways in which the critical claim to the postmodern appears to find its deepest sense if the postmodern is understood to be itself an allegory of the modern. This possibility lies at the heart of these notes, setting the terms in which I would pose the question of Michael Fried's continuing visibility for and relevance to contemporary criticism.

At the conclusion of his compelling two-part essay on "The Allegorical Impulse," Craig Owens writes, "This deconstructive impulse is characteristic of postmodernist art in general and must be distinguished from the self-critical tendency of modernism."[38] (Derrida likewise writes of his own deconstructive project, "Si elle en était restée, ce qu'elle n'a jamais fait qu'aux yeux de ce qui tiraient

bénéfice de n'y rien voir, à une simple déconstitution sémantique ou conceptuelle, la déconstruction n'aurait formé qu'une modalité—nouvelle—de l'auto-critique interne de la philosophie. Elle aurait risqué de reproduire la propriété philosophique, le rapport à soi de la philosophie, l'économie de la mise en question traditionelle."[39]) I want to cast such suspicion as I can—not on Owens's imperative, which is a late and necessary repetition of the imperatives we have seen in Greenberg and Fried—but on the possibility of our making, successfully, such a distinction, however imperative it may be (remember Fried's insistence on the necessity of distinguishing the serious and the frivolous). I want to say that it is precisely because Owens repeats belatedly and for criticism the attempt at radical distinction and exclusion that Fried attempted for painting in "Art and Objecthood" that the distinction will not hold up—will break down just the way Fried's does—which is to say: powerfully, insistently, centrally.

The Truth of Allegory and The Necessity of Rhetoric

> . . . *la dissémination qui ne joue pas, comme on le croirait trop facilement, avec le pluriel, le dispersé, l'épars, pas entre le multiplicité et l'unité, mais entre l'unique.*
> —Derrida, "Pas"

> *Aux métaphores. Ce mot ne s'écrit qu'au pluriel. S'il n'y avait qu'une métaphore possible, rêve au fond de la philosophie, si l'on pouvait réduire leur jeu au cercle d'une famille ou d'un groupe de métaphores, voire à une métaphore "centrale," "fondamentale," "principale," il n'y aurait plus de vraie métaphore: seulement, à travers une métaphore vraie, la lisibilité assurée du propre. Or c'est parce que le métaphorique est d'entrée de jeu pluriel qu'il n'échappe pas à la syntaxe; et qu'il donne lieu, dans la philosophie aussi, à un texte qui ne s'épuise pas dans l'histoire de son sens . . ., dans la présence, visible ou invisible, de son thème (sens et vérité de l'être).*
> —Derrida, "La Mythologie Blanche"

Allegory is indirect discourse. It is so either because directness is forbidden (in which case its indirectness is merely its disguise, to be removed as soon as the coast is clear) or because directness is impossible for reasons inherent to that which would otherwise be communicated (in which case removing the disguise is removing the thing, revealing nothing—the ineffability to be communicated being present, to the extent that it is, precisely in—by virtue of—the disguise). Allegory divides itself into moments of concealing and revealing, covering over and bodying forth—and this division will generate the terms in which we will evaluate allegorical works, condemning those that appear to be artificial, merely coded, and playing simply upon the hiding of sense, and praising those that appear as more purely and properly allegorical, showing forth that which can be shown only as deferred and in deferral—postmodern decorum.

This is, of course, an attempt to separate the merely allegorical from the purely so, and is, as such, condemned to the fate of all such projects. It is the details of this fate that are of interest to us. Allegory without a key—pure allegories, as it were—is no longer recognizable as allegory (allegory as such is lost in a pure play of signifiers and ungrounded process of semiosis—allegoresis by itself either falls below or passes beyond the region we want to call rhetorical). Allegory that is merely keyed, translatable, is dispensable and uninteresting, a code and nothing more. Allegory is undone by—lost in—its truth at both extremes; whether we take it literally, discarding the rhetorical shell to eat the inner meat, or take it literally, as the pure structure of purloined sense, *allos agoreuein*, we lose it.[40] Allegory enforces its rhetoricity—its complexity—upon us. This rhythm internal to allegory should recall the rhythm internal to criticism.

To put it another way: allegory maintains itself between—and is deeply, internally menaced by—two automatisms, automatisms of sense and of semiosis. In different ways, each offers the double possibility of the achievement and the undoing of allegory. Allegory remains its own doing only for so long as it is unachieved, seaming, in time, semiosis and sense, succumbing to neither. Allegorical work that presents a claim upon us does so because of the way it insists on time, recognizing it can exert that claim only in time, so perhaps only for a time (history is its condition). A new wrinkle in the dialectic of

absorption and theatricality: a work can remove us from the time in which we come to it only by rewriting that time as its own.

The claim to allegory takes up a definite position in relation to and in terms of the dialectic explored in Fried's work. If the theatrical temptation in Greuze (for example) is that we will be drawn into the work only to lose ourselves and it in the narrative that flows through it and plunges us back into the time we thought to transcend (the paintings appear finally sentimental), the new works would explicitly pose their openness to narrative(s) in such a way that one cannot be simply swept away by the story. (Cindy Sherman's pictures are perhaps nostalgic, but would be rigorously unsentimental.) The work thus becomes an emblem of narrativity ("as such") and gains its (difficult) presence—its claim upon us—precisely through this admission of time. More radically: it gains its presence and claim upon us through its appropriation of the time in which we think to come to it, and through its mastery of this "unavoidable condition of intelligibility." What needs stressing here is that this claim takes its sense from a problematic that implicitly recognizes the continuing need for painting to (impossibly) recover itself from theatricality and that further assumes that the continuing deep task of painting is to master the conditions of its own intelligibility, "the primordial convention that paintings are made to be beheld." Painting has—still—to make itself count as painting, as art: as counting.

This brings us to what I take to be the deepest and most difficult point in Fried's work. However convinced we may be that the making of art is natural to man, we have no access to it, no way to speak of it, except insofar as it is profoundly conventional and thus caught between invisibility and fragility. Art makes itself count only by exposing itself and so also its fragility, its gratuitousness and arbitrariness; such strength as it has it has only so long as it remains invisible, so long as it passes for natural. Fried's phrase, "the primordial convention that paintings are made to be beheld," conceals and reveals at once the essential contradiction that makes of art a historical activity. The same contradiction makes of art history simultaneously a means and a block to that activity. (This, I hope, is a way of saying something about what Smithson glimpsed in geology and the fact of the prehistoric.)

We know or we think we know, more or less, what it means to speak of, for example, a "convention" that certain paintings are not to be beheld. A religious sanction perhaps. But we ought to feel very confused by the notion that it is also a "convention" that paintings are made to be beheld. In the case of the religious prohibition we know what it means to defy the convention—we just go ahead and do what (so to speak) comes naturally, we look at the painting instead of averting our eyes. But what could it mean to subvert this other convention? In a sense, this convention is failed or broken exactly the same way it is met: by "casting one's eyes on" (I'm groping for a neutral phrase) the canvas. What intervenes between success and failure here is just the recognition of the conventionality of this act (the recognition that we could have looked and still not seen). (This is why Fried glosses theatricality in "Art and Objecthood" in terms of "seeing works as *nothing more* than objects" and why he goes on to write that "literalist sensibility is, therefore a response to the same developments that have largely compelled modernist painting to undo its objecthood—more precisely, the same developments *seen differently*, that is, in theatrical terms, by a sensibility *already* theatrical, already (to say the worst) corrupted or perverted by theatre."[41] The eye the critic needs here is more than formal.)

In acknowledging the conventionality of beholding, we rescue our vision from its own automatisms—automatisms, variously, of more or less natural habit and more or less sophisticated and art historical taste—automatisms released by a thirst for the guarantees of the literal or by a surrender to the simplicity of radical flux.

"Automatism" is then the name of a risk,[42] a deep motive to self-criticism and to indirection, menacing both (so that what I take to be self-criticism may be mere narcissism; what I take to be indirect discourse may be self-indulgence or nonsense). "Self-criticism" may appear as the demand for the reduction of the literary and rhetorical. Indirection may appear as a call for rhetoricity and a recovery of ornament. Each is justified, to the extent that it is, by the history it makes and in which it would inscribe itself. Each such call appears as an emblematic summary of an unsummarizable history (a text), inscribing itself as such within the inner plurality, dissemination, of art history. "Breakthrough paintings" are now—and have therefore

always been—everywhere and nowhere—painted and repainted in works that complexly hinge their pasts.

"Art history" is, now more than ever (but always now more than ever) the Great Automatism through which modern art lives its death and dies its life. Heads I win, tails you lose: art history quarantees at once everything and nothing. Cavell's caution is, finally, terrifying:

> A familiar answer is that time will tell. But my question is: What will time tell? That certain departures in art-like pursuits have become established (among certain audiences, in textbooks, on walls, in college courses); that *someone* is treating them with the respect due, we feel, to art; that one no longer has the right to question their status?[43]

We can only stand, unsponsored, ever more directly before time's radical (non)certification of our art and criticism, bearing and baring what we can, clinging to the difficult uncertainty of a present divided from itself—an uncertainty that demands our judgment, our acts of inclusion and exclusion, if its experience is to count for us:

But in waiting for time to tell that, we miss what the present tells—that the dangers of fraudulence, and of trust, are essential to the experience of art.

Conditions of Publicity

> The recognition that the art of painting was inescapably addressed to an audience that must be gathered . . .
> —Fried, *Absorption and Theatricality*

> For not just any mode of composition will tell us something we cannot fail to know and yet remain enlightening; not just any way of arguing will try to prevent us from taking what is said as a thesis or a result. Theses and results are things that can be believed and accepted; but Kierkegaard and Wittgenstein do not want to be believed and accepted, and therewith, of course, dismissed. And not just any way of

addressing an audience will leave them as
they are, leave them alone, but transformed.
These are effects we have come to
expect of art. . . .
—Cavell, "Existentialism and Analytical
Philosophy"

This is then where we stand, in difficult times. If there is a simple moral in our situation, it is perhaps just this: the existence of the beholder, which is to say the primordial convention that paintings are made to be beheld, has emerged as problematic for painting as never before. And: what we are newly recognizing is that the art of painting is inescapably addressed to an audience that must be gathered. And: we are attempting to acknowledge that this is now as fully and explicitly a problem for criticism as it is for painting.

We have been concerned throughout this essay with the way—and time—in which that audience is gathered—with the conditions under which a work has a public. This concern demands a new or renewed attention to and awareness of the depth of complicity between painting and criticism.

In this situation, criticism stands, or could, or should stand, in an altered relation to the art it serves. At any time, it is subordinate to that art, and expendable once the experience of an art or period or departure is established. But in the modern situation it seems inevitable, even, one might say, internal, to the experience of art. . . . Often one does not know whether interest is elicited and sustained primarily by the object or by what can be said about the object. My suggestion is not that this is bad, but that it is definitive of a modernist situation.[44]

Art is not simply and accidentally given over to criticism. This is part of what follows on our recognition of the primordial conventionality of art. We might also say that criticism is not (not simply) observation. Allegory forces these recognitions; allegorical works do not exist except in a universe of continuing allegoresis, commentary, and interpretation. Allegory demands criticism, confusing the line between itself and its criticism—in such confusion criticism must take account of itself as well as of its simpler "object." (The risk here is of the theatricalization of criticism, its regressive sublation into the ether of what might then be called "metatheory" or "metacriticism" [as if these were names for a purer criticism or theory].)

The present essay would not constitute a work of metacriticism or an exercise in the metatheoretical. It is occasioned by an experience of criticism and would speak of and to that; it would speak also (obscurely, indirectly) of the condition of art. But it can guarantee nothing out of itself.

Allegory, as a trope of revelation and concealment, is a mode at once public and private, and if allegorical works appear to embody the deep and obscure promptings of the self, they do so successfully only to the extent that these promptings are communicable, are already what we might call "public." Such works pose as a condition of their inner sense their outer publicity; they are works that demand a beholder, and they do so in order to show the beholder his or her own difficult presence to (absence from) the work. The allegories of sense and gesture, convention, that have been seen in the work of Longo, Anderson, Goldstein, Sherman, and others are visible as such only to the extent that they are recognized as deeply responsive to the issues raised in "Art and Objecthood"—questions of anthropomorphism, the privacy and publicity—hiddenness and openness—of the self, of the other.

"Art and Objecthood" tends strongly to align surface with publicity and depth with privacy. The hollow literalist form appears as a person who presents himself to us in and from his sense of radical privacy—presents himself as withdrawn, distant, distancing, even mocking. In this view, Pollock counts as a discoverer of surface and it is this discovery he hands down to his strongest heirs—to Louis, Noland, Olitski. The weak are left with the rest—an expressionist ideology, an insistence on the self. As the surface becomes ever more compellingly and powerfully charged, the self, having become its own deep and private object (having become object to itself—ironized, distanced) becomes ever more naked, ever more exposed to its public. The passage from Smith and Judd to Acconci is—as I have tried to show elsewhere[45]—simply a matter of consequences literally drawn.

In dialectics the world unfolds through the failures of the moment. It was only out of the drive toward radical privacy in art and out of an insistence on forcing the relation between art and its beholder into mere externality (the reduction of that relation to one of mere objectivity and knowledge), that the failures of such a vision

of privacy (and of publicity) could become once again visible. (And here the essential contrast is between an art that insists on criticism as a reflection and acknowledgment of the way in which public and private always have interpenetrated one another and so are seamed in one another, and an art that would construct itself as an epistemological problem, daring its beholder to know it.)

Success, whatever its other virtues, rarely has a future. The trick some painting seems now to be attempting is to succeed precisely through its failure. As Owens writes:

> When the postmodernist work speaks of itself, it is no longer to proclaim its autonomy, its self-sufficiency, its transcendence; rather, it is to narrate its own contingency, insufficiency, lack of transcendence. It tells of a desire that must be perpetually deferred; as such, its deconstructive thrust is aimed not only against the contemporary myths that furnish its subject matter, but also against the symbolic, totalizing impulse which characterizes modern art.[46]

If Pollock, for example, counts for this painting, he counts now in the tension between his surface and its presumptive depth, the way these terms interlock in and as the condition of his work's gathering an audience, the way in which his work means to mean and does not (quite). This Pollock is one who painted in time, whose canvas marks the time of that painting, its dissemblings and forgettings (of drawing, for example), its revelation and concealment of its own depths—a flatbed, a table, a tableau that would explicitly bear the marks of the time it freezes and gathers into itself. If Louis is a recovery and repetition of Pollock, so also is Rauschenberg—the two possibilities are entwined in one another, are each other's condition of possibility. But it is through Rauschenberg that the story of painting's confusion with and dependence on the theater is narrated, and it is Rauschenberg's work that seems increasingly capable of standing as emblem—hinge—for the past decades.

(On page 43 of the catalogue for the 1976 Rauschenberg retrospective there is a photograph of a rehearsal for a dance called *Spring Training*. Rauschenberg stands in the foreground, carrying Steve Paxton. To the right, in the background, Trisha Brown, dressed perhaps as a bride, walks with what appears to be a radio. To the left and in the background. Alex Hay turns away from the camera, looking for

all the world like a figure out of Longo. How many ways do the limits between the modern and the postmodern, painting and theater and dance and photography, presence and representation, hinge in this picture?)

In the spring of 1980 Joel Fineman published an article on psychoanalysis and allegory in *October*. His piece was accompanied by an essay on the allegorical impulse by Craig Owens. The next issue included a second essay by Owens on allegory and postmodernism, and an essay on Rauschenberg and museums, photography and postmodernism by Douglas Crimp. Further in the background is Crimp's essay, "Pictures," from *October* 8—which first picked out the group of artists and issues around which the ensuing discussions have turned. Now there is this baggy monster, as well as whatever may have intervened between then and now.[47] All of this may amount to—in the minds of the various writers concerned or in the minds of their readers or in fact—the articulation of a particular theoretical and critical *prise de position* (like, perhaps, "Art and Objecthood"). Inevitably it will be at least that.

But that may also be merely the least of what this spate of articles is or should be. To the extent that this series of writings amounts to the taking of a position, the presentation of a thesis, it presents a position that is fundamentally not different from (only later than) the position Fried has been building all these years—and it is powerful, if it is, precisely because this is what it is. If there is something newer than this in these writings, it is in themselves, their rhythms, and their embeddedness in one another: the world in which they are present to one another and to their readers. If the present notes seem designed to force a certain acknowledgment of Fried—of what is not (so) new in the postmodern—this design can only be accomplished by forcing the novelty as well, by insisting on the opacity and heterogeneity of criticism, the complexity of its allegiances and the absoluteness of its entanglement with the terms and practices it is tempted to theorize more simply and know. In this sense, I hope to recall criticism from its attained positions to the time of its practice and the risks concomitant with it. Cavell, continuing his discussion of the ways in which criticism has become central—perhaps internal— to the experience of art, turns to the dangers and difficulties of this situation:

Perhaps it would be nicer if composers could not think, and felt no need to open their mouths except to sing—if, so to say, art did not present problems. But it does, and they do, and the consequent danger is that the words, because inescapable, will usurp motivation altogether, no longer tested by the results they enable . . . this suggests that a central importance of criticism has become to protect its art against criticism. Not just from bad criticism, but from the critical impulse altogether, which no longer knows its place, perhaps because it no longer has a place.[48]

The dangers here are dangers to which this essay may have already succumbed. We began, it may be recalled, by dismissing certain fears that have now returned in a much deeper form and, so to speak, for real. I may be forgetting Fried even in my claim to recall him—I may be forgetting the notion of art he (and I) claim to serve. There is no way the news can be gotten out without risking, undecidably, a crime or glory of one's own.

A part of the news that would be gotten out is of "postmodernism," and the crime risked in getting this out is that of forgetting modernism as something that has counted and continues to count for us (the name, for example, of the way in which we can now gather about a work of art). Such forgetting may also be the glory.

"Postmodernism" means, if it means anything, something about the way in which modernism must inevitably come to see in itself its own allegory (and so also something like its own failure, its nonidentity with itself—but these then would be the terms of its power and success). Where postmodernism would mean something more radically separate from modernism (where it would forget modernism) it will end by forgetting itself as well—and it will do so by falling into the trap of modernism's favored mode of (self-)forgetting, the (non)dialectic of the mere and the pure. Postmodernism would proof itself against this risk by appealing to a deconstructive impulse working beyond the (merely) self-critical tendency of modernism—but the risk shows itself in the bare statement: the practice of deconstruction cannot rigorously hold itself apart from something called self-criticism except by hypostasizing its self in just the way it would avoid; it can articulate itself only insofar as it acknowledges explicitly its emergence from and dependence upon what might otherwise appear as mere self-criticism. If postmodernism names modernism insofar as it is

inevitably its own allegory, deconstruction likewise names self-criticism insofar as it cannot exempt itself from itself.

These are names with time in them, emerging at the crossing of art and criticism as at the crossing of art with itself, recalling each to each, recalling each to the other and its embeddedness in that other (so disseminating each from itself as well, working between what is purely what it is and what is merely so), doing and undoing the complexity of presence, folding and unfolding works of art and criticism into one another, sounding out the rhythms in which they find themselves and their audiences for such time as they do—for such time as they master, hold, or submit themselves to.

1982

Review of **Courbet's Realism** by *Michael Fried*, Chicago and London: The University of Chicago Press, 1990, 378 pp., 16 colour plates, 115 b. & w. illus., £24.95

*M*ost readers of this journal will, I imagine, already be familiar with the broad claims advanced in Michael Fried's *Courbet's Realism*—that Gustave Courbet's painting is crucially organized by the painter's impulse toward 'quasi-corporeal' merger with his work; that this impulse takes on its sense of power within a tradition, rooted in 18th-century France, that poses the essential condition of painting between the prospects of 'theatricality' and 'absorption'; and that in the wake of Courbet's achievement this tradition will be obliged to a new difficulty and complexity, gaining its first compelling articulation in the painting of Edouard Manet. The bulk of the book (five of the seven chapters) explores these propositions through detailed readings of Courbet's work, beginning with a treatment of the early self-portraits, moving through what Fried calls the 'breakthrough' paintings of 1849–50 to sustained considerations of the allegorical dimensions of Courbet's work, in *The Painter's Studio* and elsewhere, and closing with the already controversial essay 'Courbet's "Femininity" '. Versions of almost all of this material have been published previously, but Fried has revised extensively in bringing his project to completion.

That project is considerably broader than a study of Courbet. Fried's earlier book *Absorption and Theatricality* (1980) explored the origins of this painterly tradition and problematic (the first chapter of the present work follows the passage from the Diderotian origins of the problematic to the moment of Courbet's entry into it), while Fried's directly critical writings of the 1960s explored the fate of 'theatricality' within the then immediate context of minimalism and

post-painterly abstraction. Two essays for *Artforum* from this period offer an early sketch of Fried's historical interests: the first chapter of *Courbet's Realism* takes up, with considerable modification (including the setting aside of Couture), the terrain covered by 'Thomas Couture and the Theatricalization of Action in 19th Century French Painting', while the concluding chapter strongly suggests a future return to the issues of 'Manet's Sources'.[1]

Given this history, it is perhaps natural to take Fried's general project, and the Courbet book in particular, as essentially involved in justifying his critical judgments of the 60s. *Absorption and Theatricality* did indeed present itself in such terms ('this book may be understood to have something to say about the eighteenth-century beginnings of the tradition of making and seeing out of which has come the most ambitious and exalted art of our time' [p. 5]). While nothing rules out taking a similar view of *Courbet's Realism*— indeed Fried explicitly and implicitly acknowledges the inevitability and necessity of such a view at a variety of points—what should nonetheless be most striking in this new book is a measurable shift in Fried's understanding of the relation between his art-historical work and his writing on abstract painting and sculpture in the late 60s: 'My approach to nineteenth-century realism has been conditioned by my early and continuing involvement with abstract painting and sculpture: not because, as formalist doctrine would suggest, I have been enabled by that involvement to see past the realist experience of Courbet's paintings to some (nonexistent) abstract core, but rather because, being at home in abstraction, it's realist painting like Courbet's or Eakins's that has particularly seemed to me to require explanation' (p. 52).

This is a significant recharacterization of the drift of Fried's work not simply in its repudiation of (Greenbergian, optical) formalism, a matter about which he has been increasingly explicit since the 1967 essay 'Art and Objecthood',[2] but in its shift away from an implicitly Hegelianizing mode of history writing in which the past is called upon to render the present true for an eye which, standing in that present, claims to see both it and the buried logic which brought it into being. Fried now works in a clearly post-Hegelian mode that accepts the present in all its contingency as nonetheless the unsurpassable condition of access to the past. This shift is registered in Fried's increasing

engagement with contemporary French theory (Derrida, Foucault and Lacan all figure with some prominence in the book) as well as in a general softening of the dialectical edge to the argument of *Courbet's Realism* in favour of a more nuanced and varied historical attention (the influence of the 'New Historicism' associated with the journal *Representations* is amply testified to in the footnotes). Stylistically it is perhaps most apparent in the increased foregrounding of what might be called a 'wilful' rather than 'authoritative' first person—a writerly presence that recognizes its interpretations as interpretations and is willing to be responsible to and for what may be forced or excessive in them. This historian is no longer a magisterial surveyor of the past but an agent, accountable for his present acts.

Beginning here I mean in this review to focus on questions of method and criteria as central to any appraisal of *Courbet's Realism*. Such questions get their fullest airing within the book in the new closing chapter, itself also entitled 'Courbet's Realism', in which Fried works his way through a range of crucial questions raised by his readings. Fried's remarks about the conditions of his approach to Courbet and realism matter, not only because they offer a general guide to the shape of the revisions much of the material has undergone since its initial publication in various journals over the past ten years, but also because they connect directly with the deep structure of his argument about Courbet's work. It is to a high degree as if working on and through Courbet has led Fried to a revised understanding of his own activity as an art historian. The resulting knot of French post-Hegelianism, engagement with the post-Hegelian roots of art history (Riegl, although I will not focus on this here, is both never mentioned and never fully out of sight), and art history's stake in Realism is extraordinarily complex, and what I offer here is an attempt at a relatively straightforward analysis of some of its features. What I hope to bring out—and what I think the most significant theoretical advance in the book—is Fried's elaboration of the deep logic behind his now familiar emphasis on the beholder. This new level of elaboration makes it clear that what is at stake in the question of beholding cannot be addressed in purely visual terms.

My way into this knot begins by remarking that Fried's understanding of his activity as a historian is essentially continuous with his emphasis on Courbet's activity as a painter. For Fried, what painters

do is paint: they do not, in the first instance, 'create', 'express', 'represent', 'imitate', or anything else. It is as a consequence of their acts that we have the things we (gerundively) call 'paintings', and if we want to call these things (because they are things and not simply crystallizations of pure freedom or spontaneity) 'mimetic', then we will have to come up with a notion of mimesis answerable to the primacy of the act through which they come about. Fried's tendency here is to describe Courbet's art as directly 'anti-mimetic'; my own tendency, intrigued as I am and would like Fried to be by the writings of Philippe Lacoue-Labarthe,[3] is to oppose a restrained and essentially metaphorical understanding of mimesis to a 'wilder' and more metonymic understanding of it as something like 'prolongation'. Either way of putting the matter returns us to at least part of what I take Fried to mean in suggesting that 'being at home in abstraction, it's realist painting like Courbet's or Eakins's that has particularly seemed to me to require explanation'. Abstraction is often enough felt to stand in need of some special explanation; that Realism should be thought to 'require explanation' will or should strike many readers as surprising. Realism, in both literary and visual studies, has long been that which does not require explanation (although it has often enough been thought to need demystification, a requirement that simply reverses the radical transparency more friendly readers and viewers find in Realism).

The weight of this reversal in its relation to questions of mimesis is perhaps most evident in Fried's explication, late in the book, of a passage from Hegel's *Aesthetics* in which a child is presented as discovering itself not in some calm Narcissean mirror but in the disruption of that mirror by the simple and empty act of throwing stones into the pool—the child catching itself not in its image (indeed the best we can say of the image here is that it is irremediably shattered) but through its act, grasping, in the fact of consequences, its own agency above and beyond the emptiness of the activity through which that fact was uncovered: 'A boy throws stones into the river and now marvels at the circles drawn in the water as an effect in which he gains an intuition of something that is his own doing.' As Fried remarks, 'the primacy of action over seeing is anticipated in the substitution of a river, implying flow and movement, for Ovid's secluded pool . . .' (p. 276).

That this child might, in the aftermath of such a moment, see its image in the restored mirror of the pond and so mis-take *that* for its self-discovery offers perhaps a potentially instructive parable about the fate of mimesis, in art history and elsewhere, as well as about the place we assign to 'realism' within our explanatory narratives.

Fried means to find the activity—the 'throwing'—in the painting that we too often mistake for a likeness; and Courbet is crucial here because in his painting—object and activity—this mistaking is both most fully achieved and most deeply contested. The early self-portraits have a certain privilege for Fried just because they are *not* representations of Courbet's self; or, to put it slightly differently, if they began—were intended—as such representations, the repeated discovery of their painting is that Courbet could not make himself palpable to himself except through prolonging that self in the act of painting: the paintings, as paintings, do not arise from Courbet's presumably natural visual availability to himself but rather from something like his visceral sense of the continuity of his self with its actions (their relation to Courbet 'himself' is, one might say, metonymic rather than metaphoric). The paintings are *visual* just because this continuity of the self and its activity cannot be realized without remainder: there will always be, in the end, not *painting* but *a painting*—mimesis taking itself for representation because it has no other way to (mis)take itself—because paintings exist, initially and finally, to be beheld, and even painting blind, a metaphorical description that tempts Fried repeatedly,[4] cannot deliver the process from vision. This insistence on a constitutive and inevitable misrecognition may put one in mind of Lacan, a theorist who clearly matters to Fried, but one might also do well to think of Maurice Blanchot on reading, misreading and authority.

In this complex light neither 'absorption' nor 'theatricality' is a simple or simply contingent evaluative term, nor is their joint power to organize a painterly tradition issuing in modernism and abstraction merely a historical accident. The focus on drama as a central issue in painting, whatever its proximate historical causes (the new publics of the salon or the problematic publicity and decorativeness of Rococo, for example) and whatever the historically contingent path through which it worked itself out (the grand accidents of the Revolution and of Napoleon, for example), had always within itself the possibility of passing the central focus of painting from the rep-

resentation of action to the action of representation, from drama in the painting to the drama of the painting,[5] which drama necessarily entails a systematic uncertainty about what is agency and what mere act or performance. As these frames shift, the site of the beholder and mimesis itself come into active, inevitable and painted question.

Fried's reposing of the relationship between the art-historical work of *Courbet's Realism* and his criticism of the late sixties and early seventies includes a claim not to be seeing past the 'realistic appearance' to 'some (nonexistent) abstract core', and insofar as this is part of his repudiation of formalism[6] it is surely accurate. But I have also stressed the way in which Fried locates his interest in Courbet precisely in terms of a certain experience of modern painting and sculpture. We may now perhaps begin to see something of how these two claims fit together—something, that is, of how Fried is resituating and revising the terms of the historical attention and medium-specific concerns that drove his early work (at times this revisionist work comes very near the surface of the text in quite extraordinary ways; see, for example, the second paragraph on p. 108, which all but explicitly refers back to 'Art and Objecthood' and the controversies around its terms of judgment).

In particular, Fried continues to be concerned above all with the specificity of painting—but now with 'painting' not primarily conceived as an embracing medium possessed of something like a proper internal logic or truth but as an act, like all acts, submitted to historically forged material conditions. Fried's question of the objects he considers thus does not arise in the first instance from a formalist concern with structure or composition, and it demands no reduction of apparent subject matter to somehow 'purer' terms of design and colour and facture. The question is rather on the order of 'How has this managed to be a painting?' Arguably, it is because formalist criticism has at its best always actually worked within this question that we have taken it seriously at all, and one may regret Fried's willingness to surrender the term to the narrow construction both Greenberg and his opponents have imposed upon it. In any case, it should be clear that for a modern, the hard place of this question lies not in abstraction but in realism.

The explicit focus on agency shifts the burden of explanation away from questions of meaning. More pointedly, the obligation to

what Fried calls variously 'reading' and 'interpretation' does not depend upon any notion of meaning—expressive, conventional, intentional, or whatever—somehow inherent in (or even absent from) the work. Reading and interpretation are demanded precisely by the play between act and limitation in the work, and the work of reading or interpretation is a recovery of the indeterminability of the act over and against the meanings that may appear to be fixed in and by it (and here Fried's path would seem to intersect with that opened up by Heidegger's controversial and less than historically alert treatment of Van Gogh[7]). It is the irresolvability of this play that obliges us to refer to the historian's activity as both 'reading' and 'interpretation' without being able to fix a clear difference between the two descriptions. All this is perhaps clearest in Fried's dealings with *The Studio*: there is in the end no necessary conflict between Fried's 'reading' and those of, for example, Klaus Herding or Linda Nochlin—or there is no such conflict at the level of decoded meanings—just because Fried uncovers no coded meanings. If there is to be an argument here it will not be, in the first instance, about the rightness or wrongness of certain claims about meaning. It will be about whether or not the project of decoding touches the fact of the painting; or about whether or not the process of reading is reducible to a matter of codes.

Fried is in this respect perhaps surprisingly close to T. J. Clark, who, albeit in a very different way, finds that what matters in Courbet is a certain hostility toward or closure against the current order of meaning. This is a central move in Clark's later argument about Manet's *Olympia* as well—and it is worth noting that Clark continues to have a problem (as is clearest in the differences between his preliminary and final treatments of the painting) about how far this resistance is to be construed as itself a meaning and how far it can only be grasped as a resistance to meaning (even including the political construal of that resistance). Fried's is, in this light, arguably the more general account.[8]

Both positions can be strongly contrasted with Linda Nochlin's attempt to ground interpretation in a theory of the open-endedness of meaning. The differences here are at once subtle and absolute. One way to begin thinking about them is to note that for Nochlin the success of art-historical scholarship with, e.g., *The Studio* threat-

ens to put an end to interpretation, whereas for Fried such success only sharpens the demand for it (the difference here is perhaps interestingly caught in Nochlin's omission of Fried from her list of *The Studio*'s interpreters).[9] Another dimension of this divergence between Fried's understanding of the role of theory in art history and Nochlin's understanding is visible in their respective construals of the situatedness of the art historian. It is no doubt an overstatement to say that Nochlin's understanding of the role of 'positionality' in criticism and history simply frees the interpreter of any obligation to the past under examination, but that is clearly the drift of the arguments she advances on behalf of her rereading of *The Studio* (such arguments have considerable currency in contemporary literary theory). For Fried, closer I think to both Foucault and Derrida, to accept the present in all its contingency as the unsurpassable condition of access to the past means to acknowledge an ineradicable insistence of each temporal moment in the other, and to interpret means to enter into the ultimately undischargeable play of debt within and between the two. This sense of the field in which interpretation is engaged blocks for Fried the almost universal assumption 'that realistic paintings are normative in essential respects' (p. 88), and this, in turn, forecloses any fundamental orientation to demystification or decoding, whether in the name of abstract formalism or that of political utility.

What has then evidently interested Fried in much recent literary theory (and this interest has been deeply prepared by his long association with Stanley Cavell) is not the proposition that meaning is indeterminable but a certain critical apprehension of meaning as both effected and effective, not graspable outside of its material circumstances, compelling us to reading and interpretation as prolongations of it. It is against the background of such an understanding of reading that one can begin to ask about the criteria for Fried's interpretations. These interpretations are, after all, recurrently extreme and excessive, almost as if 'going too far' were itself some kind of criterion. We are, for example, at various points asked to believe that the two figures of *The Stonebreakers* are both the painter's hands and his initials, that all sorts of objects either long and thin or in some sense hairy are brushes and that others flat or colourful are palettes, that the falling grain of *The Wheatsifters* is at once a display of pig-

ment and of menstrual blood, and the painting's figures are, like the tendrils of Jo's hair in her portrait, yet further variations on Courbet's G and C, and so on. Some of these we will probably find we believe, of others we will be uncertain, and some certainly we will want to say we do not believe. But what does 'believing' mean here? What kind of conviction are we supposed to feel in the face of these readings? What kinds of resistance to them would Fried have to take seriously?

Such questions are badly posed if it is not explicitly recognized that they are not foreign to Fried himself. One of the most difficult features of the book is its way of mixing overt speculation and fierce conviction. The closing treatment of the *Hunter on Horseback* is per-haps as good an example as any (and is clearly intended as such): one can, I think, be tempted to dismiss the painting itself as fairly ordi-nary, and Fried's hastily sketched reading of it (invoking figurations of the act of painting, the presence of left and right hands, the brushi-ness of the horse's tail, the blood redness of the scarf, the possibility that the horse might be thought of as standing in water rather than snow, and so on in quick succession over a mere two pages) can be still more easily cast as simply arbitrary and incredible. But it is clear that Fried himself feels very much the same way, at least about the particular interpretations he proposes: 'How persuaded am I by this interpretation [of the horse's tail as a brush]? Not nearly so per-suaded as, for example, by my reading of the sword and wound in the *Wounded Man* . . . And yet . . .' (and now Fried continues across his own expressions of doubt into a further sequence of both interpreta-tions and questions about their credibility) (p. 289). The opening description of the painting calls it 'haunting', and this may be as good a word as any for what one may come to feel about Fried's interpre-tations, here and elsewhere. They do not go away, even when dis-missed—as if even where one wants to argue against their belonging to the meaning of the thing, one finds them there prior to the ques-tion of meaning, bound up with one's seeing the painting at all.

But then it may be a question whether 'seeing' is the right word here. Why not say 'grasping'? What we might as well call 'haptic' and 'optic' are knotted in these paintings' resistance to being seen. After Courbet, one might imagine (Fried perhaps once did imagine), painting becomes irreducibly visual. But once the entanglement of

painting and paintings has been recognized, the passage toward 'pure opticality' is closed. Fried's footnote to his brief discussion of Manet goes directly to the point: 'I might add that the frequent characterization of Manet as exclusively preoccupied with vision is at bottom a response to (and misdescription of) his concern with "facingness" ' (n. 125, pp. 364–5, see also pp. 286–7).

It is an odd kind of conviction Fried is after, one that can be achieved only through the work of interpretation but that is not compelled by the interpretation as such. What one is apt to retain of the pages devoted to the *Hunter on Horseback* may not be the particular associations Fried weaves around it—these one can continue to call, if one wishes, arbitrary and incredible. What will be harder to shake is the sense aimed at by these associations that the thing could not in fact have been painted by just anybody, that to see it is to grasp it as a Courbet—that is, to grasp it as unspeakably entangled in a network that is neither formal nor thematic and to realize that it depends crucially for its existence on the act of interpretation in all its excessiveness and extremity and fragility (surely a part of what determines the place of Fried's discussion of *Hunter on Horseback* is its subtitle, 'Refinding the Track'). Would it be right to say, with Lyotard, that Fried's judgments (and perhaps ours of him) are thus 'without criteria'? would it be better or different to say, with Kant, that these judgments are 'disinterested'?

If one recalls the 'presentness is grace' with which 'Art and Objecthood' closes, it may seem that Fried in some sense dreams of a moment of pure painting as pure act of meaning—the moment of the child throwing a stone before it knows itself to be performing an act in so doing and so, that one time, doing the thing wholly. But he is clear that such a moment does not and cannot exist for painting: to perform the act is always to make the thing and so to be at grips with the difference between act and thing, self and other. Courbet's project is doomed and could not be otherwise; our imagination of its success is bound to be blank: paintings are only as they are failures of painting. More positively, paintings inevitably happen as figures for painting which cannot itself happen apart from what we might otherwise imagine as its fall into representation. Fried's emphasis on Courbet as allegorist is thus intimately bound to his understanding of the structure of painterly action; and both determine in their turn his

understanding of his own activity as reader and interpreter. More particularly, allegory, figure and the need for reading all arise from the way in which the act of painting is bound to an essential passivity. We might say that the (Hegelian) thrower is always first of all thrown (in a more or less Heideggerean sense), its agency always discovered too late (what *was* that child doing?) and as something less than pure: outside of such impurity there would be no painting to claim us. To imagine agency without appealing to any background of absolute spontaneity and creativity demands thinking an essential passivity or receptivity as the inner lining and essential ground of action. Fried's stake in Courbet's hands is then that there are always two, palette *and* brush—no simple divine and undivided touch.

Paintings happen only for finite beings—embodied beings two-handed, gendered, thrown . . . As such, paintings are historical, compelling us to reading and interpretation. The conviction established in us by such works and by their interpretations is neither more nor less contingent than we are ourselves—which is not therefore to say that what is established in us is anything less or other than conviction. It is here, in the midst of such propositions, that one might want to speak, as Fried does in his writings on contemporary art, of a certain priority or advance of acknowledgment over knowledge in our dealings with such objects. But just here Fried holds back. Courbet is not modern: he is, one might say, that which both allows and obliges Manet to become modern. Courbet's effect was to oblige the recognition that he made paintings, but, on Fried's account, that recognition was not open as such to Courbet. His work—his painting—depends on and is driven by closure against what one might call 'self-recognition'. And this is the profoundly anti-mimetic sense of the project of 'quasi-corporeal merger with the canvas', as it is also the profound sense of Courbet's realism. These paintings could not have happened abstractly (there is no formal truth behind or within them), but they are mistaken if they are therefore taken to be representational (there is nothing they represent to be seen through or behind them). Their visibility to us is at once obvious and bottomlessly obscure; they would deny us and are undone in that ambition because they themselves cannot be denied. Fried would have us understand this as the structure of their beholding, of our attachment to and detachment from them. He gives the last words to 'the poignant elegiac mood of the *Hunter on*

Horseback, which as we stand before the painting, comes to seem almost tangible, express[ing], if not an awareness of that self-division, at any rate an intuition that death alone could bring it to an end'.

Courbet's Realism is clearly a major contribution to the highly active field of Courbet studies, and it will, I am sure, gain attention, stir controversy, and be reviewed as such. But to contribute here is now necessarily also to contribute to central debates about art history itself, and so the book is also—I hesitate to say 'more importantly', because of the way object and method are woven together in it—a major contribution to current attempts to rethink the foundations and objects of art history, and I have tried in these pages to bring out something of this dimension of it. It will not be an easy book to come to terms with; for all its engagement with contemporary literary theory and related developments, it is not an application of anything, and its deeply thought-through arguments will not fall easily into line with the emerging shapes of the various 'new art histories' that tap many of the same theoretical resources. At this moment, there may be nothing more valuable than such a work.

1991

CHAPTER TEN
PAINTING PUT ASUNDER: MOMENTS LUCID AND OPAQUE LIKE TURNER'S SUN AND CINDY SHERMAN'S FACE

"You could not become the mirror of a heart-rending reality if you did not have to be broken . . ." (Georges Bataille)

The late 1970s in the New York artworld was one of those times and places during which 'the end of painting' seemed the urgent claim. This is, each time it comes around, a funny kind of claim—polemical (and in that measure always known to be false); inevitable (and thus accorded the measure of truth we are inclined to give to historical necessity); and, as we seem to know with ever greater explicitness, constitutive of modernism itself.[1]

The scope and consequence of this claim can vary considerably: for Hegel, it's of a piece with a larger claim about the end of art,[2] while for Duchamp it is tied specifically to overcoming 'the retinal' and/or to some radical shift in the locus of the decision about art.[3] For a particular group of artists and critics around whom central discussions about 'postmodernism' turned, this claim was tied quite specifically to a revisionist valorisation of photography.[4] The specificity—and oddness—of that moment lay perhaps in its twining together of (1) a certain conceptual activity grounded in a mood close to that in which one will assert the passage of art over into philosophy, (2) a specific orientation to the priority of the automatism of something like writing, and (3) a renewed recognition of the difficulties imposed on the practice of art by photography.

I mention all of this by way of preface, because I find myself acutely aware of the difference between the American situation of painting, at least as I have been led to engage it, and the situation of painting in Britain. The conjunction of painting and philosophy (especially that peculiar self-deforming brand of it called 'deconstruction') does not take the same shape in Britain and the United States. Attempts to somehow bring into the purview of deconstruction the work of, say, Francis Bacon are likely to seem—to the American observer—at best odd, and at worst weak and unproductive compared to similar engagements with the work of Cindy Sherman or Sherrie Levine.[5]

One might wonder why there should be this disjuncture. Obviously there can be no simple answer to such a question; the broad strokes in which I am about to paint obviously will not do. But there is perhaps something to be said for sheer speculation in the face of such a large and shapeless question, and in these pages I want to take that license for whatever it may be worth.

Several years ago I heard Hillis Miller responded to a series of papers on 'deconstruction and the visual arts' by exploring aspects of Turner's *The Sun of Venice Going Out to Sea*. The exact tenor of his remarks now escapes me (and I do not believe they have been published). But I do recall quite clearly my sense that he was doing exactly the wrong thing, and that a part of its wrongness was that it kept him from seeing the various right things the people on the panel were doing—most particularly the very important things Krauss was doing with Duchamp in her paper. Certainly Miller was not wrong about the features of the Turner that commended it to his interest. The painting entitled *The Sun of Venice Going Out to Sea* and dominated by a good Turnerian sun that is at the same time blocked by the sail of a ship on which are emblazoned both the words 'Sol di Venezla' and a rendering of the sun seems an obvious instance of deconstruction's celebrated *mise-en-abîme*—and indeed one startlingly close in its form to the old honorific and heraldic sense of the term. So the claim must be not that Miller got the painting wrong, but that the thing he got right about it was not the important thing to address. The proposition I want to explore is that if there was indeed a kind of error here, it was not—or not simply—Miller's but Turner's, and that this 'error' has something to do with the historical grounds for disjuncture between

the situations of American and British painting vis-à-vis philosophy. As a claim about Turner, I suppose this amounts to saying that his painting undoes in advance the possibility of modernism for British painting. This is a claim I take to be at once monstrous and banal, and I don't really know what it would take to support it.

I suppose it might be clarified by a developed contrast between the French passage from Courbet to Manet and the apparently similarly structured British passage from Turner to the pre-Raphaelites. Insofar as the general structure of this passage is in each case from work that lays powerful claim to some form of presence to a body of work that takes itself as implicitly or explicitly allegorical, it evidently lays out as well the ground on which certain kinds of claims about postmodernism might ultimately be entered. What will then presumably matter about Turner is the way his painting fails to settle itself, for good or ill, on its own ground and passes its irresolution on to a ground it cannot acknowledge as its own—the textual ground on which Turner seeks to supplement his paintings and recall them, as his brush also did on *Varnishing Days*, to the representation they threaten to outrun. What would be wrong with Miller's attempt to find deconstruction in *The Sun of Venice Going Out to Sea* would then be that the painting's apparent *mise-en-abîme* is nothing of the kind but simply a literal attempt to capture itself reflexively—of a piece with his titles' frequent reflexive attempts to capture themselves literally. Both of these characterisations of what fails in Turner's painting would presumably be founded in some more general suspicion of his attempt to capture that by grace of which there is vision as itself an object of vision. If we are to find our way to Turner's strength it must lie along some other route.

None of these remarks count as anything like an actual argument about Turner; what interests me in them is their drift towards making visible a different sense of 'the end of painting' than that from which I started out. This 'end of painting'—an end I am toying with attributing to Turner—would be utterly invisible; it would consist in nothing other than the continuation of painting as such. A peculiarly lucid end, one might say; a death invisible even in broad daylight, perhaps most especially in that light.

Light is, of course, a figure far from unfamiliar to philosophy, and the notions of both modernity and postmodernity in philosophy seem

to entail crucial reference to the project we call—and which called itself—Enlightenment. This embedded and almost catechrestic metaphor is presumably serious—a particular extension and transformation of a trope installed at the very origins of philosophy and which makes of knowledge always a matter of vision. It is a curious fact, of which I hope to make something, that in the wake of Enlightenment, German and English-speaking philosophers believed different things about the behaviour of light and so wrote it—light, philosophy—differently. One way to work into my worry about Turner is to notice that he straddled this divide—painters tend to do this if only because Goethe offers a better guide to how material colour behaves than Newton.

But I am getting somewhat ahead of myself here; although it does matter to me that Heidegger writes from within an inheritance of Goethean thought about light and so forecloses in advance on any prospect of untrammelled lucidity, I want to begin from a slightly different phrasing of his critique of Enlightenment. This is the version that speaks of Enlightenment and modernity as the reduction of the world to an unacknowledged picture (unacknowledged not because someone is concealing the evidence but because the picture just is evidence and self-evidence, pure visibility). In the passages that interest me, Heidegger seeks to make visible within this apparent lucidity and availability of the world to knowledge and research something other than that light, something as if concealed within or as it. He writes as follows:

> The gigantic is rather that through which the quantitative becomes a special quality and thus a remarkable kind of greatness . . . what is gigantic, and what can seemingly always be calculated completely, becomes, precisely through this, incalculable. This becoming incalculable remains the invisible shadow that is cast around all things everywhere when man has been transformed into *subjectum* and the world into picture.

It is not difficult to recognise in this invocation of an immensity beyond calculation and its generation of the oxymoronic figure of 'the invisible shadow' a revision or recovery of what Kant called 'the sublime' (although Heidegger does not himself name it as such).

An appendix to this passage offers a further gloss that helps with filling out Heidegger's sense:

> Everyday opinion sees in the shadow only the lack of light, if not light's complete denial. In truth, however, the shadow is a manifest, though impenetrable, testimony to the concealed emitting of light. In keeping with this concept of shadow, we experience the incalculable as that which, withdrawn from representation, is nevertheless manifest in whatever is, pointing to Being, which remains concealed.[6]

Captivated, then, by the harmony and proportion of the picture in which we are, we are blind to the absolute—I will eventually turn to Heidegger's gloss on this word—the absolute incalculability and gratuitousness of what thus appears: which means that we fail to take it as a picture, mistaking it for the unframed order of things in their sheer availability to us. Heidegger seems to hold—although he does not draw upon the terms—that if the beautiful is perhaps what pleases us *in* a picture, the sublime enters centrally into our registration of it *as* a picture: the world of research is of a piece with a certain aestheticism just insofar both refuse recognition to this embedded sublimity. Heidegger's central essay 'The Origin of the Work of Art' seems to me to complete this linkage of the sublime to the matter of the frame as pictorial fact, internal to the structure of picturing.

Turner makes pictures of the sublime. And they are beautiful. In this beautiful sublimity nature coincides with itself, and with art too. The claim of *The Sun of Venice* thus lies against its condition as painting—that it might also be said to display itself as nothing other than painting makes no difference.[7] Nothing is lost and nothing bequeathed—in the absence of mourning, what is continued is only the actuality of painting, the various minor possibilities of virtuosity or of meaning, the possibilities within which Turner's work incessantly manoeuvres. Turner's painting cannot but succeed—nothing has become impossible.

To say that in Turner 'nothing has become impossible' is I think simply to say that there an encounter with philosophy has been decisively missed and this 'miss' is, in his painting, made constitutive of the actuality of painting.[8]

Am I then saying that this encounter is not missed in French painting? And if so how would I argue for that? Surely I do not mean

that Manet read Hegel?—I don't see how I could make that stick, although it matters to me obscurely that Mallarmé did.

I suppose rather that I am claiming that the kind of retreat Manet's painting enacts with respect to the ambition of Courbet (its acknowledgment of a certain failure or limit) marks that tradition for an encounter with philosophy, so that this encounter will have taken place whether one or another painter has read one or another philosopher or not. Courbet's visibility is his problem, and this problem never leaves the ground of his painting—so that Manet, forged by that painting, is obliged to begin by accepting the necessity of this failure.[9] There is, no doubt, more than one way to put this failure: One might, for example, speak, as Michael Fried does with respect to Courbet, of a certain failure of painting to hold itself utterly within its act, or one might speak, as Thierry de Duve does with respect to Duchamp, of a certain inability to definitively tell the thing from its name. Such choices are the very stuff of modernism's historicity. But the event will always be the same: something— painting—has become impossible. Nothing has happened, and Manet, as Duchamp later, is obliged to its registration and continuation in a way the pre-Raphaelites, in Turner's wake, are not. Philosophy will find itself to have been encountered by Manet sooner or later.

I am claiming a certain encounter with philosophy—enacted as a certain missing of identity—to be central to the emergence of what we call modernism in painting, and I can begin weaving my way back to the issues from which I started by noting that there are accounts of modernism which would make much more of a presumed encounter with photography. These claims for the impact of photography have certain things going for them; photography is, after all, a real social fact and practice with a clear ability to put the painter (a particular kind of painter—representational, at least apparently committed to a certain coincidence of art and nature) out of business. Placed against this threat, Turner looks, if anything, ahead of the struggle, helping to move painting towards its own, essentially non-photographic ground. But the nature of his 'advance' is wholly continuous with the photographic ambition that nature and its registration should in some sense coincide; Turner can re-cognise his painting in photography without thereby rediscovering it.

I suspect that I am on the way here to arguing that Turner's painting, for all its atmosphere and colour, remains fundamentally engaged with a problem of representation—which is to say, in this context, drawing. Were one called upon to imagine a certain competition with photography it would be founded there; and in Turner's case, to the extent that the encounter with photography can be said to happen at all, it does not happen as a competition. Against this and in arguing for the primacy of an encounter with philosophy (or, in the case of Turner, a non-encounter). I am insisting on the priority of a problem of light, as bearer of darkness and as ground of colour: a problem that photography itself can only come to when painting has prepared its conditions—as it does in the work of Pollock and Louis and Stella. It is when the questions of colour and frame have been knotted as they are in this tradition, that work like Cindy Sherman's can begin to become visible.

The essential problem of photography has been that it has not known what to do with its absoluteness. In one sense, a photograph is no more or less absolute than a painting or a sculpture, a piece of music or a poem. But is nonetheless different in that it seems essentially unable to fail, and so is itself evidently incapable of modernity. Its only real decision is about what it will look like—like painting or like life? Like life when it falls into resemblance to a painting? We've had instances of all these things, and some of them hang in museums. What they are remains unclear.

Something special would have happened to photography if it were to have discovered among its possibilities that of looking like a photograph (that is, of *merely* looking like a photograph and so of failing to be one). It is no doubt this recognition that underlies in some measure the various printing practices that eventually emerged within art photography—the displaying of sprocket holes, the use of oversize sheets of paper, and so on. Presumably these are all for persuading the viewer that there is a medium here and that it has features. But none of these, in the end, interfere in the least with the automatism of the process: the unalterable fact that finally all one need do to make a picture is to take it.[10] The pencil of nature does not fail to draw (that there is a certain symmetry between this and my description of Turner is, as I understand these things, not an accident).

One might think there would be a future for photography, an event within it, only if it could free itself from the understanding inscribed in its name, and so shake off its submission to drawing. But then it would apparently enter into a different competition with painting, one where painting's openness to abstraction would seem to give it the edge. This way of putting the problem of photography suggests a certain continuing pertinence of the old opposition of *disegno* and *colore* within the new technology—but if this opposition is indeed pertinent, the problem is that photography does not know what counts for it as colour.

In the end, then, photography appears unable to outflank its absoluteness and is as if obliged to wait upon the work of some other art to find a way to itself. It offers no real rivalry to painting (I doubt this is news to painters).

What I have been calling photography's absoluteness is of a piece with its lucidity—say, its material and conceptual obligation to light—and it is only when this lucidity is placed in active and material question that it has any chance of failure (and so also of success). Rosalind Krauss has recently argued that something like this is what happens in and around surrealist photographic practices, and I tend to agree, although I will phrase the matter somewhat differently. Krauss speaks of such photography's ability to expose the world as the unceasing production of signs.[11] I would say, more generally, that even before a photograph shows us anything of the world, it shows us the world's separability from itself, its inherent tendency to representation in and as presentation. It is, I suggest, against this background that what I have been calling the absoluteness of photography might become a graspable feature of it—and here, at last, I need Heidegger's way of reading this word and its centrality for post-Kantian philosophy:

> What is different about the way German Idealism understands philosophy? The fundamental interpretation of these thinkers can be expressed in an adequate correspondence as follows: *philosophy is the intellectual intuition of the Absolute* . . . Thus, the intuition which constitutes the first and true knowing must pursue the totality of Being . . .
> In accordance with its nature, this totality can no longer be determined by *relations, in terms of* relations *to something else*— otherwise it wouldn't be the totality. This totality of Being lacks a relation

to other things, is not relative, and is in this sense *absolutely* absolved
from everything else . . . This absolute *relationlessness* to anything else,
this absolutely absolved is called the *Ab-solute.*[12]

If the problem of photography has been its absoluteness, this can be
discovered also as its prospect: the astonishing thing about a photo-
graph is that it is at all, that the world can lend itself to us (ab-solve
itself of or from itself) that way. This evidently akin to the astonish-
ment that is said to underlie philosophy (which is perhaps why
philosophy is constitutionally given to claiming the end of that aston-
ishment).[13]

The absoluteness of photography is just that what gives itself to
the camera tears against itself in doing so. Just as light, for Goethe,
breaks itself into visibility and colour. Or just as light can be dis-
covered by the camera to sacrifice itself on the emulsion. But this
absolvence cannot become visible so long as the photographic
image remains entrapped within its inevitable representational suc-
cess. It happens when the camera, without ceasing to represent,
comes to know—or show—this not as drawing but as an act of
enlightenment.[14]

(And there is, of course, much more to be said about Heidegger—
about absolution and system, frame and jointure. But that will need
another occasion.)

The apparent design of the present essay is circular, a vortex at
once spiralling out and closing in itself, bringing everything—paint-
ing and philosophy and photography and Turner and Cindy Sherman
and God knows what else—into the light. It should also be apparent
that this design cannot be fulfilled except at the cost of making noth-
ing impossible. The claims I've advanced are as excessive as the argu-
ments for them are inadequate, and the chain of claims is at this point
broken, leaving nothing quite secured.

There are, I hope, some propositions working here: That the
critique of Enlightenment is carried out in no other place than that
of light, and does not happen apart from the acknowledgment of a
certain sublimity that is the condition of any art we are prepared to
call beautiful—that is, to which we are prepared to assent and from
which we feel our assent demanded. That this will thus take always
the form of a discovery of light, and that light will be Goethean,

darkness its condition and colour its consequence. That it is of little moment whether we call this critique modern or postmodern, but of great moment that it be a moment—which is to say that after it nothing might be possible.

And, of course, I hope that what will have happened somewhere in these pages will have been an encounter within the complex skeinings that bind histories of philosophy and of painting to one another and to the particular times and places it is given to us to write.

1992

*T*he pleasures of being publicly read—especially when that reading is appreciative and conducted by someone whose writings you yourself appreciate—will perhaps seem too obvious to bear remarking, and it may also be that any attempt at such remarking can only appear as a self-indulgent effort to prolong those very pleasures. If I nonetheless aim in this postscript at something of the fact of being read, it is because I hope or believe that something worth noting becomes visible by thinking about the interest one might find in being read.

One of my old teachers, Mircea Eliade, used to tell a story about a friend of his who had written the definitive monograph on prehistoric Rumanian folk music (at least that's how I recall the topic) and who, having done so and aware that he was the only person who actually cared about prehistoric Rumanian folk music, dumped the completed manuscript in the river (the Danube, I presume, although for some reason I find myself always imagining it as the Seine). It is in its intentions a good University-of-Chicago-type story about disinterested knowledge and a certain essential modesty entangled with the very terms of scholarly achievement. It's also a rather sad story and very different, I think, from a roughly equivalent story in which the friend would have learned all there was to know about prehistoric Rumanian folk music and then not written any of it down because it only mattered to him. There's no hint of a kind of suicide in that second story—only of a certain withholding one might variously praise or blame but which implies no inner unhappiness in, so to speak, the knowledge itself. If the first story saddens one (I don't know that it did Eliade), it is because writing exists to be read and the

drowning of the manuscript takes on the character of a failure, per-haps of the writing or perhaps of the world: either way the interest, not in prehistoric Rumanian folk music, but in the writing of it, is seen to find itself without a place in the world, and the picture that lingers with me at least is of a man by a river who has been obliged to find himself essentially alone.

One writes to be read, just as (in ways some of the essays in this volume try to chart) one paints to be seen—that is, for the writing to be read (the painting to be seen)—and what the hesitation and qual-ified repetition intends to make clear is that the boundary between showing one's self and showing something other than one's self (an object, a text, a representation, a mask, a veil, a work . . .) is hardly clear. Writing, one means to enter a space between one's self and. . . . We can call the space the ellipsis marks that of "the other" but it will be filled, if it is, always by *an* other, some particular other by whom your interest is secured, rendered concrete or objective in ways that both fulfill and outrace the terms of your intention. And what mat-ters here is that this is never a confirmation of your "self," that what is secured—what I am calling "interest"—is a being between, *inter-esse*, not simply bracketed by the self but at once internal to it and unutterably beyond it.

Being read establishes a relation to the self that is grounded in something other than recognition, which is why a response to such reading that returns to or draws upon the self's standing stock of recognitions is essentially a refusal of the very exposure—placing outside—that the writing was in the first place (and that it will remain in the end). This is not to say that reply is necessarily inap-propriate—exposure is not an unequivocal good, and there can cer-tainly be reasons to scramble for cover, to fire back, or to move forward aggressively to block certain dangerous approaches—but it is to say that sometimes silence, a certain courting of time or a wait-ing for further writing, may be the best acknowledgment that what has been done is reading. It is something I mean this postscript to partly do while also at least touching on the prospects Jeremy Gilbert-Rolfe's introduction opens.

"Prospects" in this sense might be something like phrases that one can see compellingly written in, as it were, one's own name but which one cannot (yet) write one's self—phrases like "an intervention

rather than a production," which speaks an idiom I know to count and which I have not rendered native to my tongue; or "the mark as a depth suspended in a depth," which perhaps more than any other in Gilbert-Rolfe's essay carries the burden of everything in his writing that I am obliged by or through that phrase to find myself folded in and out of; or again, "something very like action masquerading as reaction" as it borders on questions I have had about dialectic and about passivity but have not seen the joining of. Perhaps Gilbert-Rolfe's turning of my use of Turner is another such prospect, bringing into view something obscured—forgotten or refused but also pressing and palpable—in that essay's words.

To say that these are instances of phrases or thoughts I cannot (yet) write myself is to say that they bear, or bare, a relation to someone not myself who will, should he come into existence, recognize my self as a component of his, someone whose beliefs will appear to him an unfolding, revision, or turn against my own. They thus underline the present possibility within what has been written of someone other than the writer, and they make that presence continuous with that writing's readability, a fact of its exposure. In doing so, they offer me some comforting proof that what I have been doing is in fact writing and not merely repeating myself (or, to put it the other way around, they offer some evidence that my writerly repetitions of myself are still open to difference, have not foreclosed on the possibility of work).

It would be important that some of the phrases and thoughts that demand of me such acknowledgment may well also be essentially not open to me to write, so that the acknowledgment they call for demands recognizing the odd knotting of contingency and necessity that divides in me things I am nonethless obliged to admit as "my" possibilities. The work and words of Gilles Deleuze and Félix Guattari as they surface and disappear in Gilbert-Rolfe's essay, ordering its metaphors and generating (not, surely by themselves, not, I assume, apart from his own experience of painting and the experience of his own painting) the evident naturalness of "a depth within a depth," may perhaps mark such a seam of (im)possibility. For the moment in any case they are there for me to read but not, except occasionally and by opportunity, to write or rewrite, and so they are a part of what is at stake for me in reading Gilbert-Rolfe (here and elsewhere). Being read is the guarantor of what does not

return within what all too implacably does; in this its pleasures are precisely opposed to those of self regard. (This would be, for example, one way I can understand Foucault's claim to write in order to become anonymous.)

Why should I feel these things are worth saying? I cannot dissociate my urge to say them from a sense, growing over the years, that the stake we may have in such matters as art and art history (but also literature and literary theory and philosophy) can no longer be fully explored apart from a certain questioning of the university. And I suppose that one form of that questioning comes to bear upon the act of reading or, more accurately, upon the interest the professionalized denizens of the university acknowledge or fail to acknowledge in being read. If it is right or fair to say that the university is increasingly the site of a merely formal self-reproduction which takes in the humanities the form of the production of "readings," those readings will inevitably be, regardless of what one might imagine as their intent or desire, received only as objects of consumption, things to be counted, rather than, as I would have them be, occasions for displacement and revision (this may be what Gilbert-Rolfe also means in his speaking of intervention and production).

Once perhaps—in for example the university or intellectual community Eliade's story assumes—this would not have mattered, because knowledge could be imagined as its own reward and writing only the means of its communication. Knowledge can, of course, still be its own reward, but writing now is no longer simply the means of its communication and has become that through which the community the university claims either exists or fails to exist. And if we look, now, not at where readings are being produced but at where writing is being read, we may find ourselves looking—or being taken—more often than not beyond what appear in gilded memory as the walls or lawns of the university toward those other places outside or seams within the institution that continue to stake themselves in the notion that work exists as work only for an other. All this, then, to mark one further way in which art may now be a crucial context for philosophy.

N O T E S

Introduction

1. Chapter 1, "Robert Smithson: 'A Literalist of the Imagination,'" p. 34.
2. Chapter 2, "Description," pp. 48–49.
3. Jeremy Gilbert-Rolfe, "Eugene Kaelin, Artist's Philosopher," *The Journal of Aesthetic Education*, forthcoming 1996.
4. Chapter 8, "Notes on the Reemergence of Allegory, the Forgetting of Modernism, the Necessity of Rhetoric, and the Conditions of Publicity in Art and Criticism," p. 153.
5. Ibid, p. 154.
6. Chapter 4, "Positionality, Objectivity, Judgment," p. 84, p. 83.
7. Chapter 8, pp. 185–186.
8. Judith Butler, "Performative Acts and Gender Constitution: An Essay in Phenomenology and Feminist Theory," *Theatre Journal* XL:4 (December 1988): 519.
9. Chapter 6, "Division of the Gaze, or, Remarks on the Color and Tenor of Contemporary 'Theory,'" pp. 123–124.
10. Chapter 10, "Painting Put Asunder: Moments Lucid and Opaque Like Turner's Sun and Cindy Sherman's Face," p. 202.
11. "Goethe's emphasis on the polar structure of both the formation of colors from light and dark and their reception by the eye made his system the ancestor of Hering's opponent-color theory. It was this, too, which made his scheme, rather than Newton's, so attractive to Romantic philosophers such as Schelling, Schopenhauer and Hegel . . . All these thinkers, however, were attracted primarily to the logical structure of Goethe's ideas and were hardly concerned with experiment or even experience, for which they depended on the example of painters," John Gage, *Color and Culture: Practice and Meaning from Antiquity to Abstraction* (Boston: Little, Brown, 1993), 202. See also 108: "it was . . . William Blake who developed the most bitter opposition to Newton in England. Yet, in contrast with . . . Blake's contemporary Novalis who scathingly derived the term 'Enlightenment' from a toying with the more trivial aspects of light, *Newton's* optics was barely mentioned in Blake's polemic; in the frequent rainbows and rainbow glories that appear throughout the work, the number and sequence of colours is always essentially Newtonian."

12. Chapter 7, "Color Has Not Yet Been Named: Objectivity in Deconstruction," pp. 141–142.
13. Martin Heidegger, "A Dialogue on Language," in *On the Way to Language*, trans. Peter D. Hertz (San Francisco: Harper, 1982): 53.
14. op. cit., 37–8.
15. Chapter 6, p. 119.
16. Chapter 5, "Psychoanalysis and the Place of *Jouissance*, p. 105.
17. Chapter 6, p. 114.
18. Chapter 4, p. 73.
19. Chapter 4, p. 74.
20. Chapter 2, p. 46.
21. Chapter 7, p. 139.
22. Chapter 4, pp. 79–80.
23. Chapter 2, p. 46
24. Chapter 6, p. 114.
25. Chapter 4, p. 74.
26. Hans-Georg Gadamer, "The Rehabilitation of Authority and Tradition," in *The Hermeneutics Reader: Texts of the German Tradition from the Enlightenment to the Present*, ed. Kurt Mueller-Vollmer (New York: Continuum, 1988): 262.
27. Jean François Lyotard, *The Inhuman, Reflections on Time*, trans. Geoffrey Bennington and Rachel Bowlby, (Stanford: Stanford University Press, 1991): 93. See also Gilbert-Rolfe, *Das Schöne und der Erhabene von heute*, aus dem Englischen von Almuth Carstens (Berlin: Merve Verlag, 1996): 23.
28. Gilles Deleuze, *Kant's Critical Philosophy*, trans. Hugh Tomlinson and Barbara Habberjam (Minneapolis: University of Minnesota Press, 1984): 53. For my own use of this quotation and of Deleuze as a theoretician of fluidity, see my *Beyond Piety: Critical Essays on the Visual Arts, 1986—1993* (New York: Cambridge University Press, 1995): 298, and also 43, 62, 69, 161, and passim.
29. Chapter 1, p. 31.
30. Chapter 1, p. 38.
31. Ibid.
32. Jacques Derrida, "The Violence of the Letter," in *Of Grammatology*, trans. Gayatri Chakravorty Spivak (Baltimore: Johns Hopkins, 1974): 110.
33. Friedrich Nietzsche, "The Birth of Tragedy," in *The Birth of Tragedy and The Geneology of Morals*, trans. Francis Golffing (Garden City, New York: Doubleday, 1956), 120.
34. Chapter 1, p. 36–37.
35. Jacques Taminiaux, *Dialectic and Difference: Modern Thought and the Sense of Human Limits*, eds. James Decker and Robert Crease (Atlantic Highlands, New Jersey: Humanities Press International, 1990): 55, and 55–114 in general. It is also interesting to note that this work was published five years earlier in hardcover, by the same publisher, with the subtitle *Finitude in Modern Thought*.
36. op. cit., 73.
37. Chapter 1,p. 33.
38. Ibid, p. 33.
39. Chapter 10, p. 203.
40. Martin Heidegger, *Early Greek Thinking*, trans. D. F. Krell and F. A. Capuzzi (New York: Harper, 1975): 115. Also in Taminiaux, 72.
41. Chapter 10, p. 203.
42. Ibid, p. 204.

Chapter One Robert Smithson: "A Literalist of The Imagination"

My subtitle is taken from Northrop Frye's *Fearful Symmetry: A Study of William Blake* (Princeton: Princeton University Press, 1947), a work to which I will refer in these notes.

1. Robert Hobbs, *Robert Smithson: Sculpture* (Ithaca: Cornell University Press, 1981). The volume contains an introduction and essay by Hobbs, additional essays by Lucy Lippard, Lawrence Alloway, and John Coplans, and individual discussions by Hobbs of 76 works by Smithson. The overlap with the exhibition is substantial but not total. (The exhibition catalogue itself is little more than a checklist.)

2. "To the objection that Pope has as much right to work his poem out in couplets as Blake has to work his picture out in a rectangle, Blake would perhaps have said that the rectangle is one of the boundaries of the medium, like language in poetry, whereas the couplet is a barrier thrown across the medium" (Frye, p. 95).

3. It is thus unsurprising that a recent critic writing on the work of Charles Simonds can claim that such works as *Spiral Jetty* now appear as too flat: "It reads as a drawing as much as a landscape element." (John Beardsley, "On the Loose with the Little People: A Geography of Simonds' Art," in *Charles Simonds*, catalogue to the exhibition at the Museum of Contemporary Art, Chicago, Nov. 7, 1981–Jan. 3, 1982).

4. I quote from Frye's opening chapter: "Any attempt to explain Blake's symbolism will involve explaining his conception of symbolism. To make this clear we need Blake's own definition of poetry:

 > Allegory addressed to the intellectual powers, while it is altogether hidden from the Corporeal Understanding, is My Definition of the Most Sublime Poetry; it is also somewhat in the same manner defin'd by Plato.

 "It has often been remarked that Blake's early lyrics recall the Elizabethans; it is not so generally realized that he reverts to them in his critical attitude as well, and especially in this doctrine that all major poetry is allegorical. The doctrine is out of fashion now, but whatever Blake may mean by the above definition, it is clear that there is a right and a wrong way of reading allegory. It is possible, then, that our modern prejudice against allegory, which extends to a contemptuous denial that Homer or Virgil or Shakespeare can be allegorical poets, may be based on the way of the 'corporeal understanding.'

 "... Blake's idea that the meaning and the form of a poem are the same thing comes very close to what Dante appears to have meant by 'anagogy' or the fourth level of interpretation: the final impact of the work of art itself, which includes not only the superficial meaning but all the subordinate meanings which can be deduced from it. It is therefore hoped that if the reader finds his ideas of Blake at all clarified by the present book he will be led to the principle which underlies it. This is that, while there is a debased allegory against which there is a reasonable and well founded prejudice, there is also a genuine allegory without which no art can be fully understood"

(Frye, pp. 10–11). Frye goes on to remark (p. 12) that "If Blake be consistently interpreted in terms of his own theory of poetry, however, the interpretation of Blake is only the beginning of a complete revolution in one's reading of all poetry." The work of what is now called "deconstructive criticism" can be seen as, to a very large extent, the working through of this insight in new and radical detail.

It is within the general terms of this problematic that we should read Frye's later statement that "in all periods of his life, Blake moves toward an undifferentiated art, art addressed not to a sense but to the mind that opens the senses" (p. 417). The statement touches something essential to Smithson's art as well—as does Frye's remark that "when Blake defines his art as allegory addressed to the intellectual powers he must have meant, strained as the interpretation may seem to some, intellectual powers" (p. 84).

5. I intend here to link Smithson's work to a similar impulse in the writings of Georges Bataille. For a dissenting view, see Nicolas Calas, "Scandal's Witnesses: Grafting Smithson on Bataille," *Artforum* (Feb. 1981).

6. Another way to put this would be to suggest that Smithson was interested in rearranging the conditions of art's publicity, and here too we can note a spiritual kinship to Blake: "Blake's primary objective is to revive public painting: the revival of other aspects of civilization will then follow more easily. Against him will be the whole trading combination of commercial painters, with their patrons and connoisseurs . . . Blake's immediate program, being concerned with the reestablishment of fresco in public buildings, involves an overthrow of the easel oil-painting monopoly and a return to the pure colors and sharp outlines which only fresco and water color can give" (Frye, p. 408).

7. The visual ambiguity of the photograph of the Century apartments with which Smithson illustrated his essay bears remarking.

8. Smithson's preoccupation with prehistory and with lost continents would then seem to be of a piece with Blake's insistence that we see "a city behind the garden of Eden" (Frye, p. 231). Smithson's "The Monuments of Passaic" can be understood as a Blakean undoing of the naturalizing Beulah-myth of California futurity in the name of the prehistoric urban and suburban fact of New Jersey. City and prehistory, mirror and *Alogon*-perspective meet in Smithson's "crystallizing mind" (I take the phrase from Frye on Blake) and its vision of Passaic as Eternal City: "Each city would be a three-dimensional mirror that would reflect the next city into existence" (p. 94).

9. For an exploration of this affinity (and the linkage to Poe on which I touch below), see Craig Owens, "Earthwords," *October*, 10 (Fall, 1979) and "The Allegorical Impulse: Toward A Theory of Postmodernism," *October*, 12 and 13 (Spring and Summer, 1980).

Chapter Two Description

1. Maurice Merleau-Ponty, *Phenomenology of Perception*, trans. Colin Smith (London; Routledge and Kegan Paul, 1962), vii.

2. Martin Heidegger, *Being and Time*, trans. John Macquarrie and Edward Robinson (New York: Harper & Row, 1962), 58–62.

3. *Phenomenology of Perception*, x–xi.
4. At the same time, it is worth remarking that Panofsky can in important ways seem to open art history to the impulse toward cultural studies—which is to say that divergent ways of taking the pertinence of contemporary theory to the discipline of art history can in some measure at least appear to pivot around his work.
5. *Logos* XXI, 1932, pp. 103–119, as cited in G. Didi-Huberman, *Devant l'image: question posée aux fins de l'histoire de l'art* (Paris: Minuit, 1990), 120 ff.
6. Hans-Georg Gadamer, *Truth and Method*, 2nd revised edition, trans. Joel Weinsheimer and Donald G. Marshall (New York: Crossroad, 1989).
7. One might note, by contrast, that Panofsky's "Iconography and Iconology" means to enforce a clear separation of method and example in its division into two distinct parts. But one should also note that the "example" is not simply that—it is an account of the privilege of the Renaissance precisely in terms of its achievement of the appropriate kind of hermeneutic distance toward the past (the kind of distance that admits the separation of method and example). This is the self-denying shape of Panofskyian art history's embeddedness in its object.
8. It would be the work of another essay to sort out the system of relations underlying the initial appearance of Meyer Schapiro's attack on Heidegger, "The Still Life as Personal Object—A Note on Heidegger and Van Gogh," in *The Reach of Mind: Essays in Memory of Kurt Goldstein*, ed. M. L. Simmel (New York: Springer, 1968).
9. "As to perception, I should say that once I recognized it as a necessary conservation. I was extremely conservative. Now I don't know what perception is and I don't believe that anything like perception exists. Perception is precisely a concept, a concept of an intuition or of a given originating from the thing itself, present itself in its meaning, independently from language, from the system of reference. And I believe that perception is interdependent with the concept of origin and of center and consequently whatever strikes at the metaphysics of which I have spoken strikes also at the very concept of perception. I don't believe there is any perception." Jacques Derrida, "Structure, Sign, and Play in the Discourse of the Human Sciences," in *The Structuralist Controversy: The Languages of Criticism and the Sciences of Man* eds. Richard Macksey and Eugenio Donato (Baltimore: The Johns Hopkins Press, 1972) 272.
10. See Jean-François Lyotard, *Discours. Figure* (Paris: Editions Kincksieck, 1971).
11. Lévi-Strauss approvingly cites Ricouer's description in the "Overture" to *The Raw and the Cooked*, trans. John and Doreen Weightman (New York: Harper & Row, 1969).
12. Martin Heidegger, "The Origin of the Work of Art," in *Poetry, Language, Thought*, trans. Albert Hofstadter (New York: Harper & Row, 1971).
13. "What in truth is the thing, so far as it is a thing? When we inquire in this way, our aim is to come to know the thing-being (thingness) of the thing. The point is to discover the thingly character of the thing. . . .
 "The stone in the road is a thing, as is the clod in the field. A jug is a thing, as is the well beside the road. But what about the milk in the jug and the water in the well? These too are things if the cloud in the sky and the thistle in the field, the leaf in the autumn breeze and the hawk over the word, are

rightly called by the name of thing. All these must indeed be called things, if the name is applied even to that which does not, like those just enumerated, show itself, i.e., that which does not appear. According to Kant, the whole of the world, for example, and even God himself, is a thing of this sort, a thing that does not itself appear, namely a 'thing-in-itself.'"

14. See Jacques Derrida, *The Truth in Painting*, trans. Geoff Bennington and Ian McLeod (Chicago: University of Chicago Press, 1987).

15. And he also knows—must know—that making his points depends on displaying a gap between description and interpretation—that is, he knows his interpretation is wrong (even if he believes the part about the peasant woman).

16. Putting it this way may have the virtue of recalling how far Derrida introduces his own grammatological writing as a renewal of the question of technology in the face of Heidegger's too-simple disparagement of it. This would be to say that from the beginning what is in question for Derrrida is Heidegger's unreaderly romanticism, one version of which is altogether too palpably on display in the fantasy of the peasant woman and her continuity with the earth.

17. See Derrida, *The Truth in Painting*.

18. See Jacques Derrida, "Me—Psychoanalysis: An Introduction to the Translation of 'The Shell and the Kernel' by Nicolas Abraham," trans. Richard Klein, *Diacritics* 9:1 (Spring, 1979).

19. Erwin Panofsky, "The First Page of Giorgio Vasari's 'Libro': A Study on the Gothic Style in the Judgment of the Italian Renaissance" in *Meaning in the Visual Arts* (New York: Doubleday & Co., 1955).

20. Heinrich Wölfflin, *The Principles of Art History: The Problem of the Development of Style in Later Art*, trans. M. D. Hottinger (New York, Dover Publications, 1950.)

21. "Frame" here is, of course, my metaphor, and for the purposes of this paper I am content to let it carry whatever just weight it can in the context of the argument. My sense, for what it's worth without any further elaboration, is that it is a serious and necessary metaphor—one that can be justified within a fuller reading of the *Principles*.

22. The disentangling is accomplished through the highly visible distinction between Classical and Baroque; the entangling is reflected in the too-often overlooked facts that no work is, in itself and apart from some particular contrast, either Classical or Baroque, and that in some such particular contrast it may figure as either.

23. The sense of "prove" here (and so also of "method") is close to Hegel—as, for example, in his writing that "in the case of the object of every science, two things come at once into consideration: (i) that there *is* such an object, and (ii) *what* it is." Hegel continues: "On the first point little difficulty usually arises in the ordinary [i.e. physical] sciences. Why, it would be at once ridiculous to require astronomy and physics to prove that there are a sun, stars, magnetic phenomena, etc.! In these sciences which have to do with what is present to sensation, the objects are taken from experience of the external world, and instead of *proving* them, it is thought sufficient to *point* to them. . . .

"Now the doubt whether an object of our inner ideas and general outlook *is* or is *not*, like the question of whether subjective consciousness has generated

it in itself and whether the manner and mode in which it has brought it before itself was also in correspondence with the object in its essential nature, is precisely what arouses in men the higher scientific need which demands that, even if we have a notion that an object is or that there is such an object, nevertheless the object must be exhibited or proved in accordance with its *necessity*." G. W. F. Hegel, *Aesthetics*, trans. T. M. Knox (Oxford: Oxford University Press, 1975), 23–24.

24. See Martin Heidegger, ". . . Poetically Man Dwells . . ." in *Poetry, Language, Thought*.

Chapter Three Aesthetic Detachment

1. I do not intend to explore the grounds of this absence; it is itself the subject of a growing revisionist discussion of modernism. Serge Guilbauli's *How New York Stole the Idea of Modern Art* is certainly relevant here.

Chapter Four Positionality, Objectivity, Judgment

1. The panels in question were at the International Congress for Art History in Berlin, July 1992, and the annual meeting of the College Art Association in Chicago in March 1992.

2. The key texts are Sartre's *Critique of Dialectical Reason*, published in France in 1960, and Claude Lévi-Strauss's "History and Dialectic" in *The Savage Mind*, originally published in 1962. It is worth remarking that these debates precede by some two decades any palpable impact of "theory" on Anglo-American Art History.

3. I should also say, since this is now a matter of considerable argument, that it is at least not clear to me that or in what way Heidegger's politics are a direct consequence of his more general philosophic positions.

4. It seems to me that some substantial part of the interest of T. J. Clark's work lies in its sometimes ambiguous resistance to this tendency.

5. Erwin Panofsky, "Iconography and Iconology: An Introduction to the Study of Renaissance Art," in *Meaning in the Visual Arts* (New York: Doubleday, 1955).

6. Hans-Georg Gadamer, *Truth and Method*, 2nd revised edition, trans. Joel Weinsheimer and Donald G. Marshall (New York: Crossroad, 1989).

7. One way to put it—and I am grateful to my student Zhou Yan for making this clear to me—would be to say that he withholds from the historian the hermeneutic freedom he assumes for the artist, although the two positions are wholly analogous to one another and, indeed, mutually dependent.

8. The same can and must be said of Derrida as well, despite all he has done to radicalize and throw into question the hermeneutic formulations I am exploring here.

9. Arthur Danto, in a recent lecture on Lichtenstein, has gone so far as to suggest that art history has to date displayed two great modes that he characterized as "Vasarian" and "Greenbergian." This seems to me about right.

10. See on these matters, Michael Holly, *Panofsky and the Foundations of Art History* (Ithaca: Cornell University Press, 1984); Michael Podro, *The Critical Historians of Art* (New Haven: Yale University Press, 1982); and Georges Didi-Huberman, *Devant l'image: question posée aux fins de l'histoire de l'art* (Paris: Minuit, 1990).

11. See also Hans-Georg Gadamer, *The Relevance of the Beautiful and other essays*, trans. Nicholas Walker (Cambridge: Cambridge University Press, 1986).

12. See Sarah Faunce and Linda Nochlin, eds. *Courbet Reconsidered* (New York: The Brooklyn Museum, 1988).

13. Estimates of who "won" the exchange, and why, also vary quite wildly, and all of this can, of course, be taken as evidence that it does indeed unfold at some crucial juncture within the profession.

14. Perhaps most notably Jacques Lacan's psychoanalysis.

15. Faunce and Nochlin, 40.

16. Michael Fried, *Courbet's Realism* (Chicago: University of Chicago Press, 1990).

17. Michael Fried, "Art and Objecthood" in *Minimal Art: A Critical Anthology*, ed. G. Battcock (New York: E. P. Dutton, 1968).

18. In phrasing this in terms of "strikingness," I mean also to mark what seems to me a certain proximity to the work of Philippe Lacoue-Labarthe in his *Typographies*.

19. In the context of Fried's work in particular it is worth noting that this poses a certain historically fluid and ontologically ungrounded "medium-specificity" as a direct consequence of the fact that art appears.

20. Friedrich Nietzsche, "The Birth of Tragedy," in *The Portable Nietzsche*, selected and trans. Walter Kaufman (New York: Viking Press, 1968), 65.

Chapter Five Psychoanalysis and the Place of *Jouissance*

1. By and large the evidences of the Lacanian clinic are closed to us in consequence of Lacan's insistence on theoretical elaboration. But it should not go unremarked that much of the work of Lacan's school seems to have focused on areas traditionally recalcitrant to psychoanalytic treatment—alcoholism, retardation, and psychosis—and that such an emphasis is responsive to traditional empirically minded critiques of the limits of psychoanalysis.

2. It should perhaps be noted in this context that the project of a genuinely public presentation of Lacan's seminars seems to have been abandoned in favor of the more circumscribed circulation of texts through the Lacanian journal *Ornicar?*

3. Angus Fletcher in discussion following Jacques Lacan, "Of Structure as an Inmixing of an Otherness Prerequisite to Any Subject Whatever," in *The Human Sciences and the Languages of Man: The Structuralist Controversy*, ed. Richard Macksey and Eugenio Donato (Baltimore, 1970), p. 195. See Lacan, *Encore, 1972–73*, Le Seminaire, livre 20, ed. Jacques-Alain Miller (Paris, 1975), p. 86:

> S'il m'était permis d'en donner une image, je la prendrais aisement de ce qui dans la nature paraît le plus se rapprocher de cette réduction aux

dimensions de la surface qu'exige l'écrit, et dont déjà s'émerveillait Spinoza—ce travail de texte qui sort du ventre de l'araignée, sa toile. Fonction vraiment miraculeuse, à voir, de la surface même surgissant d'un point opaque de cet étrange être, se dessiner la trace de ces écrits, où saisir les limites, les points d'impasse, de sans-issue, qui montrent le réel accédant au symbolique.

Further references to *Encore*, abbreviated *E*, will be included in the text.

4. On *jouissance*, see Stephen Heath, "Difference," *Screen* 19 (Winter 1978–79): 51–112; Jane Gallop, "*Encore* Encore," *The Daughter's Seduction: Feminism and Psychoanalysis* (Ithaca, N.Y., 1982); and Juliet Mitchell's and Jacqueline Rose's introductions to Lacan and the *école freudienne, Feminine Sexuality*, ed. Mitchell and Rose, trans. Rose (New York, 1982); further references to this work, abbreviated *FS*, will be included in the text. This book includes a translation of two chapters from *Encore*, "God and the *Jouissance* of the Woman" and "A Love Letter."

 The only treatment of the mathemes I know of in English is in Sherry Turkle, *Psychoanalytic Politics: Freud's French Revolution* (New York, 1978), chap. 7 and the epilogue.

5. On anaclisis in Freud and Freudian conceptuality see Jean Laplanche, *Life and Death in Psychoanalysis*, trans. Jeffrey Mehlman (Baltimore, 1976).

6. But one does well to note the French here: "On s'y range, en somme, par choix—libre aux femmes de s'y placer si ça leur fait plaisir" (*E*, p. 67). This last qualification is hardly neutral, and Rose's rendering "if they so choose" papers over a potential abyss in Lacan's remarks on feminine sexuality: sexual identity may be "conventional," but if that convention in its turn depends on one's pleasure, everything seems to dissolve back into mere nature after all.

7. See *FS*, p. 149; *E*, p. 73. I have added a bit to Lacan's diagram—numbers identifying various propositions, connections between logical equivalents in the upper part, and the labels "masculine" and "feminine."

8. See Luce Irigaray, *Ce Sexe qui n'est pas un* (Paris, 1977); see also Rose's introduction to *FS*, pp. 53–55.

9. "Rien ne peut se dire de la femme. La femme a rapport à S(Ⱥ) et c'est en cela déjà qu'elle se dédouble, qu'elle n'est pas toute, puisque, d'autre part, elle peut avoir rapport avec Φ" (*E*, p. 75). I have altered the symbols in the English translation to correspond to those in the original, which I use throughout this essay.

10. ". . . parce que jusqu'à nouvel ordre, il n'y en a pas d'autre" (*E*, p. 69).

11. I take it that one is free to read this diagram as a pictogram of the sexual act as well.

12. See Shoshana Felman, *Le scandale du corps parlant: Don Juan evec Austin, ou, la séduction en deux langues* (Paris, 1980), and Marie Balmary, *Psychoanalyzing Psychoanalysis: Freud and the Hidden Fault of the Father*, trans. Ned Lukacher (Baltimore, 1982).

13. Lacan's interest in Borromean knots lies precisely in their ability to model the kind of mutual imbrication he sees holding between the three registers of the Imaginary, Symbolic, and Real; and the model in its turn makes clear the unavailability as ground of the Real.

14. *E*, p. 71. Whatever the theological stakes here—and I don't doubt that for Lacan they are substantial—it should not go unremarked that the fiction appealed to here is epistolary, a matter of letters.

15. On the general topic of Lacan's teaching see Catherine Clement, *Vie et légendes de Jacques Lacan* (Paris, 1981); Stuart Schneiderman, *Jacques Lacan: The Death of an Intellectual Hero* (Cambridge, Mass., 1983); François Roustang, *Dire Mastery: Discipleship from Freud to Lacan*, trans. Ned Lukacher (Baltimore, 1982); Roustang, *Psychoanalysis Never Lets Go*, trans. Lukacher (Baltimore, 1983); and Turkle, *Psychoanalytic Politics*.

16. This table is adapted from *E*, p. 21. Mitchell and Rose offer a summary in a long note to their selection from *Encore*; see *FS*, pp. 160–61.

17. This stack of signifiers can be made visible in Schema R by following Lacan's remarks in "On a Question Preliminary to Any Possible Treatment of Psychosis," *Ecrits: A Selection*, trans. Alan Sheridan (New York, 1977), p. 233 n. 18, which suggest that the schema is to be read as the flattening out of the figure that would be obtained by deforming the surface so that the lower right corner overlies the upper left. This figure would be a Moebius strip. It is worth noting that Lacan's psychoanalysis so mixes "self" and "other" that the mappings of "intersubjective discourse" and of "intrapsychic agencies" are just transformations of one another.

18. Mitchell and Rose trace this chain back to the unpublished 1969–70 seminar *L'envers de la psychanalyse*; see *FS*, p. 160 n. 6.

19. "Kanzer Seminar," *Scilicet* 6/7 (1976): 26. All further references to this work, abbreviated "KS," will be included in the text; all translations are mine.

20. Lacan, *Télévision* (Paris, 1974), p. 22; my translation.

21. This paper has left unexplored Lacan's application of the notion of *jouissance* to the jubilation of the mirror-stage infant in his anticipation of bodily unity; something of this sense is at work here.

22. The notion of the "pure signifier" is the impossible cornerstone of Lacanian theory, and the constellation of this notion with questions of feminine sexuality, psychosis, and the nature of psychoanalytic science seems to me fixed at least as early as the 1955–56 seminar, *Les psychoses*, 1955–56, Le Seminaire, vol. 3 (Paris, 1981). The "pure signifier" is the essential object of Jacques Derrida's critique in "Le facteur de la vérité" in *La carte postale: de Socrate à Freud et au-delà* (Paris, 1980), translated as "The Purveyor of Truth," *Yale French Studies* 52 (1975).

23. See Lacan, *The Four Fundamental Concepts of Psycho-analysis*, trans. Sheridan (New York, 1978) pp. 49, 167.

24. Lacan, *Four Fundamental Concepts*, p. 209; see also the useful translator's note, pp. 279–80.

25. It has been suggested to me that Lacan's interest in the mathemes was fueled by a highly ironized game between himself and the mathematical logician Georg Kreisel, opening up yet another region in which *les non-dupes errent*. This is certainly in line with my reading of the standing of these things, and I would suggest that the game is now being played out, stripped of its irony, in the claims of Jacques-Alain Miller. Readers less easily daunted than myself might want to look at Kreisel and Jean Louis Krivine, *Elements of Mathematical Logic (Model Theory)* (Amsterdam, 1967); Kreisel's

evident foundationalist antipositivism, engagement with the "structuralist" work of Bourbaki, and friendship with Raymond Queneau are all likely to make him of interest to Lacan. One might note Kreisel's description of his work as a reformulation and analysis of "intuitive" or "informal" mathematics:

> This reformulation is only a tool in the study of foundations; depending essentially, as does any description of an intuitively understood subject, on our conception of the objects described: it is only from this point of view, i.e., that of meaning, that the formal language expresses correctly the assertions of informal mathematics, since, from the point of view of external form, formal and informal language have (fortunately!) very little in common. [*Elements*, p. 160]

26. Philippe Lacoue-Labarthe and Jean-Luc Nancy, *Le Titre de la lettre: une lecture de Lacan* (Paris, 1973). Lacan refers explicitly to this book in *E*, pp. 62–63.

27. My project thus arises in the wake of Derrida's reading of the Freudian legacy as it is inscribed in *Beyond the Pleasure Principle*; see "Spéculer—sur 'Freud' " in *La carte postale*.

28. Immanuel Kant, *The Metaphysical Elements of Justice*, trans. John Ladd (Indianapolis, 1965), p. 96.

29. On this distinction, see Lacan, *Four Fundamental Concepts*, pp. 174–86.

30. G. W. F. Hegel, *Hegel's Philosophy of Right*, trans. T. M. Knox (Oxford, 1952), pp. 12–13.

31. Ibid., p. 50.

32. Inheritance, we might note, is a mode of translation (this is a point of Roman law as well as a fact of literary history), and we do not, for example, know what in "deconstruction" is to be taken as legacy and what as translation, or what the relations might be between legator and legatee, translator and translated, Heidegger and Derrida.

33. A subsidiary question at work here is whether or not there are "phases" in Lacan. It seems to me that there are not—not in the senses I have been meditating. No doubt there are changes of emphasis and formulation, but the interlinking of questions of feminine sexuality, psychosis, and the nature of science with the doctrine of a "pure signifier" which I take to define Lacanian psychoanalysis is in place from early on and *Encore* elaborates on but does not revise these formulations. What is to be remarked about *Encore*—and may ground our sense of something like a turn in Lacan's work around 1970—is its awareness that it will be read, and its determination to overmaster that prospect.

Chapter Six Division of the Gaze, or, Remarks on the Color and Tenor of Contemporary "Theory"

1. See Laura Mulvey, "Visual Pleasure and Narrative Cinema" in *Visual and Other Pleasures* (Bloomington: Indiana University Press, 1989); Michel Foucault, *Surveiller et punir: Naissance de la prison*, (Paris: Gallimard, 1975);

and Norman Bryson, *Vision and Painting: The Logic of the Gaze* (New Haven: Yale University Press, 1983). A later summary statement of Bryson's position, "Semiology and Visual Interpretation" can be found in Norman Bryson, Michael Holly, and Keith Moxey, eds., *Visual Theory: Painting and Interpretation* (New York: HarperCollins, 1988), pp. 61–73, along with my "Reflections on Bryson," pp. 74–78.

2. At the time this chapter was written I was unable to draw upon either Rosalind Krauss's *The Optical Unconscious* (Cambridge: The MIT Press, 1993) or Martin Jay's *Downcast Eyes: The Denigration of Vision in Twentieth-Century French Thought* (Berkeley: University of California Press, 1993), both of which I take to be central to the renewed focus on questions of vision. Elements of both works have been available for some time, either in published from or as public lectures, and have had considerable influence on the way some issues are posed in this essay, so I should perhaps note that I am in general drawn to Krauss's way of exploring vision (although we also place our emphases in significantly different places and, at least at times, draw significantly diverse consequences because of that). Because *The Optical Unconscious* is animated primarily by questions arising from Clement Greenberg's emphasis on modernist "opticality," the interested reader may also want to consult Krauss's "Cindy Sherman: Untitled" (in *Cindy Sherman: 1975–1993* [New York: Rizzoli, 1993]) where she more directly engages issues arising from Mulvey's account of vision—especially Section 3 ("Gleams and Reflections"), which takes up much of the Lacan material I also discuss. By contrast, Jay and I seem to be at some odds, both about the interpretation of Lacan and about the actual role of vision in recent French thought. I would hope that the differences on narrowly Lacanian issues will be apparent to any reader of both texts, but it is perhaps worth being explicit that much of what Jay takes to be denigration of vision I am much more inclined to read as (an admittedly complex) valorization of it.

 I should also note in this context Margaret Iversen's even more recent essay, "What is a Photograph?" (*Art History* XVII: 2 [September 1994]: 451–464) which argues—entirely persuasively to my mind—that Roland Barthe's *Camera Lucida* is best understood as a direct derivation from Lacan's work on vision, and explores much of the same Lacanian material I engage here. In a footnote to her closely related review of Jay's book (*The Art Bulletin* LXXVI: 4 [December 1994]: 730–732), Iversen makes explicit the difference between our two readings. The final revisions to this essay have thus attempted to be as explicit as possible about how I take the specifically psychoanalytic allegory of Lacan's central scenario.

3. A further, related thought, less argued than enacted, is that the current prominence of the problematic of vision is itself the product of a special moment of disciplinary division and interference as "theory" passes from the fields in which it was first elaborated into art history and art criticism. It is the implied relation of this interdisciplinary situation to Goethe's theory of color discussed below that underlies my title's juxtaposition of color and theory.

4. From a little lower on the same page: "This book will argue the proposition that the only way to think the visual, to get a handle on increasing, tendential, all-pervasive visuality, as such, is to grasp its historical coming into being." Fredric Jameson, *Signatures of the Visible* (New York: Routledge, 1992), 1.

5. Jean-Paul Sartre, *Being and Nothingness*, trans. Hazal Barnes (New York: The Citadel Press, 1968), 235, 236.

6. Ibid., 237, 238, 239.

7. Sartre's discussion of the look opens with the following sentences: "This woman whom I see coming toward me, this man who is passing by in the street, this beggar whom I hear calling before my window, all are for me objects—of this there is no doubt. Thus it is true that at least one of the modalities of the Other's presence before me is object-ness." Ibid., 228–229.

8. It is perhaps worth remarking that the passage from visual submission to linguistic interpellation invites one to think about a further contrast between the Althusserian view of language as naming (and so subjecting) and J. L. Austin's arguments for the ethical centrality of the performative dimensions of language. Although such a comparison would obviously move beyond the visual terrain staked out by this chapter, I believe it would uncover a parallel range of issues.

9. See, for example, Craig Owens, *Beyond Recognition: Representation, Power, and Culture* (Berkeley: University of California Press, 1992) and my review of it in *Art and America* (July 1993).

10. See Jacques Lacan, *The Four Fundamental Concepts of Psychoanalysis*, trans. Alan Sheridan (New York: Norton, 1978), 84, where the rejection of Sartre's phenomenological description is explicit and unambiguous: "Is this a correct phenomenological analysis? No. It is not true that, when I am under the gaze, when I solicit a gaze, when I obtain it, I do not see it as a gaze." The grounds for this rejection are important to my argument: "Painters, above all, have grasped this gaze as such."

11. See Ibid., 95 ff.

12. Jacques Lacan, "Le temps logique et l'assertion de certitude anticipée: Un nouveau sophisme," in Lacan, *Ecrits* (Paris: Seuil, 1968), 197–198.

13. Note that "recognition" is at best a transient and preliminary moment in the dialectic.

14. Jacques Lacan, "Le séminaire sur 'La Lettre volée" in *Ecrits*, 11–61.

15. The social consequences of this thought are perhaps most fully played out, beyond Lacan, in Jean-Luc Nancy's central emphasis on "exposure" as the medium of community. See Jean-Luc Nancy, *The Inoperative Community*, trans. Peter Connor et al., (Minneapolis: University of Minnesota Press, 1991).

16. Were one to push further into this insofar as it pertains directly to psychoanalysis one would need to examine the fit between Sartre's theory of the Look and his rejection of the Unconscious. One might also want to take note of remarks like the following (from a review of Bernard Williams's *Shame and Necessity*): "With shame, the internalized other is a watcher (thus, primitively, it is shameful to be seen naked, but not to be naked); with guilt, the internalized other can be imagined as a voice, speaking as victim or judge." Richard Jenkyns, "How Homeric Are We?" *New York Times Book Review*, April 25, 1993: 3.

17. This suggests a way of reading Lacan's play with Venn diagrams in *Encore* as also an exercise in the Gothean optics I turn to below, the circles in it now appearing as the work of a figure carried over its boundary—a thought I like insofar as it extends the suggestion I've made elsewhere ("In the Light of the Other," *Whitewalls* 23 [Fall 1989]: 10–31) that Lacan's diagrams frequently

engage a desire to account for their own visibility and so can often be treated as elements in a visual and not simply schematic practice. (This last distinction takes it, in keeping with the over all argument of this chapter, that opacity is a defining dimension of the visual over and against the [intended] transparency of the schematic.)

18.	On this, see my discussion of the postscript to "The Seminar on 'The Purloined Letter' " in "Psychoanalysis and the Place of Jouissance." *Critical Inquiry* [December 1986]: 349–370.

19.	See the discussion of the "Four Discourses" as I take Lacan to present them in *Encore*, in my "Psychoanalysis and the Place of Jouissance."

20.	Between the Lacanian theory of vision (or visibility) and that discussion, there is, of course, the argument, conducted one way by Philippe Lacoue-Labarthe and Jean-Luc Nancy in *The Title of the Letter: A Reading of Lacan*, trans. François Raffoul and David Pettigrew (Albany: State University of New York Press, 1992) and another way by Derrida in "Le Facteur de La Vérité" (in Jacques Derrida, *The Postcard: from Socrates to Freud and Beyond*, trans. Alan Bass, (Chicago: University of Chicago Press, 1987), over how exactly one is to count or admit one's inability to count the number of agents in this scene. One way to work through that puzzle might be review the argument over "The Seminar on 'The Purloined Letter' " with an eye to these issues.

21.	On the critique of visual instantaneity, see Rosalind Krauss, "The Blink of an Eye," in *States of Theory* ed. David Carroll (New York: Columbia University Press, 1990), 175–199, and "The Story of the Eye," *New Literary History* 21:2 (Winter 1990): 283–298.

22.	Stanley Cavell, *Must We Mean What We Say*? (Cambridge: Cambridge University Press, 1976), 264.

23.	Maurice Merleau-Ponty, *The Visible and the Invisible*, trans. Alphonso Lingis (Evanston, Illinois: Northwestern University Press, 1968).

24.	This is not Lacan's only published engagement with the work of Merleau-Ponty; I will touch briefly below on his 1961 hommage "Maurice Merleau-Ponty" in *Les Temps Modernes* 184–185 (October 1961): 245–254.

25.	Merleau-Ponty, *Visible and Invisible*, p. 126. It is, I think, less clear that Lacan would reject this position or reject it as vigorously in the early 1950s.

26.	This is a distinctly visual version of what Heidegger had put more generally as a matter of "de-severance" and spatiality in *Being and Time*, §23 ff. For Sartre, this spatial distance-and-bridging becomes the absolute distance between Being and Nothingness—so that, as Mark Magleby has pointed out to me, in Sartre's text objects within the narrator's visual field are repeatedly presented in measurable relation to each other whereas the narrator's distance from or proximity to the object in this field remains unmeasurable.

27.	See Marshall Brown, "The Classical is the Baroque: On the Principle of Wölfflin's Art History," *Critical Inquiry* 9 (December 1982): 379–404, Margaret Iversen, *Alois Riegl: Art History and Theory* (Cambridge: The M. I. T Press, 1993), and Stephen Melville, "The Temptation of New Perspectives," *October* 52 (Spring 1990): 3–15.

28.	The "double dihedron" introduced in Chapters 8 and 9 of *Four Concepts* is nothing other than a figure of chiasmus. I have tried elsewhere (see "In the Light of the Other") to sketch out something of its complexity as a visual figure.

29. Notice especially here how Lacan passes from Merleau-Ponty on the painter's hand and eye to the thought that a bird would paint by dropping its feathers, a snake by casting off its scales, and a tree by letting fall its leaves (*Four Concepts*, 114).

30. This has meant that a certain tradition of art history in France, oriented to both Merleau-Ponty and Lacan, has repeatedly moved to take up the problem of painting in terms not of a surface and what lies or seems to lie behind it but of a surface and an obverse that is its necessary and irreducible concomitant. See, for example, Yves-Alain Bois, "Painting as Model" in his *Painting as Model* (Cambridge, Mass.: MIT Press, 1990); Hubert Damisch, *Fenêtre jaune cadmium, ou les dessous de la peinture* (Paris: Seuil, 1984); and Georges Didi-Huberman, *La peinture incarnée* (Paris: Minuit, 1985). Jacques Taminiaux's "The Thinker and the Painter," in Marshall C. Dillon, ed., *Merleau-Ponty Vivant* (Albany: State University of New York Press, 1991), pp. 195–212, explores the foundations for this view in Merleau-Ponty.

31. Lacan, *Four Concepts*, p. 112

32. I would not want to leave the impression that Lacan and Merleau-Ponty have the same theory of vision; the various rephrasings and displacements I've tried to briefly chart have deep and serious consequences. Lacan's 1961 essay on Merleau-Ponty lays these differences out clearly—Merleau-Ponty remains fixed on "presence," misses the insistence of the Symbolic within the Imaginary and of the signifier within the body, and so on. At the same time, this essay clearly lays out a preliminary version of the rapprochement that informs the discussion in *Four Concepts*. Lacan is fully justified in his response to the question that concludes the section on vision: "Miller: This leads me to ask you if *Le Visible et l'invisible* has led you to change anything in the article that you published on Merleau-Ponty in a number of *Les Temps Modernes*? Lacan: Absolutely nothing" (119).

33. I hesitate to include Gilles Deleuze within this broad generalization simply because I have not read enough of him. Certainly *The Fold: Leibniz and the Baroque*, trans. Tom Conley (Minneapolis: University of Minnesota Press, 1993) seems to work in this same region.

34. To take but one example, the critique of knowledge pictured as "a more or less passive medium through which the light of truth reaches us" in §73 of the *Phenomenology of Spirit* is not comprehensible on Newtonian theory but has to be made out by reference to Hegel's *Philosophy of Nature* and its reference back to Goethe.

35. The essay on Merleau-Ponty for *Les Temps Modernes* is, if anything, even more explicit about a shared recognition of the materiality of light: "Comment s'égaler à la pesée [pensée?] subtile qui se poursuit ici d'un éros de l'oeil, d'une corporalité de la lumière où ne s'évoquent plus que nostalgiquement leur théologique primauté?" (253).

36. And this should make us wary of Lacan's willingness to diagram his theory in apparently Newtonian or Cartesian terms. See my "In Light of the Other."

37. Johann Wolfgang von Goethe, *Theory of Colours*, trans. Charles Eastlake (Cambridge, MA: MIT Press, 1970), §208.

38. It is around this formulation that one can draw together Lacan's interest in *The Visible and the Invisible* and his appeal to Roger Caillois's "Mimicry and Legendary Psychaesthesia" (translated in *October* 31 [Spring 1984]: 17–32).

Rosalind Krauss has picked up particularly strongly on this side of Lacan's meditation in a series of essays, including "Corpus Delicti," *October* 33 (Summer 1985): 31–72.

39. If Krauss is in some ways exemplary here, she is also not the only player in the field. In addition to the various works in which Hubert Damisch, Georges Didi-Huberman, and others approach the question of painting and its obverse, one would also have to mention the work of Michael Fried, whose focus on a dialectic of absorption and theatricality in modern painting finds its own historical and theoretical way through the complex twining of Merleau-Ponty and Lacan and whose exchange with Linda Nochlin over Courbet's paintings of women offers a striking picture of the stakes in the current theoretical division of the gaze. See *Courbet Reconsidered*, eds. Sarah Faunce and Linda Nochlin (Brooklyn: The Brooklyn Museum, 1988); and Michael Fried, *Courbet's Realism* (Chicago: University of Chicago Press, 1990).

40. The tendentiousness lies in the widespread identification of the phrase "radical self-criticism" with the work of Clement Greenberg and Michael Fried, so my appeal to that phrase here marks, among other things, the passage from the critique of vision as it has been elaborated primarily in literary criticism and film study to the very different critique emerging in art history and criticism as a response to that field's own strong problematic of modernism.

41. This is a way of saying that they are playing at the table Nietzsche set in *The Birth of Tragedy*. In a sense one has said everything that needs to be said about Socrates and the project he set in motion in saying that he alone joined the Athenian audience as spectator—until he found in Euripides a writer of plays for which participation simply meant spectatorship.

42. See Joan Copjec, "The Orthopsychic Subject: Film Theory and the Reception of Lacan." *October* 49 (Summer 1989): 53–71.

43. This is, of course, an interpretation of the impact of Jameson's writings— from *Marxism and Form* (1971) through *The Prison House of Language* (1972) and on up to *Signatures of the Visible*—on the current understanding of theory in the United States. It can also serve as a way of understanding the importance of the encounter with Jameson's work for a critical itinerary like that of Craig Owens in the visual arts.

44. It is just here that one might begin to think about the differences between Krauss's *The Optical Unconscious* and Jay's *Downcast Eyes* not simply in theoretical terms, but in terms of the ways those theoretical differences carry with them radically different stances toward the writing of history—that is, radically different understandings of one's attachment to the past and therefore also of the appropriate way that relation is to be registered in its writing. Jay offers a somewhat uneasy defense of his "look from above" as integral to "seeing" the past in the closing pages of the introduction to *Downcast Eyes*, and a fuller defense of the position of the "synoptic intellectual historian" in "Two Cheers for Paraphrase" in his *Fin-de-Siècle Socialism and Other Essays* (New York: Routledge, 1988).

45. Such "appropriation to the look of things" might equally well be called "depropriation," and it is indeed in something like these terms that Rosalind Krauss and others have written about the work of Cindy Sherman in contrast with those accounts that attempt to assimilate Sherman's work to the

problematic of "the male gaze." One might also note in this context Philippe Lacoue-Labarthe's account, in *Portrait de l'artist en général* (Paris: Christian Bourgois, 1979), of the Swiss artist Urs Lüthi's "depropriations." One way to put the general thrust of the present essay is to say that it takes vision to be unthinkable outside of the movement by which "appropriation" and "depropriation" are bound to one another.

Chapter Seven Color Has Not Yet Been Named: Objectivity In Deconstruction

1. One moral of the controversy with Lacan would be the further caution that these things also are not "pure signifiers."
2. On both the relation to *Abbau* and the choice of *déconstruction* to render it, see Derrida's "Letter to a Japanese Friend," in *Derrida and Differance*, ed. D. Wood and R. Bernasconi (Evanston, Ill.: Northwestern University Press, 1988).
3. I think most notably here, of course, of Gregory Ulmer's *Applied Grammatology* (Baltimore: Johns Hopkins University Press, 1985).
4. C. Belsey, *Critical Practice* (London: Methuen, 1980), pp. 7–10.
5. The inadequacies of this translations have been more than adequately discussed, particularly by Barbara Johnson in her translation of Derrida's *Dissemination* (Chicago: University of Chicago Press, 1981), pp. xivff. In this context, though, it may be worth stressing that Derrida's general interest in "textuality" is more fully caught through his notion of "spacing" than through any explicit theory of language as such.
6. An expanded version of this talk has recently been published in *Illustration* (Cambridge, Mass.: Harvard University Press, 1992), Michel Foucault has famously addressed similar issues in his treatment of *Las Meninas* in the opening section of *The Order of Things: An Archaeology of the Human Sciences* (New York: Random House, 1973), and Michael Fried brings a similar interest to beat on Courbet's *Studio* in his *Courbet's Realism* (Chicago: University of Chicago Press, 1990).
7. De Man would seem to need separate treatment here, but it seems fair to say that his work unfolded in a frequently difficult relation to projects of ideological critique, and that late in his career he became increasingly willing to articulate the motives of his work in such terms.
8. Bryson is thus methodologically "at home" with, for example, certain tendencies within eighteenth-century art and art theory in a way he is not with nineteenth-century French painting or with the genre of still life. This is, however, not to suggest that he does his strongest work where he is at home; the reverse seems to me more nearly the case—*Looking at the Overlooked: Four Essays on Still Life Painting* (Cambridge, Mass.: Harvard University Press, 1990), in particular, threatens everywhere to break with its semiotic frame.
9. That a purely semiotic construal of color may become possible and even central in twentieth-century art is something a Brysonian approach would be obliged to overlook just insofar as that semiotic availability depends upon both a radical shift in the material conditions of painting and the availability of an understanding of art history in which that shift could be actively registered. On

these matters, see the writings of Thierry de Duve, most notably "The Readymade and the Tube of Paint," *Artforum* (May 1986):110–21.

10. For Adami and Titus-Carmel, see J. Derrida, *The Truth in Painting*, trans. G. Bennington and I. McLeod (Chicago: University of Chicago Press, 1987): for Loubrieu, see "Illustrer, dit-il" in J. Derrida, *Psyché: Inventions de l'autre* (Paris: Galilée, 1987), pp. 105–8. The reader may also want to consult *Mémoires d'avengle: L'autoportrait et autres ruines* (Paris: Réunion des Musées Nationaux, 1990), the catalogue for the drawing show curated by Derrida at the Louvre.

11. "I thought at first that perhaps [deconstructive architecture] was an analogy, a displaced discourse, and something more analogical than rigorous. And then—as I have explained somewhere—then I realised that on the contrary, the most efficient way of putting Deconstruction to work was by going through art and architecture. . . . Deconstruction goes through certain social and political structures, meeting with resistance and displacement as it does so." "Jacques Derrida, in Discussion with Christopher Norris," in *Deconstruction: Omnibus volume*, ed. A. Papadakis, C. Cooke, and A. Benjamin (London: Academy Editions, 1989), pp. 71–2.

12. "The failure of the work in a certain way was that I was not contained, that I was not played out of my position into some new position. Jacques contributed an unfinished text that he was working on from Plato's Timaeus. We took this as the programme. We then worked with the idea of chora as the programme. Jacques would criticize it until we got to the point where he was more comfortable with what we were doing: I think really more comfortable with architecture than any particular part of the work. I was probably and not coincidentally doing chora before I read his text. I think it is a collaboration that will happen some day; it has not happened yet. We finally forced Jacques to draw something," *Omnibus*, p. 145. Derrida's role, as described here, is essentially that of a client, not a collaborator. Eisenman's more recent exchanges with Derrida are still more stringent in their ascription of failure to the project; see J. Derrida, "A Letter to Peter Eisenman," and P. Eisenman, "Post/El Cards: A Reply to Jacques Derrida," both in *Assemblage*, no. 12(August 1990):7–17.

13. In general, Derrida's remarks on architecture—for example, "Fifty-two Aphorisms for a Foreword," *Omnibus*, pp. 67–9—seem oddly committed to trying to imagine an architecture adequate to the work of deconstruction.

14. To pursue this topic further would entail a discussion of the influence of Foucault's *Discipline and Punish: The Birth of the Prison*, trans. Alan Sheridan (New York: Vintage, 1979), on our general notions of the work of theory. I will simply note that my own use of the word "discipline" aims at activity fundamentally alien to the modes of surveillance examined by Foucault. Foucault's linkage of vision, discipline, and surveillance certainly has played and will continue to play a strong role in one's general imagination of the poststructuralist stake in the visual; it is a more or less tacit thesis of this essay that this can be, and has been, deeply misleading. I have taken up some of the issues involved here in a reading of Lacan; see S. Melville, "In the Light of the Other," *Whitewalls*, no. 23(Fall 1989):10–31.

15. Donald Preziosi's *Rethinking Art History: Meditations on a Coy Science* (New Haven: Yale University Press, 1989) is perhaps the example nearest to hand,

and the fundamentally Foucaultian parameters of the book are worth noting. I approach the examples of Riegl and Wölfflin within what I take to be a more Derridean frame in "The Temptation of New Perspectives," *October*, no. 52(Spring 1990):3–15. See also Marshall Brown's "The Classic Is the Baroque: The Principle of Wölfflin's Art History," *Critical Inquiry* 9(December 1982):379–404.

16. This is not the place to spell out or defend in detail a deconstructive sense for a phrase like "critique of representation," but it is worth the reader's recalling that Derrida's most characteristic description of his activity is in terms of a "critique of presence" and that it is not clear what this entails for our understanding of "representation." It may then seem that my own invocation of something like "touch" in phrasing deconstruction's relation to its objects falls short of the standard implicit in "the critique of presence." The questions raised here demand separate and lengthy argument, so I will simply assert that I do not understand deconstruction's critique of presence to entail skepticism in any normal sense and that I do understand deconstruction as always called for by something other than itself: something that is there—object, event, text.

17. The participants were Andrew Benjamin; Geoff Bennington, Christopher Norris, and Michael Podro.

18. The complete discussion can be found in *Omnibus*, pp. 76–8.

19. *Omnibus*, p. 84.

20. The secondariness and relative passivity of human agency in relation to such formulations seem deeply characteristic of deconstruction.

21. Nor is there the same structure of apocalyptic hope that emerges in the work of the later Heidegger; but see J. Derrida, "Of an Apocalyptic Tone Recently Adopted in Philosophy," trans. J. P. Leavey, Jr., *Semeia*, no. 23(1982). One might say that for Derrida, "writing" names the impossibility of what Heidegger calls "thinking."

22. Heidegger's thought—and this I take to be the central burden of Derrida's critique of it—continues to grant a certain demystificatory privilege to philosophy/poetry.

23. Although Lyotard works in considerably greater proximity to art and art history than Derrida, he is equally clear about the determining role of the name of philosophy for his writing. The relation between Derrida and Lyotard is difficult: Are we to understand it as offering us a choice? Or is it more nearly the case that to choose one must be also to choose the other, despite or even because of their differences? No doubt something of this ambivalence marks this essay.

24. Recently translated works by Lacoue-Labarthe include *Typography: Mimesis, Philosophy, Politics*, ed. C. Fynsk (Cambridge, Mass.: Harvard University Press, 1989), and *Heidegger, Art and Politics: The Fiction of the Political*, trans. C. Turner (London: Basil Blackwell, 1990). Lacoue-Labarthe's essay on the work of Urs Lüthi, *Portrait de l'artiste, en général* (Paris: Christian Bourgeois, 1979), is of special interest in the context of discussions of "post-modern" appropriation.

25. Or to "mimetologism," the appropriation of mimetic supplementarity to a prior logos and the consequent thinking of mimesis as appropriation or participation rather than as permanent disappropriation.

26. I have tried to explore some of these issues in a preliminary way in "The Temptation of New Perspectives." See also Georges Didi-Huberman, *Devant l'image: Question posée aux fins d'une histoire de l'art* (Paris: Minuit, 1990).

27. For Krauss, see (among a great many other things) "The Im/pulse to See," in *Vision and Visuality*, ed. H. Foster (Port Townsend: Bay Press, 1988), pp. 51–75; "The Blink of An Eye," in *States of Theory: History, Art, and Critical Discourse*, ed. D. Carroll (New York: Columbia University Press, 1990), pp. 175–99; and "The Story of an Eye," *New Literary History 21* (1989):283–98. For Fried, see especially *Courbet's Realism*, For Damisch, see *L'Origine de la perspective* (Paris: Flammarion, 1987), and for de Duve, see *Pictorial Nominalism* (Minneapolis: University of Minnesota Press, 1991), *Au ???Nom de l'art: Pour une archéologie de la modernité* (Paris: Minuit, 1989), and *Essais datés I: 1974–1986* (Paris: Editions de la Différence, 1987). See also Yves-Alain Bois, *Painting as Model* (Cambridge, Mass.: MIT Press, 1990).

28. Lyotard regularly registers this "uniqueness" within his orientation to the event as "singularity," and similarly insists on a distinction between this "singularity" and mere numerical identity. The intellectual groundwork for both Derrida and Lyotard on this topic is well displayed in M. Heidegger, *Identity and Difference*, trans. J. Stambaugh (New York: Harper & Row, 1969).

29. The priority and alterity claimed here are in some sense simple analytic truths about what it is to read. But because they are themselves always (re)discovered in reading, one should not make any easy assumptions about what these terms mean. The play of "logical" and "temporal" priority that informs the tradition in which Derrida writes is extremely complex and does not permit any easy reliance on chronology and the like.

30. Here, as also in Lacoue-Labarthe's treatment of mimesis, deconstruction betrays a markedly Aristotelian orientation.

31. Put somewhat differently, deconstruction refuses to take nature and culture as opposed terms. This clearly informs Derrida's early interest in Rousseau; see *Of Grammatology*, trans. G. Spivak (Baltimore: Johns Hopkins University Press, 1976).

32. On these topics, see, in addition to F. de Saussure, *Course in General Linguistics*, trans. W. Boggs (New York: McGraw-Hill, 1969). Umberto Eco's "How Culture Conditions the Colours We See," in *On Signs*, ed. M. Blonsky (London: Basil Blackwell, 1985), pp. 157–75, and C. L. Hardin, *Color for Philosophers: Unuraving the Rainbow* (Indianapolis: Hackett, 1988), esp. pp. 155–82 (which argues against the linguistic construction of color).

33. Julia Kristeva's "Giotto's Joy," in *Calligram: Essays in New Art History from France*, ed. N. Bryson (Cambridge University Press, 1988), pp. 27–52, is a well-known version of this argument. More interesting, for my purposes, is the case Greenberg and Fried have argued for the postpainterly abstraction of Morris Louis, Kenneth Noland, and others.

34. These remarks sketch an understanding of the current conjuncture in which a certain interest in deconstruction might arise. This understanding relies heavily on the work of Michael Fried and Rosalind Krauss, as well as on an interpretation of their differences along the lines advanced in my "Notes on the Reemergence of Allegory, the Forgetting of Modernism, the Necessity of Rhetoric, and the Conditions of Publicity in Art and Criticism," *October*, no. 19(Winter 1981):55–92, although that essay is blind to the questions of color

raised here.

35. And here I am quoting Derrida. How far in this essay have I also been reading him? And how faithfully?

"Color has not yet been named. At the moment of writing. I have not seen the color of *Chimera*. Why show drawings? What is Adami's drawing [design]? An explanation is necessary.

"Before the finished quality of a production the power and insolence of whose chromatic unfurling is well known, is it that one might want to open his studio on *work in progress*, unveil the linear substratum, the intrigue under way, travail in train, the naked *trait*, the traject or stages of a 'journey'? That would be a little simple". *The Truth in Painting*, p. 169.

Chapter Eight Notes on the Reemergence of Allegory, the Forgetting of Modernism, the Necessity of Rhetoric, and the Conditions of Publicity in Art and Criticism

1. See Robert Pincus-Witten, "Naked Lunches," *October*, no. 3 (Spring 1977), 116.

2. In literary criticism, I would point to the work of Paul de Man in particular. Relevant writings include "The Rhetoric of Temporality," in Charles S. Singleton, ed., *Interpretation: Theory and Practice*, Baltimore, Johns Hopkins, 1969, pp. 173–210; *Blindness and Insight: Essays in the Rhetoric of Contemporary Criticism*, New York, Oxford, 1971; and *Allegories of Reading: Figural Language in Rousseau, Nietzsche, Rilke, and Proust*, New Haven, Yale, 1979.

The present essay is a response to a series of essays recently published in *October*. They include: Douglas Crimp, "Pictures," no. 8 (Spring 1979), 75–88; and "On the Museum's Ruins," no. 13 (Summer 1980), 41–57; Joel Fineman, "The Structure of Allegorical Desire," no. 12 (Spring 1980), 47–66; Craig Owens, "*Einstein on the Beach*: The Primacy of Metaphor," no. 4 (Fall 1977), 21–32; and "The Allegorical Impulse: Toward a Theory of Postmodernism," parts 1 and 2, no. 12 (Spring 1980), 67–86, and no. 13 (Summer 1980), 61–80. I will refer also to Owen's "Robert Wilson: Tableaux," *Art in America*, vol. 68, no. 9 (November 1980), 114–117.

Joan Simon, "Double Takes," *Art in America*, vol. 68, no. 8 (October 1980) provides a useful overview of the discussion about allegory and painting that is currently taking place, together with a useful short bibliography.

3. Michael Fried, *Absorption and Theatricality: Painting and Beholder in the Age of Diderot*, Berkeley and Los Angeles, University of California, 1980. This book revises, expands, and gathers together a number of previously published essays.

Reference will be made throughout this essay to Fried's controversial "Art and Objecthood," which first appeared in *Artforum*, vol. V, no. 10 (Summer 1967), and has since been extensively reprinted. My references are to the reprint in Gregory Battcock, ed., *Minimal Art: A Critical Anthology*, New York, E. P. Dutton, 1968. Other works by Fried of relevance to this essay are *Morris Louis*, New York, Abrams, n.d.; *Three American Painters*, Cambridge, Fogg Art Museum, 1965; "Manet's Sources: Aspects of His Art, 1859–65,"

Artforum, vol. VII, no. 7 (March 1969); "Thomas Couture and the
Theatricalization of Action," *Artforum*, vol. 8, no. 10 (June 1970); "The
Beholder in Courbet: His Early Self-Portraits and Their Place in His Art,"
Glyph 4, Baltimore, Johns Hopkins, 1978, pp. 85–129.

4. Fineman, "Allegorical Desire," p. 48.
5. Fried, *Absorption and Theatricality*, p. 164.
6. Stanley Cavell, *Must We Mean What We Say?*, Cambridge, University, p. xix.
7. Stanley Cavell, "Existentialism and Analytical Philosophy," *Daedelus*, 1964,
 pp. 967–968.
8. Owens, "Allegorical Impulse," part 2, pp. 60–61.
9. This is more obviously true for recent developments in literary criticism than
 in art, since literary criticism has for some time explicitly valorized irony as
 the principle of literary unity. In both regions allegory offers the possibility of
 moving beyond too narrow an understanding of the purity of the work.
10. Cavell, "Existentialism," p. 968.
11. Stanley Cavell, *The Claim of Reason: Wittgenstein, Skepticism, Knowledge, and
 Morality*, New York, Oxford, 1979, p. 355. The ensuing quotation is from p.
 356.
12. Fried, "Art and Objecthood," p. 130.
13. "If it makes sense to speak of seeing human beings, then it makes sense to
 imagine that a human being may lack the capacity to see beings as human. It
 would make sense to ask whether someone may be soul-blind. . . .

 "So to speak of seeing human beings as human beings is to imply that we
 notice that human beings are human beings; and that seems no more
 acceptable than saying that we are of the *opinion* that they are (cf.
 Investigations, p. 178).—What is implied is that it is essential to knowing
 that something is human that we sometimes experience it as such, and
 sometimes do not, or fail to; that certain alterations of consciousness take
 place, and sometimes not, in the fact of it" (Cavell, *The Claim of Reason*, pp.
 378–379).

 Our concern throughout this essay—perhaps most explicitly in the section
 entitled "The Truth of Allegory and the Necessity of Rhetoric"—is with the
 continuing and twin possibilities of soul- and art-blindness.
14. Fried, "Art and Objecthood," pp. 123–124.
15. *Ibid.*, p. 142.
16. *Ibid.*, p. 123.
17. See Fried, *Absorption and Theatricality*, p. 93.
18. Fried, "Art and Objecthood," p. 142.
19. The focus on "Frenchness" in this paragraph is derived primarily from
 "Manet's Sources"; the reader may also wish to consult the essays on Couture
 and Courbet.
20. Cavell, *Must We Mean*, p. 221.
21. These remarks are derived primarily from "The Beholder in Courbet."
22. Here I simply want to register the explicit crossing of my museums with the
 museum discussed by Douglas Crimp in "On the Museum's Ruins"; my
 imaginings embroider here on his.
23. Fried, "Art and Objecthood," pp. 144–145.
24. Crimp all but makes explicit the connection between the museum and the
 problematic of "Art and Objecthood" in his attempt to relate Rauschenberg

and Manet through Fried's essay on Manet's sources; see "On the Museum's Ruins," p. 45.

25. Robert Smithson, in Nancy Holt, ed., *The Writings of Robert Smithson*, New York, New York University, 1979, p. 38.

26. Cavell, *Must We Mean*, pp. 190–191. Crimes and deeds of glory look alike, I want to say, in much the same way hello and good-bye look alike, and differ in much the same way; for Fried, "the same developments" differ as they are seen theatrically or not (see "Art and Objecthood," p. 136). This play of identity and difference is at the heart of allegorical double vision.

27. Fried, *Absorption and Theatricality*, p. 93.

28. *Ibid.*, pp. 95, 100. Fried translates: "An unexpected incident that happens in the course of the action and that suddenly changes the situation of the characters on the stage, so natural and so true to life that, faithfully rendered by a painter, it would please me on canvas, is a *tableau.*"

29. Owens, "Robert Wilson: Tableaux," p. 115.

30. Fried, *Absorption and Theatricality*, pp. 103–104.

31. Jacques Derrida. "The Theater of Cruelty and the Closure of Representation," in *Writing and Difference*, trans. Alan Bass, Chicago, University of Chicago, 1978, pp. 243–245.

32. Cited by Derrida, *Writing and Difference*, p. 249.

33. Derrida, *Writing and Difference*, p. 248.

34. Crimp, "Pictures," p. 76, as also the quoted phrases in the next sentence.

35. *Ibid.*, p. 77.

36. But there is a knot here. For us the major theorist of the heteronomous and heterological is, of course, Derrida. And Joel Fineman is quite right to say that "Derrida's project is effectively to apply Heidegger's critique of Western metaphysics to Heidegger himself," and that there is in this insistence something of an "ever-vigilant, vaguely messianic, deconstructive Puritanism" (Fineman, "The Significance of Literature: *The Importance of Being Earnest,*" *October*, no. 15 [Winter 1980], 81). Heteronomy and purity are, as it were, in each other's service; neither escapes or stands apart from the other. Purity and its quotation marks together are essential to what we mean by modernism.

37. Cavell, *Must We Mean*, p. xix.

38. Owens, "Allegorical Impulse," part 2, p. 79.

39. Jacques Derrida, "Où commence et comment finit un corps enseignant," in Dominique Grisoni, ed., *Politiques de la philosophie*, Paris, Bernard Grasset, 1976, p. 64.

40. For the figure of the shell and kernel (and its link to translation), see Jacques Derrida, "Me—Psychoanalysis: An Introduction to the Translation of "The Shell and the Kernel," by Nicolas Abraham," trans. Richard Klein, *Diacritics*, vol. 9, no. 1 (Spring 1979), and, in the same issue, Abraham's essay "The Shell and the Kernel," trans. Nicholas Rand.

On the purloining of sense, see Jacques Lacan, "Seminar on 'The Purloined Letter,' " trans. Jeffrey Mehlman, *Yale French Studies*, no. 48. The original French text appears in Lacan, *Ecrits*, Paris, Seuil, 1966, and a transcript of the actual seminar from which the essay emerged appears in Lacan, *Le Moi dans la théorie de Freud et dans la technique de la psychanalyse (Le Seminaire*, livre 2), Paris, Seuil, 1978. Derrida's rejoinder, "Le Facteur de la

vérité," first appeared in *Poétique* and is now available in *La Carte postale: de Socrates à Freud et au-delà*, Paris, Aubier-Flammarion, 1980; a translation, "The Purveyor of Truth," appears in *Yale French Studies*, no. 52 (some of the footnotes in this committee translation are seriously muddled).

The controversy between Lacan and Derrida can appear in the present context as an argument about the relation between allegory and that truth it bears (and through which it loses itself). An interest in this argument is, I take it, reflected in Fineman's effort to "maintain the validity of the distinction between literature and its criticism" over and against the "infinite, indefinite, unbounded extension of what nowadays is called textuality." It would seem that both in the case of Lacan and Derrida and that of literature and its criticism what is needed is a way of clinging to the controversy or distinction itself. Like Fineman, I want to register a certain dissatisfaction with a (presumably de Manian) criticism that "projects its own critical unhappiness onto literature, whose self-deconstruction would then be understood as criticism." But I am loath to set against such a denial of psychoanalysis an equally simple revalorization of the truth of psychoanalysis. What I would like is a more oblique approach that would let one see how both denial and reaffirmation fall similarly short of the necessary recognition of criticism. But all of this belongs, obviously, to another essay. It is perhaps enough to remark here that my Derrida suspects Fineman's Lacan as I presume his Lacan suspects my Derrida: if we can do this well we will be doing the necessary. (I have been quoting Fineman's "Allegorical Desire," pp. 64–65.)

41. Fried, "Art and Objecthood," p. 136.
42. With this I at once address and elide the central matter of the photograph. I find myself still struggling with the notions advanced by Crimp in "The Photographic Activity of Postmodernism" (*October*, no. 15 [Winter 1980], 91–101), as well as his still more recent essays, "The End of Painting" (*October*, no. 16 [Spring 1981], 69–86) and "The Museum's Old/The Library's New Subject," *Parachute*, no. 22 [Spring 1981], 32–37). My inclination here will, I assume, be obvious: it is to say that photography is a central place for the posing of questions of automatism and that photographic work will inevitably be touched by that questioning, so that we will find ourselves forced to such assertions as that the photograph has "acquired an aura, only now its is a function not of presence, but of absence, severed from an origin, from an originator, from autheticity," and that "in our time, the aura has become only a presence, which is to say a ghost" ("Photographic Activity," p. 100). But I will also say that this does not free us from problems of aura and presence—rather it frees us into them and their complexity. The loss (or gain) of aura will not be simple.
43. Cavell, *Must We Mean*, p. 188.
44. *Ibid.*, p. 207.
45. In a review entitled "How Should Acconci Count for Us? Notes on a Retrospect," *October*, no. 18 (Fall 1981), 79–89. The essay is an attempt at working out practically what it means to talk about a work in terms of the way in which it meets or fails to meet its conditions of publicity, the fact that it addresses an audience which must be gathered.
46. Owens, "Allegorical Impulse," part 2, p. 80.

47. Or even between now and now: as these notes were undergoing revision, *October* 15 appeared with the new essays by Crimp and Fineman indicated in previous footnotes: and, as the notes were edited for a final time, *October* 16 appeared with Crimp's "The End of Painting," and Benjamin H. D. Buchloh's "Figures of Authority, Ciphers of Regression: Notes on the Return of Representation in European Painting": furthermore, *Parachute* 22 with Crimp's "The Museum's Old/The Library's New Subject." A new essay by Michael Fried has also appeared: "Representing Representation: On the Central Group in Courbet's 'Studio,' " *Art in America*, vol. 69, no. 7 (September 1981), pp. 127–133, 168–173. Courbet's painting is, of course, subtitled "Allégorie réelle. . . ."

48. Cavell, *Must We Mean*, pp. 207–208.

Chapter Nine Compelling Acts, Haunting Convictions

1. *Absorption and Theatricality: Painting and Beholder in the Age of Diderot*, Berkeley, 1980; 'Manet's Sources: Aspects of His Art, 1859–65', *Artforum*. March 1969; 'Thomas Couture and the Theatricalization of Action in 19th Century French Painting', *Artforum*, June 1970.

2. 'Art and Objecthood', *Artforum*, June 1967. See also 'How Modernism Works: A Response to T.J. Clark', *Critical Inquiry*, September 1982.

3. See especially Philippe Lacoue-Labarthe, *Typography: Mimesis, Philosophy, Politics*, Cambridge, Ma. and London, 1989.

4. See for example, p. 78 (with reference to the early self-portraits) and pp. 132–3 (in reference to the *Burial at Ornans*).

5. As we have seen, the ever-increasing difficulty of dealing effectively with the issue of theatricality meant that action and expression became more and more disabled as vehicles of major pictorial expression . . . But there is an important sense in which Courbet's art too was based on the representation of significant action, specifically the action of making paintings . . . (pp. 277–8).

6. Basically, I understand formalism in art history or art criticism to imply an approach in which: 1) considerations of subject matter are systematically subordinated to considerations of 'form', and 2) the latter are understood as invariable or transhistorical in their significance . . . (p. 47).

7. See Martin Heidegger, 'The Origin of the Work of Art', *Poetry, Language, Thought*, trans. A. Hofstadter, New York, 1971; Meyer Schapiro, 'Still Life as Personal Object', *The Reach of Mind: Essays in Honor of Kurt Goldstein*, New York, 1968; and Jacques Derrida, 'Restitutions', *The Truth in Painting*, trans. G. Bennington and I. McLeod, Chicago and London, 1987.

8. See T.J. Clark, *Image of the People: Gustave Courbet and the 1848 Revolution*, Princeton, 1982; 'Preliminaries to a Possible Treatment of *Olympia* in 1865', *Screen*, Spring 1980: and *The Painting of Modern Life: Paris in the Art of Manet and His Followers*, New York, 1985.

9. See 'Courbet's Real Allegory: Rereading "The Painter's Studio" ', in Sarah Faunce and Linda Nochlin, *Courbet Reconsidered*, The Brooklyn Museum, 1988, p. 18.

Chapter Ten Painting Put Asunder: Moments Lucid and Opaque *Like Turner's Sun and Cindy Sherman's Face*

1. This last point is well addressed by Yves-Alain Bois, see his 'Painting: The Task of Mourning', in *Painting as Model*, MIT Press, Cambridge, Mass, 1991.
2. As it is also for that latest of Hegelians. Arthur Danto.
3. On Duchamp, see the various recent works of Thierry de Duve, most notably his *Pictorial Nominalism*, University of Minnesota Press, Minneapolis, 1991, as well as Rosalind Krauss's essays 'The Im/pulse To See' in *Vision and Visuality*, ed H Foster, Bay Press, Port Townsend, 1988, pp 51–75; 'The Blink of An Eye', in *States of Theory: History, Art, and Critical Discourse*, ed D Carroll, Columbia University Press, New York, 1990, pp 175–99; and 'The Story of an Eye', *New Literary History* 21, pp 283–98.
4. See, among many other pertinent writings, Douglas Crimp, 'Pictures', and Craig Owens, 'The Allegorical Impulse: Toward a Theory of Postmodernism', both in B Wallis (ed), *Art After Modernism: Rethinking Representation*, The New Museum of Contemporary Art, New York, 1984.
5. The work of Victor Burgin and Mary Kelly seems more obviously available to the American scene (and indeed the fate of this work is likely to be settled within the American context).
6. Martin Heidegger, *The Question Concerning Technology and Other Essays*, trans W Lovitt, Harper & Row, New York, 1977, pp 135, 154.
7. *Rain, Steam, and Speed*, with its wholly painted compounding of nature and industry, is a more familiar and central example of the same thing.
8. To argue this as a reading of Kant would be to say that both (1) the slippage within the double proposition that 'Nature is beautiful because it looks like art, and art can only be called beautiful if we are conscious of art while it looks like nature,' and (2) the parallel slippage within the Third Critique's unstable balancing of philosophy itself with and against art have been overlooked or forgotten.
9. Here I am drawing on what I take to be consequences of the arguments Michael Fried advances throughout his *Courbet's Realism*, University of Chicago Press, Chicago, 1990, and especially in the closing chapter.
10. I would be the last one to deny that one can screw up a photograph. But then that's all one has done. This kind of failure is roughly on the order of spilling a paint pot on one's canvas: it results in a botch, not an unsuccessful painting. And if the painter's botch is always potentially redeemable as painting, the screwed up photograph is condemned to remain in that condition.
11. See Rosalind Krauss, 'Photography in the Service of Surrealism' in R Krauss and J Livingstone, *L'amour fou: Photography and Surrealism*, Abbeville Press, New York, 1985.
12. Martin Heidegger, *Schelling's Treatise on the Essence of Human Freedom*, trans J Stambaugh, Ohio University Press, Athens, Ohio, 1985, pp 42–43. See also, Martin Heidegger, *Hegel's Phenomenology of Spirit*, trans P Emad and K Maly, Indiana University Press, Bloomington, Indiana, 1988, pp 13–17.
13. One of Lacan's remarks seems very much to the point here: 'It is because the picture is the appearance that says it is that which gives the appearance that Plato attacks painting, as if it were an activity competing with his own.'

Jacques Lacan, *The Four Fundamental Concepts of Psychoanalysis*, trans A Sheridan, WW Norton & Co, New York, 1977, p 112.

14. And this can point to what was wrong in the initial claim for the work of Sherman, Levine, and others: it never represented a turn from painting to drawing but was always a turn, within something that must still be called painting, once more towards what must likewise be called colour.